The Art
of Peace

Eight collections, one vision

Sir David Khalili

EBURY
PRESS

Published in 2023 by Ebury Press, an imprint of Ebury Publishing
20 Vauxhall Bridge Road,
London SW1V 2SA

Ebury Press is part of the Penguin Random House group of companies
whose addresses can be found at global.penguinrandomhouse.com

Text © Nasser David Khalili

Nasser David Khalili has asserted his right
to be identified as the author of this work in accordance with
the Copyright, Designs and Patents Act 1988

This edition first published by Ebury Press in 2023

A CIP catalogue record for this book is available from the British Library

ISBN 978-1-52991-818-2

The authorised representative in the EEA is Penguin Random House Ireland,
Morrison Chambers, 32 Nassau Street, Dublin D02 YH68

Penguin Random House is committed to a sustainable future
for our businesses, our readers and our planet. This book
is made from Forest Stewardship® paper.

This book is dedicated to my wife, Marion; our three sons, Daniel, Benjamin and Raphael; and to my late parents, Hadassah and Daniel Khalili, whose blessing and prayers have accompanied me all my life and are at the heart of everything I do. The love of my entire family has been the greatest blessing of my life. I also dedicate this book to the souls of the artists who, over the centuries, have created selflessly the timeless objects of beauty in our collections.

Contents

~ I ~

Beginnings

My father was an art dealer: when I was growing up in Tehran in the 1950s he was always visiting clients' homes to buy or give advice about objects they were selling, or show them objects they might want to buy themselves. I loved to go with him. One afternoon, our private viewing took place at the home of Dr Mahmoud Mehran, who'd served as Iran's minister of education. He owned many lacquer objects and was looking to sell a small selection of pen boxes. Dr Mehran was an imposing figure in a grey three-piece suit, crisp white shirt and tie; my father wore a dark suit too, and to an 11-year-old boy these tall men in their formal clothes discoursing on art and history seemed impossibly sophisticated and important.

While my father studied Dr Mehran's collection, I picked up a pen box that sat on his desk.

The box was less than a foot long and barely a couple of inches wide and high. Yet its small surface was alive with tiny figures – gatherings of men in bright red and green robes, each figure distinguished by subtle

detail: hat, turban, belt, amulet, beard, moustache, eyes and mouth, each scene framed by branching gold arabesques. When I looked closer I saw that the largest gathering was labelled in Persian, and the words drew me in still further: Alexander, in discussion with Aristotle! Alexander, already one of my heroes, who had linked the Mediterranean to Persia and India, who had untied the Gordian knot and entered Persepolis in triumph. My father was talking to Dr Mehran, about prices and potential buyers, but I'd lost track of what they were saying – all my attention was on the pen box.

As I was already beginning to learn, these richly decorated pen boxes or *qalamdan* became popular in Iran in the late seventeenth century, treasured not only as objects of beauty but as symbols of high social status – cherished by kings, amirs, prime ministers, industrialists and poets. Sometimes, the shah himself would commission a pen box for his own use or as a gift for a senior official, and he employed the finest court artists to paint them. The craftsmanship of these pieces was incredible. They were made of papier mâché, with as many as 28 layers of paper glued together using a paste made from roots, then painted in vivid detail, usually with watercolours, sometimes with oil, and finished with layers of varnish – all to make a home for reed pens, gold or silver inkwells, penknives for cutting pen tips, whetstones to sharpen the penknives, and scissors to trim the edges of the writing paper.

And this box on Dr Mehran's desk was a wonderful example – made in Isfahan around 1870–80, with a fine-tooled sliding compartment, the two parts fitting together as precisely as a key in a lock. I loved the way the figures were differentiated – dozens of distinct personalities

captured in two dimensions. And those two heroic figures I had read about and heard my father tell stories about – Alexander who laid Homer's *Iliad* under his pillow along with his dagger, and Aristotle who tutored the warrior-king in philosophy, politics, medicine, the natural sciences . . .

'Nasser?'

I looked up. Dr Mehran and my father, in their dark suits, were looking at me intently.

'Son, what are you doing?'

Embarrassed, I began talking about the pen box, telling Dr Mehran what a miracle it was that the painter managed to do so much in such a limited space. I said I felt it was like taking a horseman who was doing some amazing tricks with a horse in an open field and asking him to do the same in a tiny room. Dr Mehran looked at me seriously, and then smiled as he turned to my father.

'I wasn't going to sell this one to you,' he said, picking the box up from his desk. 'But I'm going to give it to your son as a souvenir of your visit today.'

He handed the box to me. My hands were shaking. I was so excited I could burst.

I was born in 1945, in Isfahan; my family moved to the capital Tehran when I was just eight months old. I was the only one of us born in hospital, the famous Christian hospital in Isfahan – at the time one of the most advanced in Iran. The hospital had been built by British missionaries in 1904, and the doctor predicted to my mother that one day I would live in Britain, 'tied to its fate and its glory'.

My father especially loved to remember our house in the glass-makers' district of Isfahan – the intricate muqarnas plasterwork, the marquetry on mantelpieces and archways, the beehive feeling you got from the hexagonal patterns in the mirrorwork. Each section had been given to a sibling, children and grandchildren gathered round my father's father, Eliyahu, like butterflies around a flower.

According to my father, my grandfather was a living symbol of humane and compassionate behaviour. He was often asked to mediate in local disputes and family conflicts, and he would settle these matters quoting the wisdom of the biblical prophets and the poems of Rumi. During Reza Khan's prime ministership, in 1924, parliament passed legislation which meant the entire population needed to have birth certificates, so Eliyahu headed to the registration bureau to obtain his birth certificate and choose a family name. Adding the possessive 'I' at the end of Khalil, he chose Khalili as our surname, from Ibrahim Khalil Allah (Abraham, the most cherished friend of God), with Khalil meaning 'cherished friend'. The registrar added the name Kalimi ('Jew') as a suffix at the end of his first name and also after his surname, determining that grandfather should be known as Eliyahu the Jew Khalili the Jew.

My parents lived on the same street in the necklace-makers' district in Isfahan, and after my father first saw my mother he used to walk constantly around the neighbourhood in the hope of seeing her, finding 'endless excuses to pass by her house', as he told us later. And one hot summer's day around noon, my mother's mother Sara opened the door and stepped out onto the threshold just as he was passing. She could see how thirsty he was. She invited him in and offered him water.

'She gave me a bowl of cold, refreshing water,' my father remembered. 'My eyes were searching desperately for Hadassah as I gulped it down.'

He found her, and they were soon married. This was the 1930s and they would go on to be married for 62 years, and in their old age I would watch them together and marvel as my father recalled the fire of his early love. He would turn to my mother in the midst of a family gathering.

'Do you remember that day when Sara felt sorry for me, a poor thirsty boy, and handed me a bowl of iced water?'

'Yes, I remember.'

'My beloved, I still thirst for your look, and I never feel as if I've had enough.'

We would laugh out loud when Dad spoke this way, but we knew he wasn't joking.

When my parents first met, Dad was scraping together a living by dealing in everything from old jewellery to rare manuscripts. He'd inherited an exceptional eye from Eliyahu, with an expert's talent for authenticating, dating and valuing art, along with a real knack for identifying rare objects. Over the years, this expertise would grow and grow, and he would become particularly adept at assessing precious, handwritten books, especially religious manuscripts, travelogues, philosophical texts, and poems from such great Persian imaginations as Ferdowsi, Nezami, Rumi, Saadi and Hafez, all copied out in graceful calligraphy and, in many cases, magnificently illustrated and illuminated.

We always addressed him as 'Baba-June', a Persian term of endearment meaning 'daddy's life'. He didn't come from a rich family; he never had the opportunity to go to university. But he was so knowledgeable about art, religion and history that he spoke with the authority of an academic. He read more books than anybody I have ever met, and would constantly amaze me with his learning and philosophy. Dazzled by something he'd said, I would often ask in wonder, 'Dad, where did you get that from?'

'It's out there, son!' he would reply, with a sweep of his hand to the world beyond us. 'You just need to look for it.'

It was astonishing how much he knew. He read extensively in Persian, including a translation of the Old Testament and the Psalms of King David. He relished the Hebrew-Persian writings of Iranian rabbis who produced learned commentaries on the Talmud and the Zohar. He read poetry in Hebrew as well as Persian – I still have a book of his by Mawlana ('master') Shahin Shirazi, a fourteenth-century poet who spent 30 years translating the Torah (old testament) into Hebrew-Persian verse. My dad also cherished books about the history of Jews, Christians and Muslims, and from an early age I understood the intimate familial closeness of the three Abrahamic faiths – Judaism, Christianity and Islam – as three siblings under Father Heaven and Mother Earth.

A favourite poem of his, and one which has left the most profound impression on me, was by Saadi Shirazi:

بنی‌آدم اعضای یکدیگرند
که در آفرینش ز یک گوهرند

8

چو عضوی به درد آورد روزگار

دگر عضوها را نماند قرار

تو کز محنت دیگران بی‌غمی

نشاید که نامت نهند آدمی

The sons of Adam are limbs of each other

Having been created of one essence.

When the calamity of time afflicts one limb

The other limbs cannot remain at rest.

If thou hast no sympathy for the troubles of others

Thou art unworthy to be called by the name of a man.

Hearing him recite this poem I remember the first pangs of something deep embedding itself in my soul, a knowledge, a deep understanding. It was one of those works of art that remain echoing through one's soul forever. And it did mine. Its message of love for humanity was something that I felt embodied Dad and my whole childhood, and stayed with me for years to come.

As my mother saw it, all religions flowed from the same source. The fact that she was a devout Jew didn't prevent her from being friends with Zoroastrians, Christians, Muslims or people with no faith at all. I always called her Mani, a Persian word used by many Jewish children in Iran. It translates as 'dear mummy', but it probably comes from the word *manna* – the heaven-sent food that is said to have kept the Jews alive during their 40 years in the desert. She had this wonderful optimistic nature. 'From the cradle to the grave, we all have problems,' she told me. 'But every morning, when you wake up, you're

faced with a choice. There is darkness and there is light. Choose the light. Then, you can pass it on, so that whoever you meet can also benefit from that light.' This habit of looking for the light in everything would be a lesson for life.

When I look back now and think about the many gifts that my parents gave me, I would say that my practical abilities come from my father, who introduced me to the art world. I also inherited his deep love of Persian poetry. And I owe much of my philosophy of life to him, since he would always pass on to us the wisdom that he derived from his readings of spiritual books and poetry.

But my mother had even more of an impact on me. From her, I learned above all to feel a tremendous closeness to the Creator and a trust in His benevolence. She also taught me that life is a circle: if you do good, it comes back to you; and if you do wrong, it also comes back to you. The more you share with others, the more the universe will share with you. Her own behaviour was a model and inspiration for me. She did everything in such an innocent way, with no agenda, performing countless acts of kindness without ever thinking of her own reward. She behaved in such a natural way that some people saw in her a purity and simplicity that may have been perceived as naivety – yet was anything but.

My mother always took pleasure in acts of charity, and she dedicated her life to healing the wounds of others. And she had unusual insight: parents asked her if it was a good idea for their child to marry a certain person; couples came to her for guidance on how to improve their marriages. On many occasions, she treated couples for infertility,

using a combination of herbal remedies and prayer to help grant couples their wish to have children.

I cannot explain her gifts, except to say that they somehow came from her faith. My mother was a deeply spiritual person who believed that faith has the power to pull an individual closer to God.

Daniel and Hadassah Khalili arrived in Tehran with their four children in the spring of 1946. It must have felt intimidating for them. Our family was established and highly respected in Isfahan, particularly among older, wealthier clients who knew my dad and grandfather for their discerning eye. But in Tehran, Dad was unknown. Additionally, political trouble was brewing, and it would soon give rise to unrest. Still, Tehran was the nation's capital, home to many rich families that owned precious art and artefacts. All the top collectors lived there. Dad was determined to enter this wider world of opportunity, and he needed to think on his feet – as 18 months after our arrival another little human joined our family, my brother Shahin.

With five children to care for in a new city, my father had to be careful about the family's finances. But his business grew, and we moved to a new house in the Pol-e Choubi ('wooden bridge') neighbourhood in central Tehran. This new home was small for our family of seven, so I shared a room with Shahin. We children ate, played, studied and slept in a tiny space, yet we were happy with what we had, and lived with a sense of plenty. We talked a lot and grew extremely close because we were constantly together. If the house lacked grandeur, our parents' love made up for it. Their dignity and kindness were

the greatest assets we could have. We lived modestly, but my father explained that when you feel contentment you are close to God.

Every Friday evening, we would gather for a special Shabbat dinner. My mother would make chicken soup – she used the mother chicken, the one that had finished laying eggs, the one that gave the best flavour, its belly stuffed with rice and herbs. She'd light the Shabbat candles and place a basket of radishes, mint, parsley and tarragon in the middle of the table. We'd have bathed and dressed in clean clothes, already half-giddy from the smells wafting from the kitchen. After saying the prayers over the bread and wine, my father would bless each one of us children with a prayer attributed to Moses' brother, the high priest, Aaron: *May the Lord bless you and keep you. May the Lord cause His face to shine upon you and be gracious unto you. May the Lord lift up His countenance upon you and give you peace.*

When I was seven my parents enrolled me in a primary school called the Ganj-e Danish ('trove of knowledge') School. Initial excitement soon waned. The atmosphere became tiring and depressing, and an unknown force began to pull me away. The school was far from home, and I always walked. So I began to pretend to go there in the morning, only to wander off surreptitiously in the opposite direction. Instead of being confined in a classroom, I wandered aimlessly in the many neighbourhoods around town, experiencing the sensation of being by myself under the shelter of the open sky. I stared at countless faces and even at walls until the end of the school day, daydreaming and filling my head with stories and sensations. It felt as if I was searching

for something, that the world was full of stories, and the classroom was simply too small to contain it all.

Sometimes I would walk around until the school day was over, usually near the Old Shemiran Road. The palm trees on either side of this street had a wonderful freshness to them, and they spoke to me of wind and air and adventure. I loved the beauty of Tehran, which was still unspoiled in the early 1950s, evoking the days of old when the Qajar kings rode up this very road in horse-drawn carriages and in all their finery. In my mind, it was as if the sound of these hooves clambering uphill toward Shemiran still echoed. I was delighted at the sight of the flowers around me, and watched in wonder as the sun set, feeling as if nature itself had a secret to tell me – the secret of life, the eternal wheel that had turned since the beginning of time and continues to turn long after we are gone.

Later I would read about the eleventh-century Sufi philosopher Abu Hamid Muhammad ibn Muhammad al-Ghazali, who became disillusioned with his studies in Baghdad and concluded that Truth could only be encountered through mystical experience and exploration of the self rather than through traditional education. In his 'Letter to a Disciple', al-Ghazali wrote: 'O, disciple, be neither destitute of good deeds nor devoid of spiritual states, for you can be sure that mere knowledge will not help.' When I read this I was suddenly transported back to those years of my childhood, when I felt as if knowledge found in books or in the classroom was not enough in itself, and I left the straight and narrow each morning to walk the streets of Tehran, roaming the bazaars, Valiasr Street lined with majestic plane

trees, my daydreams fired by the Golestan Palace and the snow-capped Elbruz mountains gleaming in the distance.

'Is your son suffering from any illness that has kept him from school?' the school principal asked my father.

The question took Dad by surprise. After all, he saw me returning home each day, happy and relaxed, after what he assumed was an enjoyable day at school. The principal told him that I had not shown up in a while, and that my teachers were worried.

That afternoon, I came home as usual after a day spent out walking. My dad was calm, but his silence held a thousand questions. My mother too seemed distant. Eventually, my father came to me in my room.

'I saw your school principal in the street today. He said you haven't been to school for a while. Is this true?'

'Yes.'

'Can you tell me why?'

I couldn't explain the deep feeling that had driven me away from school.

'Well, I don't learn anything new from the teachers,' I began. 'I learn more by wandering the streets.'

I reminded him he had often told me himself that 'society is the best school'.

He explained he didn't mean that you should run away from school. You must start at the first step: primary school. Later, you'll go on to the final steps, like university, where you can learn to become a doctor, an engineer, a lawyer . . .

I liked being talked to like this, two men discussing how the world worked. My dad spoke gently and modestly, without anger. He explained that life can be cruel for those who aren't in a privileged position, and I could decide for myself which path to follow to make sure I would never be in need. There were only two ways to make a living, he went on. You earn it through the strength of your muscle or the cleverness of your mind. If you want to earn a living with your hands, there is nothing wrong with that, but you usually become a follower, not a leader. A boss will give you orders, which you'll have to carry out. If you choose to build your life on the strength of your brain and to become the person whom others follow, then you must go via school and stop running away from it.

I never missed another class.

Dad's career was taking off. Distinguished figures among the elite of Tehran came to my father when they wanted to buy or sell valuable pieces. They relied on him as an honest expert who would fairly evaluate everything from manuscripts to jewellery. He had an authenticity and spiritual intuition, and the reassuring air of a brilliant intellectual. These qualities served him well in a business where being trusted is a precious commodity.

He once told me that he would readily rule against his own children in a case where he believed we were in the wrong.

To my father, it was like blasphemy to make profit an objective. Although Dad came from Isfahan, where people are known for their smart trading, his character seemed more like that of the people of Shiraz, who existed for living and loving. When he bought an object,

he wouldn't rush to buy a second or third; instead, he'd wait patiently for that first object to sell before buying again. In those tough periods when he hadn't yet found a buyer or received any payment from the sale of an object, he continued to act with generosity both to family and friends. There was a lack of selfishness and a charitable spirit in him that was like that of the Sufi teachers of the past.

Word of my dad's good character spread, helping to expand his success. Over a period of a few years, he was fortunate enough to find four or five incredible sources of art and artefacts – wealthy families who were happy to sell him fine pieces in bulk, maybe because their interests had changed or possibly because they needed the money. He bought fantastic pieces from them at reasonable prices – rare Qur'ans and manuscripts, classical carpets, Fabergé and European enamels, miniature paintings, daggers and swords with gold inlay, and lacquered pen boxes among other precious objects.

In some cases, he was offered so many valuable items that he couldn't afford to buy them all. So he became a broker, taking a fee in return for placing the objects with other dealers. With his business flourishing, Dad could finally afford to move us out of our modest home. He bought a large, two-storey house on Shadman ('happy') Avenue in one of Tehran's finest areas. The front of the house was adorned with decorative brickwork, giving the place a feeling of luxury and prosperity. We now finally had a big living room, a separate dining room and several bedrooms, so I no longer had to share a room with my brother.

Dad had slowly accumulated his own beautiful art collection, put together patiently over many years. So we lived surrounded by fine

furniture, which sat on delicate woven carpets from Tabriz, Isfahan, Kerman, Qum and Shiraz. We had French Sèvres chinaware, porcelain and enamel from Russia and France, Bohemian lanterns, eighteenth- and nineteenth-century paintings of different origins, and beautifully decorated hookahs.

The garden was beautiful, too, with a lovely pond in the middle. Gardeners planted persimmon, apple, plum, pear and mulberry trees, which produced delicious fruit. I can still smell my mum's kitchen garden, where she grew herbs such as mint, tarragon and basil. At sunset, after everything was watered, the smell would fill the air, as if these fresh herbs were begging for a place in the basket on our dinner table.

I took turns with my brothers to empty out the decorative pond in our garden and fill it up it with fresh water. Like many Iranian families, we kept goldfish, with miniature turtles swimming among them. We liked to take the turtles out and play with them or set them loose to walk slowly around the garden. One day, I decided to paint their shells, wanting to make the pool even more colourful and happy. I found some paint, which I carefully applied to the shells. I then slipped the turtles back into the water.

'Son, was it you who painted these turtles?' my father asked.

'Yes! Can you see their colours?'

But his face was solemn.

'Don't you see?' he said, turning to go back inside. 'You are tampering with nature.'

For hours I sat by the pool, desperately scraping their shells clean as gently as I could with a brush, taking care not to hurt the turtles.

A family friend gave me silkworm eggs. I set them up in our garden and looked after them, feeding them mulberry leaves and watching their slow transformation. It was miraculous to see a silkworm egg turn into a caterpillar, which became a moth inside a cocoon, which hatched and flew away, only to return to lay more eggs and start the entire process again.

Patience, I thought. Be patient.

At ten, I left the Ganj-e Danish for the Ettehad School, part of an educational system originally established by the Alliance Israélite Universelle and owing its existence to the open-mindedness of the Qajar ruler, Nasser al-Din Shah. In 1873, when Iran was still recovering from the Great Persian Famine that had killed as many as 2 million people, Shah made a historic visit to London and Paris, where Jewish community leaders including Sir Moses Montefiore, Baron Rothschild and Adolphe Crémieux spoke to him about the troubles of Iran's roughly 23,000 Jews. Shah put an end to a variety of anti-Jewish laws, and in 1898 the Alliance succeeded in opening its first Jewish school in Iran – the Kourosh School, named in tribute to Cyrus the Great, whose name in Persian was Kourosh-e Kabir, renowned, among other things, for ending the Jewish exile in Babylon in the sixth century BC and for allowing Jews to return to Jerusalem. The Cyrus Cylinder, now on display at the British Museum, is proof of his policy towards the Jews, and may be the world's first charter of human rights.

After the creation of the Kourosh School, the Alliance established a string of Jewish schools in Tehran and other cities across Iran. All

these schools were managed by the Alliance, which promoted a modern French curriculum, liberal ideals and European social manners, instead of just focusing on biblical studies and Hebrew. It was a very progressive initiative. Less privileged students not only received free schooling but enjoyed allowances for clothes, food and books. Meanwhile, the Alliance hired both Jewish and Muslim teachers, helping to narrow any cultural gaps that might otherwise have existed between us.

The quality of our education was extremely high, and students at the Alliance schools were considered among the brightest in Iran. The school's exam results were superb, even though most of us did not come from privileged backgrounds. This was a source of great pride to us. The Alliance schools gained such prestige that it was an honour to teach there. As a result, I got to study with fantastic teachers such as Hacham Uriel Davidi, who later became chief rabbi of Iran and did much to protect the rights of the nation's Jewish community. Or Abdul Majid Ardalan, whose kindness and engaging style of teaching made him particularly popular. A tall, serious-looking man from Kurdistan, Dr Ardalan taught physics not only at Ettehad but at Tehran University. He taught us physics for two hours back-to-back. In the first hour, he would lecture us; in the second hour, he would often ask me to be his deputy and repeat the lecture.

It wasn't hard for me to remember it – I soaked up everything.

There was only one teacher I took against, and who took against me. Mr Malekzadeh didn't like my attitude and told me I wouldn't get anywhere, and when he put me on probation for an algebra mistake and made me repeat my maths exam I felt unfairly put down and went

home furious. But it was like a spur: it made me work harder, determined to prove him wrong.

Around the time I moved to the Ettehad I discovered I had a strange gift for describing people's personalities based on nothing more than a photograph of them. Schoolmates would bring pictures of their relatives for me to analyse during the breaks between classes, and I would tell them what the person was like, based only on their face and expression. I could look at a photo of someone's brother, say, and tell that he couldn't be trusted because he was jealous of them, or that he would become a brilliant scientist, or that he brought harmony to the family.

'It's true,' my surprised schoolmates would say. 'But how did you know . . .'

I'd caught the collecting bug too. Stamps first, buying them from other kids at primary school. I bought stamps with pictures of different monarchs, stamps in different currencies, stamps from different periods. I asked my schoolmates about the rarity and provenance, and pestered teachers and other adults with questions. The first thing I ever bought was an album for my stamps in which I carefully wrote out their country names and dates. Nothing I bought was special, but it was so much fun. I didn't realise until many years later that the intensity of my obsession was unusual even then: sometimes I'd spend my lunch money on stamps and return home hungry.

At the Ettehad, I switched to collecting Persian banknotes. I think I felt they were more visually pleasing and maybe more important than stamps, so I exchanged my collection in return for some great specimens. Printed by the British, these notes were big and beautiful,

almost like paintings. At the time, ordinary notes weren't expensive, so I was able to buy them with my pocket money. If there was a note I particularly wanted, I'd ask my father for a tiny bit of additional cash. He never said no.

Now it seems inevitable that my eye and enthusiasm would move from stamps and banknotes to the marvellous objects that were my father's daily bread. First, I fell in love with the Persian lacquer pieces Dad used to buy and sell. I became obsessed with the delicate lacquer pen boxes, mirror cases and beautifully decorated book bindings that passed magically through the house. If I told him I liked a pen box or book binding he would let me keep it for a while, and I would tag along with him whenever he went out to art galleries or clients' homes, hearing the stories that stretched out behind each piece like a comet trail, and constantly pestering him – and other buyers and sellers – with questions. Why are you buying this? How rare is this? Where does this come from? Why do you like this one more than that one? How can you tell that this one is so old? How many times have you seen something like this?

Did I wear him out? He never let it show. Far from it – he asked my opinion of pieces he was thinking of buying. I acted as if I had the knowledge and experience of an adult, and with this confidence I gradually began to develop real knowledge and real experience. These childhood outings became for me like an early university course in the company of an expert teacher, and I soon began to learn more about the buying strategies of such collectors. The collector and historian Karimzadeh Tabrizi talked to me about the importance of buying great pieces quickly, without bargaining, and paying immediately.

Dad too would explain that it made sense to pay whatever it takes to buy a piece that is especially rare. One great benefit of paying generously, quickly and without haggling is that sellers of the best objects are more willing to offer them to you first, before showing them to other collectors or dealers.

Dad never agonised when a precious object left his hands.

'When I sell something, I close my eyes and wish the buyer luck,' he told me. 'When I owned it, it was my destiny – now it is their destiny!'

I began to help him, in small ways at first. From the age of ten, I was responsible for packaging artworks that he'd sold to clients. I'd grab newspaper sheets from a back room, wrap them carefully around these delicate objects, then slide them into a shopping bag. The buyers would often tip me a few tomans, which made me feel very grown up.

And even when packaging, I would be turning the objects over in my hands, feeling the textures of lacquer, enamel, porcelain, gilding, carving, metalwork, paint – learning through touch about craftsmanship and form. I don't think Dad had any idea how much I was absorbing all this time. But my brain was like a sponge, and my hunger for knowledge was already at its strongest. I read many art books as a schoolboy and went through thousands of photographs of fine objects, made in a huge variety of techniques and from many different locations. I began to visit as many public museums and private collectors as I could.

Meanwhile, I continued to watch my father evaluating hundreds of objects. Much of this took place as we walked around Tehran together, but he also took me further out. When I was nine, I went

with him on an expedition to Persepolis, the ceremonial capital of the Achaemenid Empire, the ruins going back 2,500 years. Here, the Achaemenid King Darius built his magnificent palace, which was looted and burned by Alexander the Great after he invaded Persia in 330 BC.

Persepolis. The columns of the Gate of All Nations and the Apadana Palace seemed to hold the sky up above us as I followed my father among the ruins, entranced by the bas-reliefs and inscriptions, and my father's stories of Xerxes and Darius, and Alexander's boldness in attacking a capital defended by roughly 40,000 troops with his much smaller army of 10,000 men. Best of all, to me, was the story of Ariobarzanes' last stand at the gates of Persepolis – Ariobarzanes, the city's governor, holding off Alexander's troops for 30 days, and, together with his warrior sister Youtab, inflicting the highest number of casualties Alexander had ever suffered.

Soon, my knowledge and my eye developed to a point where even experts were impressed. Aged 12, I visited a gallery in Tehran that belonged to Rahim Anavian, a well-known dealer in Achaemenidean, Parthian, Sassanian and Islamic art. In those days, the Japanese were among the biggest buyers in the Iranian market: they almost always visited Rahim's gallery, where he sold some seriously rare items. When I arrived there one morning with Dad, two Japanese visitors were admiring a sculpture of a ram's head. Rahim spoke to us in Persian, asking pleasantly if we could sit and wait until they finished their negotiations. Apparently, these two men were professors from a university in Japan; they collected Persian art themselves and served as advisors to other prominent collectors.

Rahim was explaining the importance of the object to the two Japanese professors. I could tell from their reactions that they were arguing about whether the ram's head dated from the Achaemenid Empire (550–330 BC) or the Parthian Empire (247 BC–AD 224). Dad, looking at me sideways as we were sitting there patiently, noticed I was getting agitated. He knew I had something to say.

'Don't interfere,' he whispered to me. 'They're scholars.'

But I couldn't help myself. Ignoring his warning, I jumped up to my feet.

'This piece is Achaemenid,' I declared.

The two Japanese gentlemen stopped their conversation. One of them asked what this little boy was saying with such passion. Rahim translated what I had said with a smile, and I went on to tell them, with Rahim's help, why I was so sure of my opinion. They listened wide-eyed as I explained how the ram looked almost identical to sculptures I'd seen on our trip to Persepolis back when I was nine: it had to be Achaemenid.

I wondered if my father would be cross with me for speaking up when he had told me not to interfere. But I could see the look on his face. He was proud.

One of my favourite teachers was Mr Mameghani, who came from Azerbaijan and taught us Persian literature, quoting poets and philosophers such as Rumi, Hafez and Saadi, and speaking about their influence. One day I asked him if there was a book that talked about their lives and work and maybe about other people similar to them. He said there were great biographies of individual authors, and he

recommended an encyclopaedia published by Larousse, since I spoke decent French. But unfortunately, there was no single volume in Persian that covered all these great figures.

The same was true with politics, science, visual art and other fields – plenty of biographies, but no single book in Persian offering a survey of the giant thinkers and makers of the world with brief and clear details about their lives and what they did.

Aged 13, I decided to write this book myself. I never thought it was strange, or that I couldn't do it. It seemed simple. There was a problem, this book was needed, so if it was going to happen, I had to do it myself.

This mission would call for extraordinary determination, and it would take great discipline to see the project through to the end. I would also need the self-confidence to believe I could cover such rich intellectual ground. My only fear was that nobody would believe I could write such an ambitious book as a child. Other than my family, I told nobody of my plan – not even Mr Mameghani, whose classes had originally inspired me to write the book.

For eight months, I slept only four or five hours a night. I would usually go to bed around 1am and wake up again at five. On days when I wasn't at school, I would work for 15 hours straight, sitting at a table in a small room beside my bedroom. This was in the basement, but still received plenty of natural light. I felt like a monk in his cell, my concentration almost devotional. It felt good to be so inside myself, thinking in the silence. Mum would come downstairs and leave a lunch tray, but I was so focused on my book that I'd usually forget it was there, only getting around to eating it hours later.

I plundered libraries such as Tehran's huge Library of the Senate and borrowed as many books from school as I could. I read every biography I could lay my hands on, writing highlights of my subjects' lives on little cards, ending up with a pile of them for each person. I then took a sheet of paper and wrote down all the information from these cards, so I had every key point about them on a single page. This gave me the skeleton of each portrait, which I'd then write by hand, trying to make it as accessible and satisfying as possible. It was like I was in a trance – something invisible was pushing me forward, a flow of inspiration.

It didn't feel to me at the time that I was doing anything unusual. This attitude would stay with me as a collector – I just get on with it, without fear, following my instincts. To my mind, my age was irrelevant. What mattered was my desire.

So here they were, jostling for space: Beethoven and Picasso, Bertrand Russell and Maxim Gorky; Rabindranath Tagore and Douglas MacArthur; Isaac Newton and Theodor Herzl. Here were mathematicians, inventors, chemists, sculptors, explorers, astronomers and more. One day I would be with John Steinbeck, fighting hunger in the Great Depression; the next alongside Leonardo da Vinci – and these were rubbing shoulders with a variety of great Persian figures too: the eleventh-century Sufi mystic al-Ghazali; the ninth-century medical pioneer Muhammad ibn Zakariya al-Razi, the first to identify the difference between smallpox and measles, the first distiller of alcohol and the one responsible for giving it its name ('alcohol' comes from from kohl, the mineral cosmetic still used for mascara), and of course the poets whose imagery and cadences I had absorbed from my father: tenth-

century Ferdowsi, author of the *Shahnamah* (the *Book of Kings*); Rumi, who regarded poetry, music and dance all as ways to reach to God; Hafez, who described himself as a servant to the love of God – a love, he explained, that freed him from the earthly troubles of the world – and such modern talents as Parvin E'tesami who won great fame before her death in 1941 when she was only 34. How proud I was to set these Iranians side-by-side with Socrates, Tolstoy, Chopin and Einstein.

In all, aged 13 and 14, I wrote 215 short biographies of some of the world's greatest figures. After I'd finished writing all these portraits, I asked my brother Shahin to test me on what I remembered. For each person, I would recite to him a list of facts – everything from where and when they were born to what they had achieved. It wasn't just that I'd remember the stories of these great lives and minds for the rest of my life: I'd absorbed more general lessons from these 215 biographies, lessons about the nature of success and achievement. It wasn't enough to have a dream – that bit was easy. You needed incredible passion and stubborn dedication to be the dream's wings – to get it off the ground. So many of my subjects started out from humble beginnings, their poverty spurring them to make their mark. Most of my subjects cared about the lot of their fellow men and women; they weren't just trying to achieve success for themselves. Many simply wanted to make the world a better place. Gradually the 215 disparate stories I'd gathered together merged in my mind's eye into a single pool of light – not an account of a series of individual acts but a collective effect on the world, a force.

Every human being who earns our praise has a light in his or her heart that generates more light in the hearts of others. Eventually,

each candle burns out, no matter how bright it once was. But if your candle has lit thousands of other candles during your lifetime, you have left a fantastic legacy. And if you have failed to bring light to others, you have not done your duty. Humility and service are at the heart of true success.

After those long months in the basement, I finally finished writing the profiles and added a few brief essays I felt would help readers to place the artists and thinkers in my book in context. Now I was ready to find a publisher. I visited a string of them, wandering around Tehran from one person to the next with that single copy of my man-uscript held tightly in my young hands. Full of hope, I'd stop by their offices and they would read a couple of pages of my book, usually making dismissive remarks along the lines of, 'Yeah, right. You wrote this book!' I couldn't understand why they didn't believe me. But they must have thought that the little 14-year-old schoolboy standing before them was playing a trick in passing off an adult's work as his own.

Still, I kept at it, knowing even then that you must knock on every door until one opens. Eventually, after leaving school earlier than usual one afternoon, I went into the bookstore on Shah Avenue, oppo-site the Sajjad Mosque. Known in Persian as Ketab Khaneh Markazi ('Central Library'), this store not only sold books but also published them. I looked around until my eyes fell on a distinguished gentleman of about 70, seated behind a desk at the back of the store, reading. He looked up.

'What are you here for, son?' he asked in a quiet, kindly voice.

He was both the manager and the owner.

'Agha [Sir], this is a book I've written myself,' I said, pulling the manuscript out of my school bag. 'It's about famous people who contributed greatly to humanity. I want it published, and I'm looking for a good publisher.'

My confidence must have made him curious.

'Young man,' he said, 'let's see what you have here.'

He looked through the neatly written manuscript, taking care to check the list of names on the contents page. I waited.

'Why don't you come back tomorrow?' he said, at last. 'That will give me a chance to look at this properly. I'll give you an answer then.'

I left the manuscript in his hands. That night, I couldn't sleep. The following afternoon, I returned at the agreed time. Mr Saheli, the owner, greeted me pleasantly from behind his desk. He was smiling kindly, but seemed suspicious.

'Son,' he said, 'I'm not entirely sure you wrote this book. You'd need to be a scholar, someone who went to university . . .'

'I'm not old enough to have gone to university,' I said. 'But you don't need a degree to do research. If you're interested, you can do research at any age, and that's what I've done.'

He still wasn't convinced, so he gave me a test. He sat me down in a room next to his office, brought me a glass of water, and gave me a couple of sheets of blank paper. Then, randomly selecting a person from the book, he asked me to write a page about them. The person he chose was the great Persian poet Hafez. I didn't lose my cool. All the people in my manuscript were so fresh in my mind that I wrote about his life and work without any problems, finishing the task

without difficulty in no more than 15 minutes. He watched over me as I wrote.

'All right,' he said. 'That's enough, son!'

I gave him the piece of paper and watched his face as he read. I can still picture him, reading with concentration. I could see his expression gradually deepen with emotion as he read my words, comparing them to what I'd written about Hafez in the book itself. I could tell that he believed me.

'I'll be honoured to publish this,' he said.

Then came the printing process, which was painfully slow and tiring in the days before computers. Mr Salehi wanted me to help with the typesetting and proofreading. So, for weeks, I spent all my spare time working at it. Given how enthusiastic I was, I'd already managed to find pictures of the people in my book. For the front cover, I had portraits of Ferdowsi, Picasso, Gorky, Beethoven and Herzl. These were meant to appear alongside the book's Persian title, which translated roughly into English as *Biographies of Prominent World Figures*. For the back, I choose pictures of Bertrand Russell and Isaac Newton. Of course, I made space for a photograph of me alongside my heroes on the back. I also wrote a dedication page, thanking my parents, 'whose souls live in mine'.

Finally, in December 1959, Mr Salehi told me that the book had arrived back from the binders. I put on the ironed suit that I normally wore to synagogue, combed my hair, and hurried excitedly to the bookstore. Mr Salehi handed me a brand new and shiny copy of my book, fresh off the presses. At first, it looked just as I had expected. But when I looked again at the light blue volume, I saw that my picture

had been taken out, leaving a strange, empty space on the back cover. On the front, an even bigger space had been left blank: Theodor Herzl's portrait had been removed, too.

'Why did you leave out my picture?' I asked. 'And why is Theodor Herzl's picture missing?'

'Your biography says you're Jewish,' Mr Salehi said. 'And you're only 14 years old. It would be difficult for people to believe you could possibly be the writer of a book like this.'

As for Herzl, he explained gently that some people would object to him being on the cover, and this would hurt the book's sales. I was upset, but I respected his opinion and tried to understand his logic. It was a purely commercial decision. I picked up a few copies of the book, thanked him and left. By the time I got home, I felt a calmer. After all, my name was there in large print on the cover. At 14, I had managed to write a 396-page book and get it published. And more importantly, I felt I was making a difference in the world and that people were listening to me.

I hadn't told my parents that I'd found a publisher. Now I ran to them, giving them the first copies of my book, fresh from the press.

Presenting them with the book was one of the highlights of my life.

My dad looked through it, examining it carefully and seriously, but I could see the tears in his eyes. He spoke with his usual quiet thoughtfulness about how proud he was, and about the importance of tempering confidence with humility. Then it was my mother's turn.

'This is only the beginning,' she said.

The book went on sale for 20 rials, which was about $3. Nothing quite like it had ever appeared in the Persian language. It sold well, and

would go on to be reprinted many times. My initial share of the profits was about $1,000 – a very handsome sum in those days for a 14-year-old boy – and more royalties came in over the next few years. To my delight, the book also received great feedback from readers across the country, and my youthful adventure attracted a lot of attention.

Our family friend Manuchehr Omidvar organised a celebration at the Kourosh School. I felt overwhelmed looking into the assembly hall full of so many people, so I sat shyly in a corner at the back of the room. My parents sat in the front row, next to other close relatives and special guests. My publisher Mr Salehi was there. So was Mr Daghighian, principal of the Ettehad School, and many other teachers. Seated among them in one of the front rows was none other than Mr Malekzadeh, the maths teacher whose criticisms had goaded me into action in the first place.

From the back of the hall, I could see the whole room and still get a good view of the speakers who took the stage to congratulate me and praise the book. One of them was Mr Malekzadeh. I remember to this day what he said to the audience.

'I once told Nasser that he would never amount to much in life. If I'd known that every student I put down would one day become a star, I would have told all my students that they would not amount to much. The sky would be filled with bright stars.'

Soon after, Manuchehr Omidvar spoke to the audience. He suggested they ask the author how he'd managed to write such a book.

'Nasser, where are you?' he asked. 'Where's Nasser?'

I hadn't expected to speak. But I told myself I had to be as grown-up and fearless as possible. Taking a deep breath, I walked up

to the stage from the back of the hall, noticing the surprised looks on people's faces as they saw me for the first time and saw just how young and small I was. With all the confidence I could muster, I began to speak into the microphone. I thanked the organisers of the event and explained why I had written the book, even mentioning Mr Malekzadeh's comment which started the whole thing. I explained how I wanted to prove him wrong, and how much it meant to me to hear him understand that, and thanked him for pushing me to this starting point, and for his words at the end. I talked about how much I had learned in writing the book, spoke of the support my parents had given me, and then – hesitantly – asked if anyone had any questions.

'Don't you think it would have been better just to focus on the geniuses of Iran?' asked a middle-aged man from the back of the hall. 'After all, this is your birthplace.'

'The geniuses of the world are not bound to their places on the map,' I answered, full of confidence. 'These incredible people are a source of pride for their own nations, of course. But their ideas belong to the whole of humanity, not to one place. They are more than just their nationalities and religions.'

To this day, I don't know how I came up with this answer under the circumstances. I think I was so passionate and had such a clear idea of what I wanted to do and say, that the words just sort of formed themselves. I still believe what I said.

I stepped down from the stage with applause ringing in my ears, and walked straight to my parents. I hugged them and kissed them. They later told me that this was the proudest moment of their lives.

Interest in my book did not stop there. I even got the chance to be interviewed on Iran's first TV station, Television Iran (TVI). One evening, I found myself sitting down in front of the TV cameras for a live interview with Ezatollah Motevajeh, one of the top presenters at the time. He introduced me as a 'personality of the year', calling me a symbol of hope for the younger generation. He then asked me about my life and my writing. My responses were innocent and sincere. I told him how a teacher had made me retake an exam, and how this injustice had given me the inspiration to write the book, and how I thought it could really benefit young people in the country. And of course, I told him how much inspiration I took from my parents.

Next day, school was buzzing. Classmates waited for me to come into the schoolyard, then surrounded me. Some congratulated me; others made jokes. One boy gave me a big smack on the back of my head.

'What did you did you that for?' I asked, confused.

'Well, last night, I was watching TV with my parents,' he explained, 'and when I saw your face on the screen, I shouted, "That's my classmate Nasser!" And so my dad said to me, "If you're his classmate, why can't you do something like that? What sort of idiot are you?" And he slapped me on the back of the head. It was your fault, so I'm just returning the favour . . .'

Thanks to my growing reputation, I began to meet writers and editors. At 16, I started writing freelance articles for magazines and newspapers in Iran. One person who took me under his wing was Nasser Khodayar, a radio journalist for the Pars Agency – Iran's official news outlet – and a former deputy prime minister. He edited

several magazines, including the *Roshanfikr* ('Bright Ideas') and *Majaleh Jibi* ('Pocket Magazine'). After reading my book he referred to me in a magazine article as the 'chosen flower' of Iran's new generation, so I showed up at his office one day to thank him for his compliment. This was the beginning of a great friendship, and I even worked part-time as his deputy editor at *Majaleh Jibi*.

Both my book and these adventures in journalism allowed me to have a modest income, and I was able to start saving some money. I would need it if I was to follow my dream of becoming a collector.

~ 2 ~

New York

It was a treasure trove – an enchanted transformation, to step into that room off 57th Street and find myself among Tiffany lamps and lamp-shades and lustreware, the brightly coloured stained glass shades floating all around me like a dream of flowers. Glass-fronted cabinets and ornate side tables were crammed into this narrow room between Park and Madison with bare wood floorboards – and there was such gleam from the glass and lights and silver that at first I didn't notice the neat woman of about 70 sitting quietly among her collection. It was the cabinets at the back that drew my attention. There were rows of Russian enamels there, each a real beauty: tea sets and boxes, frames and clocks in a riot of colours. One item really captured my imagination – a lovely enamel casket, which I immediately recognised as being made by Feodor Rückert, one of the greatest enamellers to work for Fabergé.

But it wasn't just the colourful design and execution that attracted me. On the lid was a brilliant reproduction in painted enamel of an

1882 painting by Viktor Vasnetsov, called *Knight at the Crossroads*, which I knew well from my studies. I also knew that Rückert made similar caskets, which were held in private collections and museums, and that this was a superb example. The painting shows a knight from Russian folklore called Ilya Muromets, looking down on a gravestone marked with a warning not to go any further. There's a skull in the grass, with three black crows in attendance. The knight's horse has lowered its head, as if in resignation, or submission. Rückert has matched the colours of the painting to the rest of the casket so subtly, and the scene has such suspense and charge – the knight poised at a threshold, meeting his own death, or the fact of death. And this was just one object among many in the cabinet. I had to get them.

I'd arrived in New York City on 28 August 1967, a fresh-faced 22-year-old filled with excitement, the city sparkling with light and opportunity. Even before I graduated from the Ettehad I'd wanted to study at an American university. But conscription had been introduced to Iran in 1925, and we were all expected to serve once we were 18. I didn't object to this – I felt I'd been raised in the most beautiful place, and I loved my country's history and culture. The fact that I belonged to a religious minority did nothing to lessen my patriotism or sense of debt to my country. Once I signed up, I was put into the Health Corps (I liked this – it made me think of my mother and her gift for healing) and soon I was in paramedic training at a military garrison east of Tehran, learning about everything from treating wounds to giving inoculations. Since we were to be posted in remote villages, we were taught a huge variety of skills so we could do almost

anything, including how to help the villagers take better care of themselves in emergencies.

I was posted to the north-western province of Qazvin – luckily not that far from my family in Tehran. I stepped off a bus in Qazvin City one sunny morning, all fresh in my uniform and excited to get started. I met my team in front of the Qazvin military headquarters – a doctor and one other paramedic, an easy-going guy called Rasson, whose family owned a nightclub in Tehran. A driver took us to our assigned post, the mountain village Nirej, which at the time had a population of about 800. They were very pleasant people, who had suffered greatly after a recent earthquake that had left the village in bad shape. As we approached Nirej, we heard the beat of kettledrums and other instruments the villagers played to welcome us, and a rich smell of incense was carried upon the wind. This warm greeting was something I had never experienced before, and it filled me with happiness.

'This is amazing!' I said to Rasson and the doctor. I couldn't contain my enthusiasm. 'You know what? I'm going to do my best for these people.'

They smiled drily at my earnestness, as if to say, *Give him a month or two and see how he feels then.*

We soon got used to the small practice in the village. The doctor would usually leave us in charge, as he had to spend time in other villages too. Rasson was much more laid back than me and would often disappear on little journeys to see his family in Tehran. I didn't mind. I loved getting to know the villagers, hearing about their lives, listening to them tell their stories. We would often sit under a tree

together or by a stream and chat and sing and laugh, the vastness of the mountains all around us. Sometimes we had dinner with Ahmad, the village headman, or *kadkhoda*. Literally, *kadkhoda* means 'the shoulder of God'; Ahmad functioned as a kind of religious mayor and leader to his villagers. I loved being able to be useful, helping the villagers whenever they had any medical problems. I learned so much through practice and repetition, and my training proved to be valuable. The thing I couldn't learn was detachment – I used to worry so much about how my patients were doing that it sometimes affected my sleep, especially if a villager was having a particularly difficult time with illness.

I never told anyone I was a Jew. I loved my Muslim cousins but I knew things were more complicated here than in the capital. At the end of each month, our driver Mr Kayhani took us to Qazvin so we could pick up our salary and stock up on supplies. In the final month of our assignment, he drove us to the city as usual. We were supposed to pick up our last pay packet, along with a certificate that confirmed the end of our service. We were then supposed to go back to Nirej to pick up our stuff and wait until the next team arrived for a handover.

In the Qazvin headquarters, I joined other medics and doctors in a large hall. The man handing out our pay was calling everyone's names, one by one. When it came to my turn, he shouted out, 'Nasser Kalimi Khalili Kalimi', using the full name on my birth certificate. Nasser the Jew Khalili the Jew – the same formulation my grandfather had heard all those years ago in Isfahan.

My eyes turned to Mr Kayhani. I already had a feeling he might have a problem with me being Jewish, but I hoped for the best.

Unfortunately, all I could see was how angry he was. On the drive back to Nirej he was totally silent. Once we reached Nirej, he dropped us off and hurried away.

I packed my belongings that night and put everything in order at the clinic, making a final inventory of the medicines and leaving everything neatly in its place. Next morning, our team was ready to leave. Our luggage had been loaded onto the jeep, and we would soon be hitting the road to Qazvin before returning home for good. Leaving the clinic for the last time, I found most of the villagers gathered outside, waiting for us in front of the jeep. I was smiling from ear to ear looking at my friends, thinking they'd come to say goodbye. But soon my smile wore off. There was a kind of tension in the air. Something was wrong. Some of the villagers looked angry, and there were fewer smiles than I'd expected. I guessed Mr Kayhani had told everyone about his discovery that I was Jewish.

The crowd began to edge closer. I looked around, starting to panic, dreading something terrible was going to happen. I'd heard stories of an Armenian paramedic who'd been harassed in another village, but I honestly never thought this could happen to me. I *know* these people, I thought, and they know me. Why was this happening?

Suddenly, a voice came from the back of the crowd. It was Ahmad, the village chief, the *kadkhoda*. The crowd made way for him, and I saw him passing through, his kind face beaming without a trace of anger or malice. When he reached me, he turned to address the crowd.

'Our beloved friend Nasser has done a lot for us,' he said. 'He saved the lives of many people, my own wife and child included, and

served us in ways we should never forget. He was there for us, whenever we needed him, day or night. If every Jew is like him, then I am a Jew, too.'

He embraced me, and spoke quietly into my ear: 'Forgive these people.'

The mood changed. Smiles came back, and with sincere apologies the villagers sent us on our way. I was wracked with relief, sadness and happiness, equally happy and sad to be leaving. Mr Kayhani, who was driving and witnessed the whole scene, didn't say anything. I've often wondered how he felt then, whether he was silent out of anger or thoughtfulness – reflecting on his attitudes and assumptions. I was lost in my own thoughts, to do with how easily ignorance can be turned into a weapon, what a dangerous force it is. If you break down ignorance, as the *kadkhoda* had done, you have done something for humanity. I was thinking about Ahmad, who knew the Prophet Muhammad looked favourably upon anybody who helped another person, regardless of their faith.

From Qazvin, I took the bus home to Tehran. Coming back down off the mountains I felt I was returning from a long dream. I thought about my time in the village and how it ended. I thought a lot about how people relate to each other. These were lessons I would take with me for years to come. It might not have been the farewell I'd hoped for, but I was happy and grateful to the *kadkhoda* for his moral courage.

Soon I was telling my parents how my time in Nirej had ended. My mother told me not to worry.

'What counts is that your own conscience is clear and that you're proud of what you've done,' she said. 'The rest is unimportant.'

'The easiest path to God is to serve humanity,' my father said. 'It doesn't matter if the people you serve appreciate it or not. God is aware of our actions, and He's the one who needs to know.'

Their words meant a lot to me, and I did my best to put the incident out of my mind. Then, a few days later, the doorbell rang.

It was a Friday morning; my mum had laid out breakfast in the garden, and lit the samovar. We were ready at the table, happy to be together again, waiting to tuck in. My younger brother, Shahin, went to see who was at the door. He came back quickly.

'It's someone asking for Seyyed Khalil,' he said. 'He must be from the village.'

I ran to the door. The *kadkhoda* was standing outside in the street. It was so strange to see him here, in the city, away from his home in the mountains. He'd travelled more than 150 kilometres to see me. We embraced on the doorstep.

'I had to keep asking the way, using this address I had for you,' he said. 'I came to thank you for all you did. I wanted to show you that we're not ungrateful people.'

He bent down and picked up a cage filled with partridges. He'd remembered that I loved these birds. In Nirej, they were everywhere, and he'd gathered some of them for me as a gift.

I took him by the hand, led him through the house and into the garden, and introduced him to my family. He held up the cage of partridges, as if it might reassure the birds to see trees and flowers

again. The *kadkhoda* joined us for breakfast. He was still worried about what had happened. He said he'd come to ask for my forgiveness, and I told him he shouldn't give it another thought. Then I told him how much I loved the partridges, how grateful I was, but I didn't like to think of them cooped up in a cage, I wanted to think of them flying in the mountains around Nirej, free. He understood. He smiled, and promised to release them. It would be the last time I saw him, and I have never forgotten the sight of that noble man walking away from our house with his gift of birds.

I was ready to fly, too. I could feel the big world calling me. The idea of studying in an American university had taken hold during my last year at the Ettehad. My parents supported my plan, as they always did, and the savings I had from book sales and other writing projects meant I could afford it. After paying for the flight and some accommodation in advance, as well as admission fees for an English language school for when I got there, I was left with $750. I registered at Queens College, deciding to major in computer sciences. Why not art? I was learning about art non-stop, studying art every minute of my spare time, dreaming about art, breathing it. Why not try to get a handle on technology early on, while I still had the time? I felt it would be good to challenge myself. It's pleasant in your comfort zone, but not much grows there.

I started looking for work as soon as I got to New York, and within days I was doing odd jobs at bars and restaurants. My father wrote to me and asked if I needed money – worried I was working off my feet, worried I was struggling. I wrote back to say how much I loved him

and Mum and missed them, but that by coming to New York, I'd wanted to strike out into the world, be self-reliant, I couldn't keep depending on their support. I needed to do this on my own – as scary and hard as it may be.

Ultimately what I really wanted was to be working with art – objects of rare beauty like those I grew up among. There had to be a way for me to make this into my livelihood. After all, I grew up in a family of art dealers and went through such an extraordinary apprenticeship with my father. So, from my very first days in New York, I spent every spare hour visiting museums and galleries, researching every object I came across, visiting libraries and bookshops, poring over articles, photographs and films. And I studied auction catalogues, and haunted private galleries and salerooms to learn about markets and value. I even started buying a few pieces with the little money I had – adding to the collection that began with Dr Mehran's pen box, safe in my room in Tehran.

It helped immensely that I had such a good memory, especially for visual images. Sometimes people talk about photographic or 'eidetic' memory – I think I had something like that. I filed away in my mind thousands of works of art from a variety of fields, memorising every caption and catalogue entry. Even now, when I visit a museum, I can remember exactly the books in which I first saw many of the objects in front of me. And I still remember many of the prices of items my dad sold over half a century ago . . .

I knew that this mass of knowledge, on top of everything I'd learned from my father, would help me on my way. The most important skill I'd need was the ability to recognise an object's value, and I

was already confident on that front. I loved meeting people of all personalities and backgrounds; I was curious and loved asking questions, finding out about people's enthusiasms and expertise, eager to learn from them. So it wasn't hard for me to connect with others in the art world, and develop relationships with a wide range of dealers, collectors, curators and museum professionals. I had all this on my side. But there was one thing missing.

Money. I'd need capital to start acquiring pieces. I'd managed to put together a fair amount in savings, though not enough to make a serious start. But I had a plan.

One day I headed to the bank and withdrew almost everything I had. I took the subway from Queens into Manhattan and bought a new wardrobe: two elegant suits, matching ties, shirts, shoes and an overcoat. I went into a barber's shop and got a haircut. Later, back home, I dressed up in my new clothes and looked myself up and down in the mirror.

Great look, empty pockets, I thought, imagining Dad cracking a joke if he could see me now. But in the mirror I looked like the important person I'd always hoped to be.

Taking a deep breath and with my briefcase in hand, I went to a renowned Manhattan gallery run by Nuri Farhadi and Habib Anavian. Over the years, they'd bought many important objects from my father, paying his modest Tehran prices, then selling them for many times more to collectors and museums in America. I'd known the Anavians for ages. Habib's brother, Rahim, ran the gallery in Iran where I'd made that bold intervention with the Japanese professors. Habib had known me since I was a boy. On trips to Tehran, he'd buy

lots of pieces from my father: I'd wrap them for him, and he'd always give me a nice tip. Since coming to New York, I'd visited his gallery occasionally to chat with Habib and his business partner Nuri Farhadi or ask their advice. Habib was usually travelling, so I'd often sit and chat about my family and the art business with Nuri, who treated me like a son.

Now, with my suit and briefcase and haircut and shining black shoes, I found Nuri and Habib in the gallery. As always, they gave me a warm welcome and asked after my father. We sat and chatted happily for a while, exchanging news and talking about art. Then I took the plunge. I wanted to make my way as a dealer and collector, I explained, but I didn't have enough savings to get started. If they agreed to act as my guarantors, I might be able to buy art on credit, avoiding the problem of not having enough money of my own to pay upfront. I could then sell these objects, pay back the loan and keep some profit for myself to bankroll my next purchases.

'You've known me from childhood,' I said. 'You know I would honour my word.'

Nuri didn't wait for Habib to answer.

'Of course,' he said. 'You can count on us.'

Habib happily agreed. Breathing again, I offered to give them first option to buy any objects I acquired because of their guarantee, but they insisted this wasn't necessary.

'You're the one who's starting out,' Habib said. 'We'd love you to succeed.'

This moment changed everything. In a business built on trust, it was priceless to have Nuri and Habib vouching for my character. I

could barely feel the pavement under my feet as I hurried straight to a printer and ordered a stack of business cards that read: *Nasser David Khalili, Art Expert.*

And of all the thousands of objects I'd seen in galleries and sale-rooms, which one was I thinking of with my new-found professional confidence and resource? Rückert's enamel casket in that crammed gallery off 57th Street, among the Tiffany lamps. The gallery belonged to Lillian Nassau, the biggest US dealer in Tiffany objects. In general, gallery owners at the time weren't aware that many of the objects collecting dust in their cabinets had now become fashionable and gone up greatly in value. Back then, a small gallery owner would know the value of their pieces from books and word-of-mouth, and unless you had your hand on the pulse of the market it was easy to miss the latest trends. If objects in your gallery were not in your main field of interest, or of interest to your connections, you might neglect them a bit, and so maybe something you didn't think was valuable would turn out to be very valuable indeed. This, for me, was an opportunity.

Lillian was ensconced in a chair among her crowd of lamps. She might have been communing with them, listening to them. Hesitantly, I introduced myself. I told her I was a student with a deep passion for art, I was at the start of my journey in the art sector, and I'd like to buy some of the enamel pieces in the cabinets at the back of her gallery. I explained that I couldn't afford to pay for them myself, but that I had the financial guarantee of the owners of the Farhadi and Anavian's gallery. She told me with a smile that she knew Nuri and Habib well and respected them. I proposed that I give her a cheque for the full amount, and, if I decided to keep all of the pieces, she could deposit

the money in her bank account on an agreed date. As an extra precaution, she rang Nuri: he vouched for me over the phone. I suggested 14 days for the cheque to be honoured. She agreed to my proposal. I wrote the cheque.

This was a big deal for me, a lot of money, but I was confident I could find a buyer for the enamels. I was friendly with a businessman in Queens whose family had made a fortune in property. He loved art but spent his life behind his desk buying and selling buildings, and didn't have time to live in art galleries the way I did. Taking a gamble, I kept a handful of the best enamels aside for myself, and showed him the rest, explaining what made them so valuable. As I'd expected, he fell in love. He gave me a cheque for more than I'd paid for all of them, landing me my first major profit in just a few days. It was exhilarating. I was on my way.

I rang Lillian, breathless with excitement, to let her know she could deposit my cheque even earlier than we'd agreed. She was surprised and delighted, and Nuri was proud to have created business for her. It had all worked out perfectly, but there was still much work to be done. At the time, few collectors appreciated the beauty, rarity and importance of such enamels. But I could see their appeal and sensed that they were becoming fashionable. Equally important, I could explain this to potential buyers in a compelling way, so they could understand why the price I was asking for was justified. Nowadays, it's very hard to find undervalued 'sleepers' like those enamels at the back of Lillian's gallery. If a piece goes on auction for half of what it's worth, you're probably going to see dozens of people bidding for it. But in those days, before technology lit up every corner of the

market, it was much easier to find objects that were neglected. In Lillian's gallery, I was lucky enough to find an amazing group like this. These days I doubt it would happen. Over the next three months, I bought every Russian enamel she had and sold most of them at a healthy profit to collectors I knew around town.

Something inside me was already moving, and I continued holding pieces back, at a measured pace. I began a practice that I would continue for years, always keeping pieces I especially loved for myself. It wasn't because of some shrewd business sense – I'd simply keep what was most appealing to me. They often proved, years later, to be pieces that were worth keeping. In the years that followed, as my finances improved, I bought back many of the finest objects that I'd once sold, including the casket by Rückert, sometimes even paying a much higher price than the first time around just so I could reunite them with related works in my collections, as if I were bringing members of a family back together.

After the early success with Lillian, I made it my mission to locate every relevant gallery and shop in Manhattan and its vicinity. I'd walk for hours visiting them street by street, making a mental note of pieces I might come back for. Those days there were many art galleries on the main avenues – 1st, 2nd, 3rd, Madison, Park, 5th – some virtually next to each other. There was so much to learn – each gallerist's style and sensibility, what they were after, what they sold and didn't sell, the kinds of relationships the galleries had with each other, all while keeping a sharp eye on the objects themselves and how they circulated through the world like a secret currency.

In 1970, the largest gallery with the greatest variety of objects was Rare Art, above Sotheby's (or Sotheby Parke-Bernet, as they were known at the time) on Madison, owned by renowned dealer Alan Hartman and his wife Simone. I visited often, memorising the objects on display and their prices. This meant that whenever I saw something similar in another gallery, I had a sense of how much it could be sold for, using the Rare Art prices as benchmarks. Over the next few years, I sold many objects that I discovered around Manhattan to Alan. Pretty soon, I started buying from him too.

The harder I worked, the more discoveries I made. I slept four hours a night, and spent the days hurtling between auction houses, shops, art galleries and potential buyers – while somehow keeping up with my studies at Queens College. Auctions were plentiful, and there weren't many big collectors competing against each other. The auction houses around the world were full of beautiful and rare objects at reasonable prices, and nobody seemed to think that the supply of these treasures could one day dry up. Some masterpieces, of course, were already in museums or in private collections. But I could walk into an auction house under the radar and find astonishing pieces; even the 'second best' would turn out to be extraordinary.

For someone with knowledge and a good eye, it was a golden age: incredibly exciting, and incredibly profitable. Even the auction houses were less sophisticated than they are today. They'd make mistakes and under-price objects; in the early 1970s I could go to Sotheby's and Christie's and find wonderful Mughal Empire jewellery for sale with no accompanying description. I could pick up pieces absolutely covered in diamonds, rubies and emeralds and pay modestly for them,

knowing they were worth much more than the asking price. I still remember getting the catalogue for a major sale of Fabergé enamels and Russian works of art at Sotheby's. When I got there, it was like stepping into a scene from a fairy-tale: a room glittering with gold and silver and enamel, the hoard at the back of a dragon's cave. I almost danced from one display to the next, my eyes wide at this abundance from the best enamellers of imperial Russia. I bought some of my collection's most important pieces that day.

The energy and appetite I had! I was gulping knowledge down – art books, auction catalogues, museum visits. I had a museum strategy: I'd give my full attention to one gallery or section for an hour or so, then take a break for a snack and some fresh air before heading to another wing. The moment I felt my brain was getting saturated, I'd step out and recharge. At first, my efforts centred on New York, but I also began to visit Miami, Los Angeles and San Francisco, and other cities in the US and Canada, constantly searching for more objects to buy and sell. Wherever I was, I'd visit the museums. I'd drop off my luggage at the hotel and race straight to a museum, without even bothering to see the room I'd be sleeping in. I didn't waste time. I was good at recognising value, and nothing is more valuable than time. I often say that the most expensive commodity in the world is time.

And still I was filing everything away in the drawers of my memory – not just many thousands of works of art, but also their descriptions and context. Whenever I met with potential buyers, I could compare the pieces I was selling to similar pieces I'd seen in museums, and I could justify my asking price because I could tell them exactly what a similar item had gone for at auction. I bought hundreds

of objects, selling most of them, keeping some back for my own collection, and with the profits I bought more pieces. My business grew rapidly; so did my collection, and so did my expertise. I talked to Lillian Nassau about this. We'd become friends, and she took a protective interest in me. One day, I asked her how she'd grown so successful.

'It's quite simple,' she told me. 'I focused only on Tiffany. So, if anybody in the world mentioned Tiffany, they'd immediately think of Lillian Nassau.'

Newspaper ads for her gallery never mentioned the address or phone number. The point was that any client who mattered knew who she was and where to find her.

'Whatever field you choose,' she told me, 'you have to acquire such expertise that everyone will acknowledge and respect it.'

I took Lillian's insight to heart. Just as her name was synonymous with Tiffany, I wanted to make sure that mine would be indelibly linked to each collection I assembled. In the first place, this meant enamel. Today, half a century later, some of those first pieces I found in the dusty cabinets at the back of Lillian's gallery on 57th Street, the Rücket casket among them, feature in my collection of more than 1,400 enamel masterworks, and our enamels were exhibited together for the first time at the State Hermitage Museum in Saint Petersburg in 2009. The museum's director Mikhail Piotrovsky wrote that

'*Enamels of the World 1700–2000*, which includes spectacular masterpieces from all the major centres of enamelling, is pioneering in its focused study of the subject. Unique in its scope, the Collection reveals the remarkable technical achievements

of the enamellers and encourages a greater awareness of
the range of their activity.'

I was very proud to read this. I remembered the young man I had
been, moving so breathlessly among the galleries, museums and sale-
rooms of New York, starting to make my name, starting to build.

~ 3 ~

Enamel — An Interlude

I had seen them in gardens in Agra, the great fan of tailfeathers moving past fountains, and I'd stared at their delicate headdresses, their black glossy eyes and the other eyes on the tailfeathers staring back at me. From an early age I'd been fascinated by these birds, seeing them depicted in works of art, in the pages of books, hearing my father talk about the Peacock Throne the shah had once sat upon. I wasn't the only one – from the pre-historical cave paintings of the Katkari people in India up to the present day, peacocks had captivated the imagination of so many cultures, including my homeland Iran, and inspired thousands of artists. Much later, when I'd had some success in the art business and beyond, I would make a garden at our holiday home in Italy for peacocks to wander in, and there's nowhere I feel such calm and peacefulness than sitting in the garden watching those tall, over-the-top, splendid birds making their slow way along the paths.

So, of course, when a dealer I knew in London offered me a rare nineteenth-century Japanese vase paying homage to these magnificent

creatures I didn't hesitate. The choice of the peacock-feather motif, executed with such elegance against a vivid turquoise ground, reminded me of Art Nouveau – a movement that also held a strong fascination with the peacock stretching from Whistler's Japanese-inspired *Peacock Room* to the work of René Lalique, who used the bird as motif for many of his pieces. Still, something troubled me. The vase had a glowing presence, but something was missing. This may seem mystical, but I felt strongly that the vase was *lonely* – that it was missing its twin. Sure enough, a few years later, the partner vase appeared at an auction in London, and as the hammer went down I thought of how often I had felt as if there was an invisible force guiding me to these objects, and them to me. Such a moment of reunion, in which members of a pair or set or family are brought together again after long absence, is one of the central privileges and purposes of my life as a collector.

It wasn't just the peacock motif that drew me to those beautiful Japanese vases. Since my first childhood expeditions round Tehran with my father, no material had fascinated me as much as enamel. Generally speaking, what we refer to as 'enamel' means coloured glass powder or paste, which has been applied to an object made of metal, glass or porcelain and then fired in a kiln at great heat, producing smooth and often glossy, vibrant surfaces. The use of fired glass to decorate objects has been around since the Mycenaean period more than 3,000 years ago (I love to think of those pioneers, discovering that their smelted glass would emerge transformed into such enchanted, gleaming smoothness) and there are many different techniques that can be used to achieve a variety of effects and designs: cloisonné, champlevé, painted . . . Enamelling is a skilled and laborious process:

Painting of the Christian Hospital, known as the Issa Ben Maryam (Jesus son of Mary) Hospital, by F.A. Evans, courtesy of Ali Amoushahi

The Queen Mother visiting the hospital sometime in the 1960s, when I was a young boy, courtesy of Ali Amoushahi

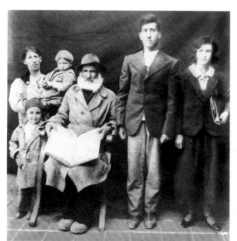

My parents with my grandfather Eliyahu Khalili in the 1930s and my two oldest siblings, before myself and my late brother were born

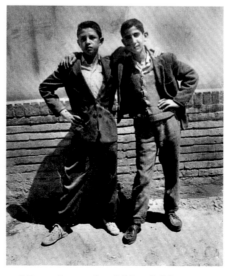

Me and my school friend, Mansour Hedvat in the 1950's

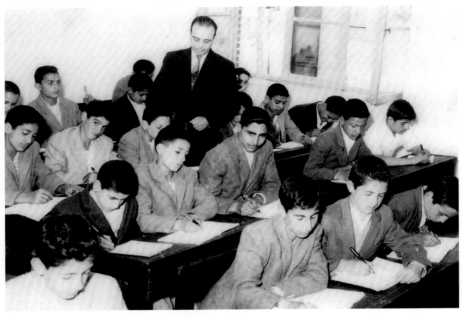

Studying at school in the 1950's. I am in the front row and Mansour is sitting next to me

Me as a young boy in the early 1950's

My parents at our house in Tehran, taken in the mid-1960's

The front cover of my first book, *Biographies of Prominent World Figures*, which was published 1959

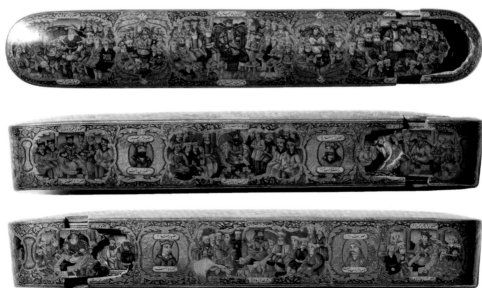

Three views of the pen box from Dr Mehran, It was made in Isfahan, Iran, c.1870–80, Papier-mâché and lacquer, 23.3 x 3.7 cm

Outside my Queens residence, where I stayed when I was studying in
New York in the early 1970's. This photo was taken when I returned
to give my commencement address to the university in 2013

The enamelled corsage by Lalique – Paris, 1903-5,
gold and plique-à-jour enamel, 4.5 x 21 cm

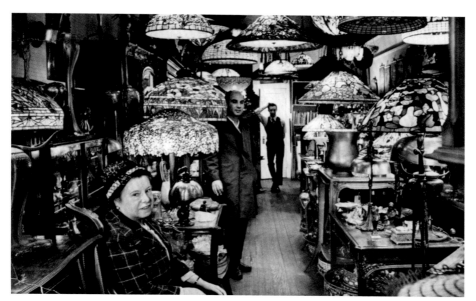

Lillian Nassau in her original gallery on Third Avenue, circa 1962. When I visited her, the gallery had moved to the nearby E 57th. Courtesy of Lillian Nassau LLC, New York

The casket I had bought from Lillian Nassau on that first visit. Feodor Rückert, Russia, Moscow, 1908-17, shaded cloisonné enamel and silver-gilt, 11.2 x 7.7 x 2.1 cm

The towering wine cistern, weighing 240lbs (108kg) which bewitched me all those years ago. It was made by Peter Bruckmann in Germany, c.1896, parcel-gilt silver, enamel and hardstone, 107.5 x 73.5 x 78 cm

Presentation charger by Pavel Ovchinnikov, given to
French president Émile Loubet, Russia, Moscow, 1899-1902,
silver-gilt and shaded cloisonné enamel, diameter 74.2 cm

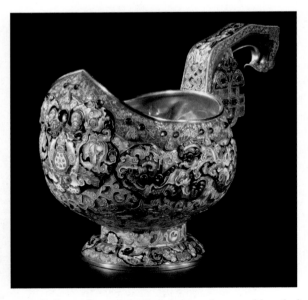

Monumental silver-gilt and shaded cloisonné enamel kovsh, largest
known to date, commissioned by the Nobel brothers, Russia, 1908,
silver-gilt and shaded cloisonné enamel, 29.8 x 38.3 x 24 cm

The Maharaja's silver and enamel coach,
weighting 2,600lbs (1,200 kg). Bombay, India, iron,
wood, silver, gilded silver, enamel, glass, silk 208 x 470 x 175 cm

Our Chinese Imperial enamel throne table, China, Guangzhou (Canton),
1736-1795, gilt copper, painted enamel, 37 x 90.5 x 42 cm

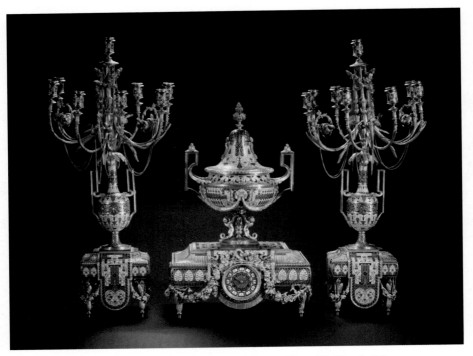

The garniture previously owned by William H. Vanderbilt,
made in Paris, circa 1880, gilt bronze and champlevé enamel,
71 x 47.5 x 33.5 cm (timepiece) 92.5 x 41 x 41 cm (candelabra)

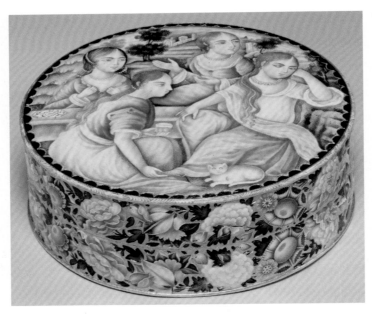

Box with translucent and painted enamel,
Iran, circa 1800, 3.4 x 8.9 cm

each different colour on an enamelled object requires its own separate firing, so an object might have been in and out of the kiln many times over. For larger enamelled objects, vast bespoke kilns had to be built especially.

Ever since I acquired that first Rückert box from Lillian Nassau, I have collected enamels from all over the world: Russia, France, Switzerland, Germany, the USA, Britain, China, Japan, Turkey, Persia, India and beyond. To the best of my knowledge, this is the first collection of its kind. Many collectors have focused on a particular artist, or period, or style, but what excited me was to look at one artistic technology (the art of enamelling) and study its diversity and glory across time and space. I wanted to show how ingeniously the greatest enamellers – from anonymous Islamic masters to famous firms such as Fabergé, Cartier and Lalique – had expressed themselves, overcoming technical challenges and limitations.

Whenever I saw a gap in the collection's great mosaic, I always tried to buy the best example to fill it. And I looked for the best advice. Haydn Williams, who had spent many years as a leading expert at Sotheby's, would often recommend enamel pieces for me to add to the collection, and it was Haydn I turned to when looking for a truly special object by one of the great masters in the history of jewellery – René Lalique.

Lalique was an incredible artist. His wish to 'create something that had never been seen before' earned him over the years the title of 'Inventor of Modern Jewellery'. He revolutionised the jewellery styles of the late nineteenth and early twentieth centuries, becoming the favourite of all the leading socialites, and was admired by the most

distinguished of his contemporaries. His work was commissioned by the great courts and collected by the world's richest, supported by such legendary figures as Sarah Bernhardt, the most famous actress of the period – an early example of the 'celebrity endorsement' as we know it today. He was known for his observation, and for his deep appreciation of nature and of cultures outside Europe, drawing inspiration from ancient Egypt and Pre-Columbian South America, and from the traditional arts of Africa, Cambodia and Japan, whose art he was particularly fond of. And in fact, Lalique's work has been admired in Japan for decades, with his pieces regularly featuring in exhibitions across the country. The ultimate recognition of his work by the Japanese came in 2005, when a museum dedicated to Lalique opened in one of Japan's most picturesque towns, Hakone.

He eventually moved away from jewellery in search of renewal and challenge, which is something I deeply admire. It takes so much courage to decide to change your ways, to explore the unknown. We all prefer to stay in our comfort zones. But Lalique didn't sit still. He decided to be a bit riskier and take on more ambitious projects: the decoration of the Côte d'Azur Pullman Express carriages; fashion designer Madeleine Vionnet's haute couture salons; glass doors for Prince Yasuhiko Asaka's residence in Tokyo; even a fountain that for a time decorated the Galerie des Champs-Élysées in Paris. He jumped – but he didn't fall. He flew.

Sometime in the early 2000s, Haydn showed me photographs of an incredible corsage ornament made by Lalique around 1905, which he felt belonged in the collection. Once I saw this piece of enamel witchcraft I knew we couldn't be without it. It had to come to us.

Unfortunately, we had no idea where it was or who owned it. But I wasn't put off. In fact, tracking down objects such as this is one of the most exciting parts of collecting – it's like a quest, a challenge. I get giddy about it. So I switched into hunting mode, calling all the dealers I knew in the field, asking for their help, putting them on the lookout. Then I dug through books, archives, auction catalogues and articles in different languages. Nothing. Eventually, it was Raphael Sinai, the son of one of my dealers, who managed to track down the object. I was overjoyed; sometimes, just asking the right person for help is a crucial part of the quest. It made me particularly happy to learn that the corsage had been shown in Japan, where Lalique was so loved, at two Tokyo-based exhibitions in 1988 and 1992.

It's as if natural forms have been filtered through dreams: two magical long-winged moths made out of gold, rubies, peridots and different types of enamel, the tracery as delicate as a spider's web, the whole thing as light as air. It was because of pieces such as this that Lalique won the admiration of connoisseurs such as Calouste Gulbenkian, who bought 145 of his creations and remarked that Lalique 'ranks among the greatest figures in the history of art of all time, and his masterly touch, as well as his exquisite imagination will excite the admiration of future cognoscenti'.

One of the joys of the enamels collection is the way it brings together objects from such a wide variety of places and makers: wildly different pieces linked by their use of coloured glass. What a leap, for example, from Lalique's intricate fragile corsage to the vast landau carriage, nearly 5 metres long and weighing well over a ton, made for the Maharaja of Bhavnagar, the entire framework from bolts to

springs covered in silver, and the silver surface adorned with enamel butterflies, flowers and birds, which went on to be exhibited at the Victoria and Albert Museum (V&A)'s 2012 *Maharaja: The Splendors of India's Great Kings* touring exhibition. I was told at the time by the curator this was the star of the exhibition, and indeed it is glorious.

Or to the monumental piece for the Stuttgart exhibition of 1896, which I had first come across by chance in the mid-1990s, dismantled on the floor of a New York gallery – a metre-high mountain of silver figures and decoration, topped by a fairy-tale silver castle, the weight and detail of silver offset and complemented by highlights in lapis lazuli and translucent champlevé enamel.

Or to a Chinese imperial throne table, discovered almost accidentally in 2003. I was at an auction in Paris. As I was leaving, my childhood friend Abraham Nejat Moussai, who is my eyes and ears on the ground in Paris and a successful art dealer, stopped me at the door.

'David, you are furnishing your new penthouse at the moment, right?' he said. 'Would you like me to take you to one of the best art galleries in Paris so you can earmark a few pieces and take a few photos? You can show them to your wife and see if she likes them.'

I told him why not, and so he took me to a fantastic gallery owned by Didier Aaron, which was full of eighteenth- and nineteenth-century European furniture.

Browsing away at what they had to offer, from the corner of my eye I noticed a vibrant patch of yellow on the floor, shining in the sea of brown. I had to look – it was a yellow enamel table which looked to be in perfect condition. My heart started beating faster as I checked it out. *Surely not*, I thought. I had seen something similar, which was in

a museum in China, in a book but I was not aware that another existed.

At this point, I was no longer interested in anything else. I tried to find out how much the owners knew about the history of the object, and they told me that this table, which was signed, was made during the reign of Emperor Qianlong (1711–99), who was part of the Qing dynasty. They explained that some of the decorations, including lotus and bats, were symbols of longevity and happiness, and that they were aware of another table existing in China. These were all things I knew, but I also knew – or at least suspected – more, and these are among the most important tools for a collector: knowledge and hunch.

I was certain of two things that the sellers weren't – that this was intended for the imperial court itself, and that its yellow colour was very significant. The reasons? Well, firstly, this type of object was often used as part of the emperor's bed platform, and the thickness and type of enamel used indicated that this was a piece made for a Chinese client, rather than export. Additionally, yellow was a colour that was heavily associated with the reign of Qianlong. With this knowledge in my memory vault (and butterflies in my stomach) I bought the piece instantly.

Once in the collection, my research team discovered that this is possibly the only imperial table of its exact kind, made for the emperor in the palace workshops of Beijing's Forbidden City, and the table I already knew about, which was in the Palace Museum, was the single other yellow example. I was right. Its magnificent relative has cabriole legs, like ours, with the top decorated in a similar way, but is squarer in shape. And I was also right about the colour – yellow is highly

venerated in Chinese culture. I learned then of a brilliant Chinese saying: 'Yellow generates Yin and Yang' (a concept central to Chinese philosophy), and I also learned that the name of the first Chinese emperor in legend was Huang Di, which means 'The Yellow Emperor'. Apparently, yellow was also used to decorate royal palaces, it was exclusive to the royal family for a time, and dignitaries would often be greeted with a yellow, rather than red, carpet.

Each of these objects in our enamel collection is a story – or rather, a *collection* of stories, because I have in mind not just the circumstances of its design and manufacture but also the story of how I encountered it and succeeded in bringing it into our collection. Another example of this is a pair of stunning gilt copper and champlevé enamel vases made by Ferdinand Barbedienne (a Parisian artist-entrepreneur famous for developing a new process of enamelling) around 1875. When I look at them, I not only think of their marvellous beauty, but also of the day I narrowly missed buying them at Sotheby's in New York, and of the day a couple of summers later when a friend took me to an antiques fair in Saint-Tropez, the coolness of the halls a relief from the burning sun outside, and there they were: the Barbedienne vases – *my* Barbedienne vases! I joked with the dealer: 'My friend, what are you doing with my vases?'

It turned out that this French dealer had bought the vases in New York, taken them to Paris, and had now brought them over to Saint-Tropez for the summer exhibition.

'I know what you paid for them at Sotheby's; and I'll pay you twenty per cent more.'

He was delighted, and so was I.

And when I look at one of my favourite presentation chargers (large, decorative dishes) in the collection made by the Russian silversmith and enameller Pavel Ovchinnikov around 1900, I'm carried away not just by the beauty of the object with its image of St George slaying the dragon, its silver-gilt surface adorned with emeralds, sapphires and amethysts, and opaque and painted enamel, but also by thoughts of Ovchinnikov working for Fabergé, and the charger being presented by the city of Moscow to the French president Émile Loubet during his official visit to Russia in 1902; and at the same time I recall the first time I saw a photograph of it in a book in New York in my student days, and how over decades I kept an eye on it as it passed from one collector to another, until the day in London when I was unexpectedly offered a group of enamels and found, when the sheet covering them was whisked off the table, that among them were three massive chargers, including the St George charger I had been tracking for so long. Naturally, I bought all three.

Sometimes, the real excitement would lie in the slow uncovering of an object's history. We have another piece by Barbedienne made up of a timepiece and two gilt copper and enamel candelabra. In photographs, it struck me like something from a nineteenth-century novel by Zola or Hugo: you could imagine powerful figures passing it in drawing rooms or leaning against the mantelpiece on which it was proudly displayed to discuss matters of urgent historical importance. The enamel by Barbedienne was as usual superbly applied, subtle and in full harmony with the object, highlighting its best features in majestic colour. But where had it come from? We had no idea. Once again, my research team dived into books and archives, and in one of the

books we found a photograph of the library in the Manhattan mansion of a nineteenth-century railway magnate, William H. Vanderbilt, with the Barbedienne garniture sitting proudly on a fireplace made of African onyx.

Vanderbilt! Having inherited nearly $100 million from his father – Cornelius 'Commodore' Vanderbilt – William H. expanded his family's railroad empire and became the richest man in America. He finished building his Fifth Avenue mansion in 1882 and it was furnished for an estimated $800,000 – an incredible sum in those days. It was full of valuable pieces by Barbedienne and others, coordinated and designed by a team made up of two of the most renowned interior designers and architects in New York – Christian Herter and John B. Snook. There was nothing else like it. William H. didn't live long after the completion of the mansion: he died three years later, in 1885. It was the last great Vanderbilt house to survive, finally being demolished in 1945, and the objects in the interiors were sold at various auctions. Some of these, apparently, were bought by Paramount Pictures, and I like to imagine such pieces as our Barbedienne garniture lighting up the sets of Hollywood's Golden Age.

Rückert, Lalique, Barbedienne – all masters. But one name looms largest in the history of European enamel: Fabergé. Enjoying the support of powerful patrons, including Russia's imperial court, the House of Fabergé was incredibly successful. Peter Carl Fabergé employed over 500 people in St Petersburg and Moscow, and experimented constantly in his early days. In fact, Fabergé's workshops developed a palette of at least 144 colours and shades and became the

face of technical excellence and creativity in the world of applied arts. But sadly, after the revolution of 1917, the Bolsheviks got hold of the firm's workshops and the family had to flee. Splitting up and making their way through Germany, Finland and finally settling in Switzerland was difficult for the Fabergés, and Peter Carl eventually died in 1920. In 1924 two of his sons, Alexander and Eugène, revived the brand in Paris, under the name Fabergé & Cie. A year later their mother, Augusta, died too, and it wasn't until 1927 that their brother Agathon and his own family managed to make their escape to Finland.

We have over 100 Fabergé pieces in the collection, from chargers and desk sets to smaller objects such as bell pushes and clocks, and real masterpieces such as a majestic kovsh (a kind of Russian drinking vessel) decorated with amethysts and painted filigree enamel, commissioned by the Nobel brothers in 1908, and a lady's cigarette case in a soft mauve, which was said to have been a colour exclusive to Fabergé's head workmaster Henrik Wigström and used for a limited period between 1904 and 1910. It was originally purchased from Fabergé's London shop by Stanislas Poklewski-Koziell, first secretary at the Russian embassy in London and a close friend of King Edward VII.

England was a phenomenal hub for enamel work, and one of the true masters of the form was Henry Bone (1755–1834) who created some of the best pieces in the collection. His accomplished and delicate style is particularly dear to me, and over the decades I have tried to collect and preserve as many examples of his work as I can. He was truly an unparalleled artist – official enameller to three successive kings, George III, George IV and William IV, he participated in almost every Royal

69

Academy exhibition between his 1781 debut and 1832, missing only one, and was elected a Royal Academician in 1810. Among the many examples of his work in the collection, there is a superb, enamelled portrait of Queen Charlotte, consort of George III, executed with incredible finesse and detail. And in fact, while we were working on our *Enamels of the World* catalogue, we managed to find a study drawing for the piece kept by the National Portrait Gallery, which shows the level of preparation and consideration he gave to creating his masterpieces. Made two years after the queen's death in 1818, it is such a moving and loving tribute. In the Royal Collection, there is an incredible piece by Henry Bone of King George III, which almost matches our piece and certainly was made very much in the loving spirit of our portrait.

And that is just Europe. One of the joys of the enamels collection is the way it allows the viewer to travel all over the world, across cultures and periods, seeing the flow of artistic exchange and inspiration. So you might move from Lalique and Fabergé to a beautiful, enamelled box belonging to the early Qajar period (*c.*1800) in Persia, with four European-looking women on the lid, in European clothes and in a European landscape, and a bare-breasted woman shown (cheekily) on the underside. Or to other Chinese treasures from the Qing dynasty (1644–1912), a period when Chinese cloisonné and painted enamels reached new heights of sophistication – a cloisonné vase in the shape of a goose, a calligrapher's brush pot, a pilgrim flask, a table ornament in the shape of a phoenix, incense burners, altar candlesticks, a fish bowl or a tiny eighteenth-century snuff bottle, 4.7 centimetres tall, its Qianlong seal mark suggesting its imperial heritage.

Sometimes I think of this collection as a book of dreams. Over a period of nearly 50 years I've managed to put together more than 1,400 pieces that present a comprehensive history of the medium – not just a history, but a *festival* of enamel. It reminds me of the book I wrote when I was 14 – that sense I had of all the geniuses existing in different bubbles across history and geography, and the longing I had for a place where I and others could see them gathered together, and hear them speaking to each other.

Take, for example, the book *Claudius Popelin et la Renaissance des Emaux Peints*, a tribute to the master of French enamel Claudius Popelin, published a year after his death in 1892. The enamelled portrait of Popelin embedded in the cover of this copy is by another giant of French enamelling, Paul Grandhomme, who was himself inspired to start working in the medium after reading Popelin's history of enamelling. Grandhomme was 20 years old when he discovered it while working in a library during the Franco-Prussian War of 1871. Launched by Popelin, some would argue that Grandhomme surpassed him. And now here he was, making a portrait in enamel of his father-in-enamel, showing how art is a living, breathing tradition, a flame passed along from one to another.

On 8 December 2009, the aforementioned exhibition *Enamels of the World 1700–2000*, composed of 320 of our pieces, opened at the State Hermitage Museum in St Petersburg. On the morning of the opening, I arrived early at the Hermitage, accompanied by Professor Piotrovsky and my family. I was so excited and nervous that I didn't even feel the cold Russian air which enveloped us. The museum hadn't yet opened to the public, and it was still dark in the Picket Hall, the

ornate palace room where our enamels would be displayed for the next four months. As the lights were turned on it was a revelation, a wonderland of gleaming colour. It was a magical experience to be walking through the exhibition with my family like this, all those miraculous objects gathered together here like old friends at a wedding or birthday. They glowed with beauty. At every turn, I was flooded with memories of where and how I had first met and fell in love with these works. They looked proud and shining, as if on their best behaviour at a parade.

~ 4 ~
India

That first night, I could barely sleep. I was just too excited, and the events of the day kept going around in my head. I kept going out onto my balcony, which overlooked a beautiful garden, and listening to the sounds of the night in the warm air. It was so different from New York and even from Tehran. It felt infused with magic. In the morning, I saw peacocks walking about on the lawn, and listened to the parakeets flying around the trees. Standing on my balcony, I felt like a character in a tale of Scheherazade's.

The Taj Mahal. It wasn't just the palace itself that had so enchanted me. I loved the two smaller buildings on either side – one nicknamed *so'âl* in Persian (*savāla* in Hindi), which means 'question'; the other *javâb* (*javāba* in Hindi), meaning 'answer'. Question and answer: a mosque and its mirror image, possibly a guest house. I loved how these three buildings related to one another, and how, for all the abundance of decorative treasures inside, the whole is itself a great work of art, form and function in perfect harmony.

The year was 1971. I'd been getting ready to visit my family in Tehran, but an Indian classmate from Queens College had another idea.

'You went to Iran last year,' he said. 'This time, come with me to India.'

Nuri knew just how to sell the trip to me, describing his home country as an ocean of cultural wonders inspired by Hindu, Buddhist and Islamic traditions. I knew that Islamic art had blossomed in India for over four centuries under the Mughal Empire, and that some of the most talented Persian artists and architects – many from Isfahan – had worked there. Nuri wasn't to know – or perhaps he could sense it – that I'd longed to see their legacy and explore the country.

I'd guessed from his refined manners that he belonged to a respectable family, but I'd had no idea quite how prominent and successful the Gupta family was. When the two of us landed in Delhi, we were greeted with bouquets of flowers, escorted to a sleek, chauffeur-driven car, and driven to the family's beautiful estate in Agra. As luck would have it, Nuri's house was in a lovely courtyard not far from the Taj Mahal.

The incredible story of Indo-Persian art begins around the thirteenth century, but really comes into its own between the sixteenth and nineteenth centuries. In 1526, Zahir al-Din Muhammad Babur – a Turkish commander descended from the famous conquerors Genghis Khan and Timur – invaded northern India and captured Delhi, establishing the Mughal Empire. Babur was succeeded by his son, Humayun, the second Mughal emperor; he died in 1556 after tumbling down a staircase while answering the call to prayer. And so his 13-year-old son, later known as Akbar the Great, took the throne.

He reigned for half a century, commanding an empire that included much of what is now India, Pakistan, Bangladesh and Afghanistan. Akbar was illiterate but cultured: he surrounded himself with artists and built a library of over 24,000 books. Enlightened and open-minded, he embraced Hinduism, Sikhism, Jainism and Christianity, instead of forcing Islam on all his subjects. His marriage to a Hindu (rather than a Muslim) princess named Mariam-uz-Zamani (known as Jodha) unsettled some, as did his founding of a new religion, the *Din-e Ilahi* ('Religion of God'), a mix of elements from all the main religions that existed in the empire.

Art bloomed under Akbar. Many Persian artists and intellectuals settled in India, attracted to a society that was known for its tolerance, creativity and wealth. In his court studios, these new arrivals worked harmoniously together with local artists, helping to create a unique Mughal style that combined Persian and Indian elements. Persian influence could be seen everywhere in the kingdom: the royal court was served Persian food, many Indian poets wrote in Persian, and the Mughal government's official language was Persian.

Akbar's son Jahangir was another great patron of the arts. Known for his openness to different religions and cultures, he built an out-standing collection of Indian, Persian and European paintings. He was succeeded by Shah Jahan ('King of the World'), who pushed the Mughal Empire still further, not just in terms of power and territory but in artistic richness too. Probably the world's wealthiest monarch of his time, Shah Jahan is best known for building the Taj Mahal as a mausoleum for his favourite wife, Mumtaz Mahal, who died in 1631 giving birth to their fourteenth child. Shah Jahan was a secular ruler,

and the surahs and verses selected to embellish the Taj Mahal were specifically chosen to project a spirit of harmony and unity. At the entrance you are greeted with the Quranic verse: *O Soul, thou art at rest. Return to the Lord at peace with Him, and He at peace with you.*

I approached the great palace as if in a trance. I felt as I had when a boy, visiting Persepolis with my father, a boundless sense of history and human capacity and enterprise opening up inside me. The scale, the dome rising into the blue, the gleaming white marble. And something deeply personal, atavistic – a feeling of connection with my own home and people. I hadn't realised how much Persian artists had contributed to this masterpiece of Mughal architecture. The alleged chief architect, Ustad (Master) Ahmad Lahori, was apparently a Persian-speaking Afghan. The mausoleum's white marble surfaces are brilliantly embellished with verses from the Qur'an, overseen by the legendary Persian calligrapher 'Abd-al-Ḥaqq. Born in Shiraz, he'd emigrated to India in 1609, and soon made his reputation designing the calligraphic inscriptions on the gateway of Akbar's tomb in Sikandra. When Shah Jahan – Akbar's grandson – decided to build the Taj Mahal, he turned to 'Abd-al-Ḥaqq to supervise the inscriptions. Renowned as a scholar, courtier and calligrapher, 'Abd-al-Ḥaqq is believed to have personally chosen the 22 passages from the Qur'an that decorate the Taj Mahal's marble walls. In 1632, Shah Jahan gave him the title Amānat Khan: Trustworthy Noble. While other artists who worked on the Taj Mahal remained anonymous, he was given the honour of signing his name beside his work. And so, on an archway in the central hall of the mausoleum, you can find the small, beautiful inscription: *Written by the insignificant being Amānat Khan Shirazi.*

He retired to a grand house he'd built in a village near Lahore. It was there, just a year after he'd signed his name on the Taj Mahal, that he created a magnificent Qur'an – 512 pages. It is one of my all-time favourite works in the collections. A small manuscript with the feel of a personal Qur'an, a book for private contemplation and meditation, but lavish, too, with much of the text written in gold, each page finely decorated with intricate brushwork, each blue and gold panel gleaming in your hands. It's as if the colours aren't just reflecting surfaces but are actual sources of light. I think of the contrast in scales – this small, delicate folio, and then the vastness of the Taj, with Amānat Khan's calligraphy as an aspect of architecture, open to millions. Whenever I look through it, I'm amazed again by the limitless artistic expressiveness inspired by all that is holy. I picture the artist entering a spiritual trance as he applied himself to this timeless work.

I don't think I'd have acquired Amānat Khan's magnificent Qur'an, nor devoted so much of my life to building a collection of Islamic art, without Nuri's kindness, and those days we spent together in Agra and beyond immersed in the world of the Mughals. The Guptas themselves were Hindus, but they had many Muslim friends, and on visiting them together I could feel these great religious and artistic histories moving through each other. In Nuri's house alone I saw the most stunning Mughal pieces – exquisitely crafted jewellery, marvellously detailed miniatures, manuscripts, Qur'ans and enamels. I was overwhelmed by the skill of the miniaturists, who painted with incredible delicacy, using brushes made of squirrel hair. And I was alive to the similarities between Persian and Indian miniatures – no coincidence, of course, as the three great regional empires (Ottoman,

Safavid and Mughal) existed almost simultaneously, and there was a huge amount of cultural exchange between them from the early fifteenth century to the late nineteenth century.

Out of piety, Muslim artists sometimes felt the need to avoid artistic representations of humans and animals, respecting the idea that artists should not imitate the Almighty by creating images of living beings. There has been an argument for some years about whether this is in fact a religious requirement or a misinterpretation of Islam's teachings. In a Hadith usually attributed to the Prophet Muhammad, we are told: *Truly God is beautiful and loves all beauty.* To my mind this includes artists' sublime portrayals of God's creatures. Under progressive Mughal rulers such as Shah Jahan, figural art blossomed, and in those days in Agra with Nuri I was struck for the first time by the sensitive and imaginative manner in which Muslim artists approached restrictions, trying to find ways to express themselves in harmony with their religious feelings and faith.

I'd come to India without meaning to buy art. But Nuri saw how mesmerised I was by these objects. I couldn't disguise it. I had the collector's itch now, and I admitted that, yes, I was interested . . . The problem was, I hadn't brought enough money to make big purchases. But I was lucky. Where Nuri Farhadi and Habib Anavian had offered to act as my guarantors in New York, now the Gupta family gave me their backing in India. I bought miniatures, jewellery and other pieces not only in Agra, but also during visits we made to Jaipur, Udaipur and Lucknow. In all, I bought over 30 objects on that trip, including quite a few masterpieces. I was blessed by timing, I know. India was not yet a popular destination for foreign collectors, and I had

once-in-a-lifetime opportunities. If you met the right people, you could pick up unbelievable pieces. It took another 20 years for other collectors to catch on, causing prices to surge in the late 1980s.

My advantage was that I had the knowledge and passion to cherish such pieces long before they grew so rare. And how I loved making trips with Nuri to those towns and people's houses, looking at great works of art, talking to the owners, sitting and laughing under the brilliant skies with the sound of birds everywhere. I only now realise what a gift Nuri had given me and how such experiences are rarely ever repeated. Being surrounded by art, friendship and nature was the rarest gift of all.

And I had another advantage: when looking at objects, I could see the connections between different areas of Islamic art. Some scholars and collectors approach their specialty in isolation, focusing exclusively on Indian paintings, or Persian lacquerware, or calligraphy, but I had a broader perspective, always seeing the relationships between different art forms and between works made in different countries and periods. The three great Muslim empires – Persian, Mughal and Ottoman – overlapped and crossed over each other, even intermarried, for roughly 400 years, sharing artists and ideas, influencing each other in ways that don't allow for neat segregation. From the very beginning, and as Islam spread, there was a constant fusion of different cultures, with the ruling regime and the local population joining to create new art forms. Seen this way, Islamic art is the ultimate form of cultural dialogue. 'Islamic art' is more than a category: it is a world.

I returned to New York full of memories and a love for Indo-Persian art which was stronger than ever, my heart full of joy and

gratitude. Once at home, I put everything I'd bought on the dining table and stared at those pieces for hours, thinking about what to do with each of them. Finally, I put to one side those that appealed to me most and would best fit into my growing collection, and placed protective papers between all the miniatures, which were sorted into two neat piles. I then divided the pieces I was going to sell into four piles, earmarking each for a different collector, and in the following days managed to sell them all for many times the total purchase price of everything I bought in India. I immediately paid back the money I owed the Guptas and passed my wholehearted gratitude to them through Nuri. I also made sure to keep in touch with many of the original sellers I had met on the trip and did numerous deals with them over the following years.

From the early 1970s, when I was first visiting auction houses in Europe and America, I was regularly asked to review sales before a catalogue was finalised and published, especially when it came to Islamic art. I had a reputation in this field already. I think I was always able to see Islamic art in its global context, and I had the reliable aid of my unusual memory to make connections across periods and geographies. The major auction houses generally had two sales a year, usually April and October. On invitation from the head of the department I would go and review most of the star pieces on offer for sale. Both they and I knew that I might also be a potential buyer. I would pick up a piece or two and tell them as respectfully and gently as I could that they'd miscatalogued something – the attributed artist was wrong, the piece was earlier than listed, the origin different, and

so on. As a result, the price often went up – which, of course, was music to their ears.

When this happened, they'd say: 'Hold on, David. You want to buy the piece. Now it's going to be more expensive. Why not keep the information to yourself and benefit from the miscataloguing?'

The answer would usually surprise them: 'If you hadn't asked me, perhaps I would have.'

Whenever I was explicitly asked my opinion, I would honour the question with honesty. Still, I've picked up many sleepers in many sales worldwide: on those occasions, as I was not specifically asked to advise, I felt it was fair to use my knowledge to my advantage.

Through my practice of keeping my favourite items and selling the rest for more than I'd paid, I was slowly building my collections with barely any expense. Nobody knew that this was what I was doing at the time – and that I continued to do this for many years and in different fields of collecting. My collections began in the buying and selling of art. Later, whenever I made money in real estate or other ventures, I used the vast majority of the profits to continue to build the collections.

~ 5 ~
Love

There's a textile I love, a cushion cover woven in rural Sweden, in the southern region called Scania, around 1800. The figures of young women and birds and reindeer are alive in the threads, and all around them is a happy abundance of hearts – 72 in all. In rural Sweden at that time, brides would weave cushion covers for the carriage ride home from church after the wedding, usually using hearts as the decorative motif, so this tapestry is not just a marvel of individual creativity and skill, but also a glimpse into the weaver's state of mind as she was preparing to get married, her hopes and apprehensions, and witness to the couple's first moments together after the ceremony, travelling home in their new intimacy. In some cases, a bride would even weave the textile on which she and her groom would kneel in church while exchanging their vows.

Tokens of human beings' attachment to each other and those they worship have never failed to move me. Throughout history, people have kept their loved ones near in any way they can. Even

beyond death – locks of hair in pendants, relics in churches and mosques, cherished photographs. Often you hear people say that pictures of loved ones are the first things they would rescue from a fire. The beauty of such objects is enhanced by that extra weight of longing and memory.

Precious textiles like these were made at home on a spinning wheel and usually kept for the weaver's own household, although sometimes tapestries would be woven on commission or given as presents. The weavers were generally taught by their own mothers, who handed down their knowledge to their young daughters. Artificial pigments didn't become available until 1856, so these women were not just experts at techniques of weaving, they were also inheritors of knowledge about natural dyes – yellow from apple bark, birch leaves or mignonette; red and indigo from plants such as madder and woad.

I usually say that the best things and worst things in life come at you suddenly. One morning in July 1976, I was walking down Bond Street in London when it dawned on me that I should get a gift for my mother to send home to Iran. I went into an arcade lined with shops selling antique jewellery. It was lovely going into the cool arcade from the blazing sun and the busy street.

I peeked into one of the shops to my right, nothing more than a small stall with a few display cabinets and a chair, and a beautiful young woman standing among the silver and gold and precious stones. She didn't notice me. But I had noticed her, and I stepped inside with my heartbeat ringing in my ears. I knew this was the girl I was going to marry.

Her name was Marion Easton, she was 19, and she was looking after the shop for a family friend. She explained that her family were Jewish from France and Belgium, and had changed their name from Epstein to Easton after settling in the UK. She understood why this was important – it's common for many Jews to try and pick a partner who shares their faith. Way too excited, and with my mouth running at a hundred miles an hour, I bombarded her with all sorts of questions, and to her credit she didn't waver or get annoyed. Soon I discovered that she was the youngest of three sisters and that the middle sister was already married.

'Sorry, I've asked you so many questions,' I said. 'Would you like to ask *me* anything?!'

'I was waiting for you to finish,' she said, laughing.

She asked me where I came from and I told her about my background – how I'd left Iran in 1967, gone to college in the US, and now lived in New York. I told her that my love and passion were collecting art and explained that I was visiting London to have a look at the seasonal auctions at Sotheby's and Christie's. I said that I wasn't married, and never had been. I was being cheeky, but I felt so at ease with her, as if we'd known each other before and were coming back together after a long absence. And that gave me the confidence to be cheeky again.

'Hold on,' I said. 'I'll be right back.'

I rushed out of the little shop and ran to the chemist round the corner. Marion had a cold, and I had a plan. I bought pretty much every cold remedy they had – decongestants, analgesics, throat soothers. I was so excited I nearly forgot to pay. And then I ran back to

Marion's shop and put the white paper bag down on the counter in front of her.

'These are for you,' I said, as she extracted the packets and bottles. 'Trust me, I was a medic in the army, and I can't help but look after people I like . . .'

So there it was, a bottle of Night Nurse instead of a bouquet. And then I gestured to the jewellery in the glass display cabinets and asked Marion if she had a special piece hidden away somewhere that she could offer me. She mentioned a beautiful emerald ring, and told me the price – a small fortune in those days.

'Can you give me a discount?' I asked.

She opened a box and took out a fine white gold and diamond bracelet.

'Here's your discount,' she said.

'Fair play – I'll take both.'

I wrote the cheque on the spot and gave it to her. I asked if she'd ever eaten Persian food, and when she said she hadn't I invited her to come to lunch with me the next day – provided she was feeling better, and provided the cheque had cleared. She agreed.

We went to one of a few Persian restaurants that existed in London at the time. After lunch, I wondered if I she fancied watching a film in Leicester Square the next evening. I didn't have a clue what was on; I wasn't the slightest bit interested in seeing a film, I just wanted to see Marion again.

'Weren't you planning to go back to the States?' she asked.

'Yes,' I said. 'But not right away.' I told her I had a lot of commitments in London, so I wasn't rushing back.

Love

The next night, Marion joined me in Leicester Square. But once we got there, it was pretty clear we weren't interested in the films. We wanted to talk and get to know each other better. The evening was bright and glorious. It was such a pleasure to walk with Marion, talking and laughing under the moon and the lights. I had never felt so free and so instantly connected to someone before. Her voice on its own made me feel calm and happy. She had so much intelligence and warmth, and I don't think she realised just how beautiful she was. These memories are some of the ones I hold most dear.

After almost two fantastic years together – a period during which I moved from the US to the UK – I asked Marion to marry me. We had no doubt where to celebrate our engagement: Jerusalem, the spiritual epicentre of so many faiths, and a place that had a lot of meaning for us both. Marion had never visited Israel and was thrilled to be going there.

A Middle Eastern Jewish tradition specifies that, if possible, the groom's parents should visit the bride's parents to ask for her hand in marriage before any wedding ceremony is planned; the groom's mother then presents them with a bowl of sweets, symbolising the sweetness of love. A few days later, the bride's family takes various gifts to the groom's family, including a copy of the Old Testament (to follow the law of Moses), a mirror (to symbolise reflection), candlesticks (to celebrate Friday-night ceremonies) and sweets (to inspire sweetness in marriage). My parents and Marion's parents observed all these traditions with joy while we were in Jerusalem, city of traditions.

One unforgettable morning, Marion and I drove to the Western Wall just as the sun was rising over Jerusalem, with its ancient hills and

olive groves. Our relatives joined us at the wall, all that remains of the magnificent Jewish temple destroyed by the Romans around AD 70.

We went on from there to have our wedding ceremony. Marion wore a beautiful white cotton dress, her hair covered beneath a white scarf. She was radiant, Beauty itself. My mother, Marion's mother and my aunts formed a ring around her, while the men of the family encircled me, led by my father. In this holiest of cities, we prayed: *Dear Lord, I praise thee! You gave me life and safeguarded my being, and in due course You will take back my soul. While I have life, I will, dear Lord, just as my ancestors have done, praise and thank Thee.* We felt at one with our faith, and with each other.

We had a British wedding, too, at the Marble Arch Synagogue. We needed to honour our home country, and the city in which we'd met. And as a surprise, and to remind her of the day we met, I had given Marion the jewellery I had bought from her on that glorious morning. At the reception at the Churchill Hotel in Mayfair, Marion wore a gold-embroidered veil, which my grandmother, Sara Khanum, had worn on her wedding day in Isfahan, and which my own mother had worn when she married my father. My mother presented Marion and me with a pearl-embroidered bedcover, passed down through her family from generation to generation, and a white silk shawl finished with Caspian Sea pearls. They are still with us, and Marion and I look forward to passing them on in due course.

We have three wonderful sons, Daniel, Benjamin and Raphael. The love for these boys is one that can be compared to no other – I always say it takes a second to become a parent, but it's a lifetime mission to stay one. It is this love that I hope passes through them and

The cover of *Claudius Popelin et la Renaissance des Emaux Peints*, bearing an enamel portrait of Popelin by Paul Grandhomme, within a tooled leather cover by renowned bookbinder Charles Meunier, France, circa 1900, 30 x 20.5 cm

Enamel portrait of Queen Charlotte by Henry Bone, London, dated 1820, 26.5 x 21.5 cm

With Mikhail Piotrovsky, director of the Hermitage Museum, at the Enamels of the World, 1700-2000 exhibition opening, St Petersburg, 2009

At the Taj Mahal with my
friend Nuri Gupta in 1971

Pages from a single-volume
Qur'an, transcribed by Amanat
Khan, the official calligrapher
for the Taj Mahal, 1050 AH
(1640–41 AD), 13.9 x 9 cm

The Rulers of the Mughal
Dynasty from Babur to
Awrangzeb, with their
Ancestor Timur, India, circa
1702-12, 20.8 x 31.5cm

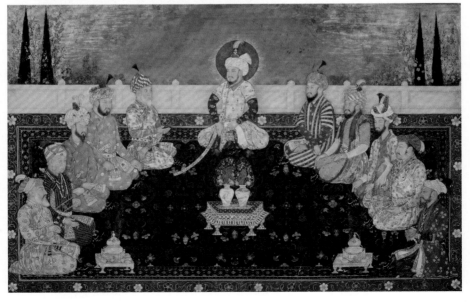

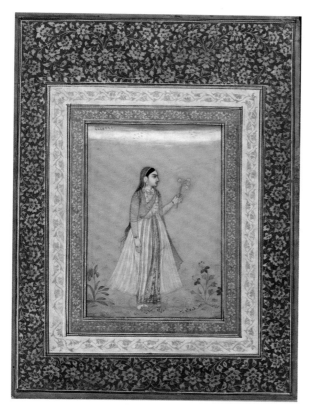

Court Lady with a Narcissus, a favourite subject during Shah Jahan's reign, India, c.1630, 8.6 x 20.7cm (page); 14.4 x 9.7cm (painting)

Marion and I on our wedding day in London, 29 October 1978

Carriage cushion cover with 72 hearts, woven circa 1800, 57 x 118 cm

A carriage cushion cover
depicting flowers, figures, and
birds, in multiple colours, woven
18th century, 50 x 94 cm

Bed cover depicting people, birds,
and horses, 1800-1860, 128 x 238 cm

Portrait Pendant of Shah Abbas II, Isfahan, Iran, third quarter of the 17th century, varnished miniature, set in a carved ivory case, 8 x 4.7cm

The Marie Louise almanac, by François-Renault Nitot, Paris, circa 1811, jewelled gold and painted enamel, 5.9 x 3.8 cm

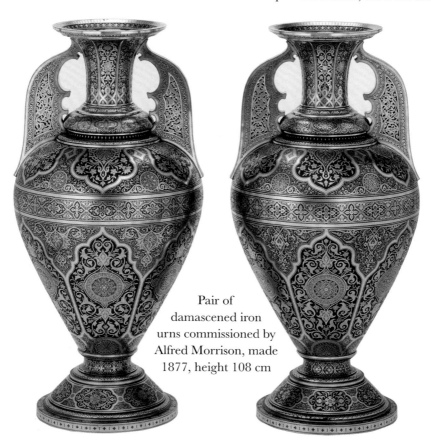

Pair of damascened iron urns commissioned by Alfred Morrison, made 1877, height 108 cm

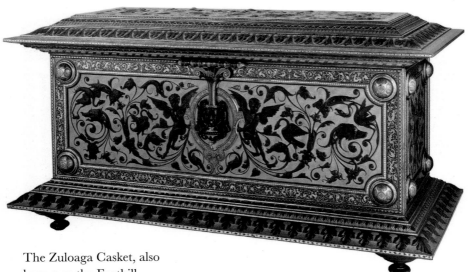

The Zuloaga Casket, also
known as the Fonthill
Casket, dated 1870-1871,
121 x 201 x 86 cm

During the opening of
*Metal Magic: Spanish Treasures
from the Khalili Collections*,
Auberge de Provence,
Valetta, Malta, 8 November
2011 - 29 April 2012, below
with Lawrence Gonzi, then
Prime Minister of Malta.

Document desk by Zuloaga, Spain, Eibar,
dated 1884-1885, 75.5 x 123.5 x 42.5 cm

The Ando Jubei screens, finally reunited in the Japanese Collection,
made 1900-1905, cloisonné enamel inserts, wood, ivory,
and cloisonné enamel mounts, 186 x 83 cm (each fold)

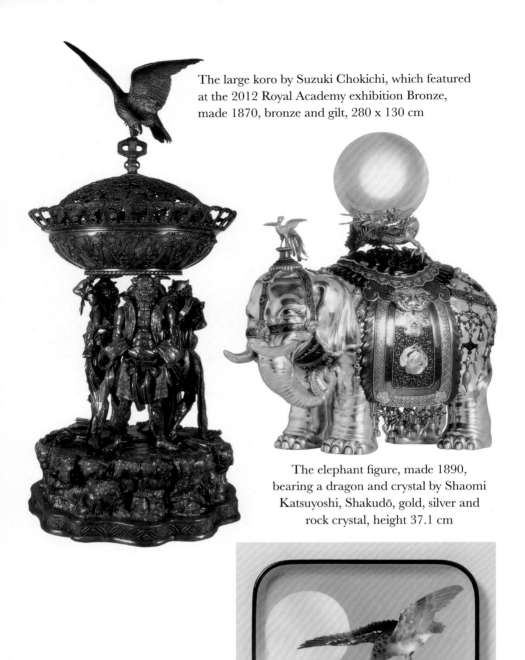

The large koro by Suzuki Chokichi, which featured at the 2012 Royal Academy exhibition Bronze, made 1870, bronze and gilt, 280 x 130 cm

The elephant figure, made 1890, bearing a dragon and crystal by Shaomi Katsuyoshi, Shakudō, gold, silver and rock crystal, height 37.1 cm

Tray with goose in flight, signed with the seal of Namikawa Sosuke, cloisonné enamel, silver wire, 1905-1910, 28.5 x 28.5 cm

allows them to pass it on to the rest of humanity and improve it. Ulti-mately, I feel very lucky to have married the love of my life, who is also my soulmate, my best friend, and the best mother to our children one could ask for. Our marriage and our family life are my ultimate strength, and I don't think it's an accident I have been so drawn to the bride's cushion cover with its 72 hearts and all those other textiles through which a lifetime's love and commitment are woven. The story of this textile, this monument to love, is one that is equally rich with discovery, love and excitement. The collections are another love of my life – my mistress, you could say. And my journey of discovery through them is a love story in its own right.

One afternoon in the early 1980s, a group of us had gathered in our research centre to discuss our Islamic carpets and textiles catalogue, needing to go over some pieces whose origin we found difficult to establish. Among these was an unusual and charming flat woven carpet, known as a kilim in most Middle Eastern and Central Asian countries. It had this joyful design – lilies set inside octagons, framed inside a border of lively zigzags, and all this done in the most vibrant colours. The geometric design made us think it might have a Caucasian origin, but we weren't sure. And was it seventeenth century . . . eighteenth? We had no idea. Even with all our combined expertise, it was difficult to tell.

Then my dealer friend Michael Franses, a real expert on classical carpets, mentioned that a New York dealer named Doris Leslie Blau was visiting London for a big sale, and suggested we try to get her perspective on it. Her gallery had dealt in classical carpets since 1965,

and she was a highly regarded connoisseur, once even dubbed 'the oracle of the rug world'.

'This is from Sweden,' Doris announced, after looking at the carpet for several minutes.

We had prepared a microscope and lighting for her so she could examine the piece more carefully, but she told us it wasn't necessary.

'I know what this is off the bat, and even though it might have been influenced by Islamic design, it is definitely not Islamic. It is a beautiful piece though, very skilfully woven, and I would say it was made in Sweden around 1800.'

I hadn't known that Doris collected Swedish textiles herself. She told us about their history, explaining that they were very often mis-identified because they tended to have characteristics that looked Islamic, probably due to the far-reaching influence of traders along the Silk Road, who carried Eastern trends across the Western frontiers. These Swedish textiles were in fact a perfect example of the type of exchange I was so obsessed with, when artistic traditions travel across borders, enriching and renewing local cultures.

'Does anyone have a major collection of these textiles?' I asked.

Doris answered that the only other major collection was based in Sweden and there was not much of an interest in them outside of the country. I asked how many Swedish textiles she owned. Over 20, she said. On the spot, I offered to buy all of them, even without examining them, because I trusted her expertise and taste. To my total delight and excitement, she agreed.

Over the next few decades, I worked relentlessly to get my hands on any important piece that helped us tell the tales of these miracu-

lous textiles. With the help of dealers such as Peter Willborg in Stockholm, Marino and Clara Dall'Oglio in Milan, and Clive Loveless in London, I managed to build one of the most comprehensive collections of Swedish textiles outside Sweden. I chose to focus on textiles from the province of Scania in southern Sweden, which is well known for its hand-weaving tradition, with many of the stunning objects in the collection dating from a golden period between the early eighteenth and nineteenth centuries. As well as rugs, these wonderful textiles also include carriage cushion covers used during wedding ceremonies or placed in the carriage for outings to the church or the market, long bench covers, which were used during feasts and sometimes as home decoration, and touching matrimonial bedspreads to brighten up bedrooms. Whatever their ultimate use, they were always made in the spirit of joy, celebration and love, and you can't believe how vivid they are – even after 250 years, they *glow*. On one of our eighteenth-century carriage cushions, a wonderfully chaotic flood of flowers, birds and people is portrayed in no fewer than 17 colours. It looks to me like the Garden of Eden recreated in threads.

Scania was an agricultural province, and most of the weavers were wives, daughters or maids. According to tradition, they learned to weave from a young age, and this skill was regarded as one of the best qualities a woman could have – not least because it meant she could make textiles for her own dowry chest. Jonas Frostensson Swanander, investigating the region in 1797 wrote, 'The goodness of a wife is measured by the number of beautiful bed-covers, cushions and carriage cushions that she makes.' I loved such artisanal traditions, and the idea of art being deeply embedded in everyday life – art that lives

with and alongside us, art that we pass on, like Marion's shawl with its Caspian Sea pearls.

The weavers of Scania lived in communities steeped in folklore and superstition. In a cultural survey of a local parish, Fru Alstad (Our Lady Alstad), taken by the Folklore Record Office of the Ethnological Institute in Lund, locals were quoted as saying:

'You could not warp on a Monday, as the weave would not turn out well. When you took down the weave you had to sweep, and no pregnant woman should walk over it, as the baby would then catch a serious disease … No husband should be in the room when the weave was taken down, if so he would not win anything . . .'

These folk traditions influenced the subject matter of the textiles, too. As well as decorating the textiles with reindeer, the Swedish weavers loved to show magical creatures such as unicorns and brook horses – scary figures from Swedish folklore, who would lure innocents onto their backs and then drown them. One of the most powerful pieces in the collection – an interlocked tapestry from 1791 – shows three supernatural horses, coloured in fiery reds: the wool seems ready to combust in front of you. As with most of the textiles in this collection, the weaver's identity is lost to history. Most of these textiles were not signed in any way; sometimes we're lucky just to have the odd letter to remind us of the identity of the artist. In the tapestry of the horses you can make out the letters MPD and HIS, but we don't know if these refer to the bride and groom, just as we don't know to whom

the initials STDR belong in a magical nineteenth-century bedcover with its design of six octagons, people gathered round horses and a magnificent tree, beneath birds, with their clothes done in such minute detail you feel the weaver's concentration as a kind of love; she used French knots for the coat buttons.

Bringing many of the finest Swedish textiles under one roof, and carefully restoring those in need of conservation, I'm proud of ensuring their safety for generations to come. The first time we exhibited them was in Malmö in 1996, and in the same year we published an extensive catalogue of the collection under the title *Swedish Textile Art: Traditional Marriage Weavings from Scania*. The book was written by Viveka Hansen, a highly respected expert on Scandinavian textiles.

In the years that followed, the collection continued to travel and has been displayed in the Swedish Cultural Centre in Paris and Boston University Art Galleries.

Why do these pieces move me so much? It's not just the creativity and technical skill of these many unknown weavers. It's the hours of solitary concentration as the threshold of marriage approaches, the promise of commitment, lives being woven together.

The Swedish textile collection is unique in it being almost entirely bound by the whispers of the heart. But tokens and pieces that chart love's tides exist throughout the collections: an almanac in the enamel collection bought by Marie Louise, second wife of Napoleon I, to commemorate the birth of their son, who sadly died at the age of 21 from tuberculosis, a tragic reminder of a bond between mother and son which she cherished; a wedding kimono delicately decorated with

cranes – symbols of longevity who mate for life – radiant with the wish for a prosperous marriage; Indian miniatures of youths in love, in couples or yearning for their soulmates; and perhaps the single piece – in my view – that captures love's essence more than anything: a small pendant containing the portrait of Shah Abbas II, who died in 1666, not even 35 years old. I found it on a market stall, 300 years later, and instantly knew what it was. When we followed up on the research I was proven right, and we concluded it was probably painted after his death by one of his court artists, no doubt to be treasured and held close by one of his beloved wives until the end of her days. This is a portrait of pure tenderness – done in (at the time) a declining style that Abbas loved, to be worn by somebody who did not want to be apart from him. There is no greater testimony to love to be found anywhere.

~ 6 ~

Damascene — An Interlude

One morning, back in those New York days in the early 1970s, I walked into the Madison Avenue auction rooms of Sotheby Parke-Bernet and chanced on an entirely new source of wonder. This was a sale of Islamic art, and among the pieces nestled a little group of tiny vases, jewellery, cigarette cases and pill boxes, all impeccably detailed, with wonderful gold and silver inlay. They were magical, but I honestly didn't know what to make of them. They didn't look Islamic, but some were decorated with Kufic script, which was often used in early Qur'ans. I stared at them a bit puzzled – imagine a big question mark hovering over my head. One object even had an Arabic inscription, *la ghaliba illa Allah*, which means 'Victory belongs to God'. This I did recognise – the motto of the Nasrids, the last Muslim dynasty to rule in Spain. Between 1238, when the Nasrids seized power in Granada, and the completion of the Reconquista of Isabella I of Castile in 1492, they brought their rich Moorish influence to the art and customs of southern Spain.

I'd seen plenty of incredible inlaid metalwork from Persia's Qajar period, but it didn't come close to the brilliance of the objects I was looking at now. I went to look for the head of the Islamic department, to try and ask him some questions discreetly. I tried to play it cool, I didn't want to seem too keen, but it was hard for me to keep my excitement bottled. These were Spanish works, the expert told me: some were made by Plácido Zuloaga, and others by artists in Toledo and Eibar. Feeling a familiar thrum of possibility, I asked if anyone had established a serious collection of this type of Spanish metalwork before. No, he said, not that he knew of. I was hearing in my mind's ear the far-off clanging of hammers in an atelier in Granada or Seville.

And then I went digging. Zuloaga was a leading figure of exceptional talent in nineteenth-century Spanish metalwork. I'd encountered the damascene style before – the inlaying of different metals into one another, usually against a dark oxidised steel background, resembling the better-known niello technique from Japanese and Islamic metalwork. But I had no idea of the virtuoso heights reached by Spanish artists. The damascener, in a method perfected by the Zuloaga family, would heat an iron object, cut lines into it, then lay down fine silver and gold wires on the cut surface, using all sorts of manual punches. Other stages of the process included shading (*sombreado*), where fine details could be added, and beading (*perleado*), where a border could be incorporated, featuring small 'beads' made from winding fine silver wire, and the end results were intricate and magnificent.

Over the next decades, just as I was doing with enamels, I sought out as many of best pieces of Spanish damascene metalwork I could find. The collection eventually grew to include 130 objects, over 40 of

them signed by Plácido Zuloaga. As usual, I operated discreetly. No single dealer at the time specialised in nineteenth-century Spanish metalwork, so I pulled the collection together from all over the world, bit by bit, piecing together the story of these masters and their milieu. The Zuloagas came from Eibar, a city in the Basque Country of northern Spain, renowned over centuries for its arms and other types of metalwork. At least 11 members of the family became professional artists. Some worked in ceramics; others made exquisitely crafted weapons for the Royal Armoury; one – Plácido's son, Ignacio – studied in Paris alongside Gauguin and Toulouse-Lautrec and became an internationally recognised painter.

Plácido's grandfather was chief royal armourer, but his father Eusebio Zuloaga (1808–98) was his greatest influence. Aged 14, Eusebio had studied gun-making for five years with an uncle who happened to be armourer to the Royal Bodyguards; then in Paris he was apprenticed to a gunsmith to the king of France; he finished his studies in Liège – at the time, France and Belgium were enjoying a revival of interest in damascene, often used to decorate luxury firearms. On his return home, Eusebio set up a workshop in Madrid and was named honorary gunmaker to Queen Isabella II of Spain. In 1847, he became lieutenant armourer, overseeing the restoration of a priceless collection of Renaissance arms and armour in Madrid's Palace Armoury. This proved an invaluable education, as, following the makers' traditional techniques, Eusebio mastered the art of damascening. Back in Eibar, he set up a gun-making factory, which led the revival of damascene in Spain. He also earned an international reputation, winning medals at events such as the 1851 Great Exhibition in London.

Plácido couldn't have asked for a better teacher. As a teenager, he apprenticed at his father's arms factory, and before long he'd stepped out of the older man's shadow, winning numerous gold and silver medals at international expositions, and honours such as Knight Commander of the Order of Isabel the Catholic, Knight of the Order of Charles III, Officer of the French Legion of Honour, and Knight of the Portuguese Order of St James. Meanwhile, he transformed Eibar into the centre of European damascene.

By the early 1850s, still in his teens, Plácido was already making incredible pieces, including pistols, swords, daggers and shields. In 1859, aged 25, he took over the Eibar factory, shifting its focus to creating damascened art objects rather than arms. As with Lalique, this bold change of direction compels my admiration. He didn't settle. He stepped into the unknown, the new. And Plácido's skills were so unusual that he continued to attract the best of clients. He made a damascened writing stand for Queen Isabella II in 1859 and a table clock for Napoleon III of France in 1865. He also created a damascened inkstand that was given as a wedding gift to the English socialite Evelina de Rothschild.

Then history barged in: a military rebellion overthrew Queen Isabella in 1868; Eusebio lost his position in the royal household; the Eibar factory nearly collapsed as the Zuloagas lost one of their most important customers. Quick on his feet, Plácido appealed to Lord Alfred Morrison, an English collector he'd met a few years before at the 1862 International Exhibition in London. Alfred was heir to the fortune accumulated by his father James Morrison, model of the nineteenth-century self-made man, amassing vast sums from textiles, banking and

more, while involved in politics and the arts, counting Charles Dickens among his close friends. Alfred, too, was well known for his love of the arts and for commissioning work from Europe's finest artist-artisans. A few days after Isabella escaped to Paris, Plácido wrote to him, saying that he would 'do all that is possible' for Morrison, and that he would be lost without him. 'The only hope that I have of working with beautiful things is from you and your wife,' he declared.

This passionate appeal struck the heart. Over the next 20 years, Morrison commissioned and bought some of Plácido's finest pieces. In 1879, a critic from the *Magazine of Art* visited Morrison's London home for a series of articles called 'Treasure Houses of Art' and was 'amazed' by the 'extraordinary feats' of metalwork by Zuloaga, whom he called 'a king of his art'. One of the most striking pieces on display was a pair of stately urns, each over a metre high, which stood in Morrison's dining room. Made in Eibar and signed by Plácido in 1877, the forged iron urns were decorated with a complex web of gold and silver damascene, using patterns inspired by the artistic legacy of the Nasrids. They are now among the most cherished treasures in our collection.

Morrison's house was filled with many other marvels by Plácido, including a damascene iron table worked in gold and silver, which Queen Elizabeth the Queen Mother bought on the eve of the Second World War and is now in Buckingham Palace. The *Magazine of Art* was especially excited by Zuloaga's chests and caskets, the largest an 'extraordinary chest' that occupied 'a central point' in Morrison's 'opalescent drawing-room at Carlton House Terrace'. This vast iron casket, made in Eibar in 1870 and 1871, is over 2 metres long and 1.2 metres high and weighs over a ton. It's both monstrous and divine, extravagant and calm, loud as a

rock concert and quiet as a whisper, lavishly decorated in a seventeenth-century baroque style, with winged infants, vegetation and animal grotesques on a background of gold leaf. Mae West was right: sometimes too much of a good thing can be *wonderful*.

The casket was the first piece Morrison commissioned from Plácido, and its tour-de-force magnificence was no doubt meant to win Alfred's continuing patronage. Plácido would have had to put together a large team of craftsmen including forgers, filers, chisellers, damasceners and engravers, and then supervise every single one of them as the piece came together, paying close attention to the last detail, both choreographer and dancer. Commonly known as the 'Fonthill Casket', it may have been moved at some stage to Fonthill Manor, the country estate Alfred had inherited from his father. And from there it came to me.

In the mid-1980s I received a surprise call from the arms and armour expert Howard Ricketts, who'd sold me many pieces for the Islamic collection and quite a few of Zuloaga's daggers. I still remember exactly how Howard opened the conversation.

'David, the possibility of buying the *mother* of all Zuloagas has arrived,' he said.

My ears pricked up like a hunting dog's. Howard had been given a mandate to find a serious buyer for the Zuloaga casket, which was still in residence at Fonthill, and now he was offering it to me. It was a once-in-a-lifetime opportunity, but the amount he quoted over the phone was mad, even by the standards of the 1980s. To put it into context, if I were to invest that amount into central London real estate – which I was actually doing at the time to expand my portfolio – it would have given me

returns of about ten times or more. But then again, the casket was a masterpiece, a one-off, a singular astonishment, and a central piece in a jigsaw I had committed to putting together.

I bought it for the full price.

In the early days, there were many exciting stories. At an auction sale in Monte Carlo, I was bidding for two extraordinary Zuloaga pieces: a mesmerising bronze and blue enamel casket, different from anything I'd seen of Plácido's; and a beautiful mirror frame, wood adorned with silver and gold, a marriage of woodwork and metalwork so harmonious it was as if one had dissolved into the other. The price of both objects went through the roof, as one other bidder stayed with me, each of us apparently determined to secure the prize, until finally my competitor gave way, the hammer slammed down, and I could breathe again. When my heart had stopped racing, I spoke to the man who'd been bidding against me. He was representing Grace Kelly, Princess of Monaco.

Over the years, I continued to add a wide variety of Zuloaga's extraordinary damascened pieces to the collection: an elegant writing desk made of iron, wood and gold damascene; a charger made of iron, silver and gold; several small iron caskets; a shrine with a silver figure of the Virgin and Child; a fantastic pair of pocket pistols, the only known firearms to bear Plácido's signature.

On one occasion, a contact called me about an object in a Sotheby's sale catalogued as an 'enamel casket' without any attribution. Because of this, the price was incredibly reasonable. I asked him to take as many photos of the object as he could and send them as soon

as possible. It was a Plácido, no question – the kind of piece known in the art world as a sleeper, slipping under the radar, unnoticed. My favourite. My only fear was that dealers trying to get Zuloaga pieces for me might bid against me and drive up the cost, not knowing I'd found the piece myself and was making my move. I called around a few dealers to test the waters, asking if anyone was aware of good-quality Spanish damascene pieces being offered for sale soon. Nobody said anything and so, quietly, confidently, I went in and bought it without fanfare – a document desk by Plácido Zuloaga, an absolute marvel. That's the art of collecting: keep your ear to the ground and know what's about. That's the key.

On 29 May 1997, *Plácido Zuloaga: Spanish Treasures from the Khalili Collection* opened at the Victoria and Albert Museum in London, featuring around 80 of our pieces, including 30 works by Plácido – the first major exhibition of Spanish damascene metalwork in living memory. To my delight, the collection toured Spain in 2000 and 2001, displayed in Bilbao, Toledo and the Alhambra Palace in Granada. As I walked through the halls of these exhibitions it wasn't just the beauty of the objects or their extraordinary craftsmanship that moved me. As always, it was the story – in this case, the story of the Zuloaga family, that special gift and vocation passed down the generations. My father used to tell me that a family is like a chain – that we're all linked, and that the happiness and sadness of one is the happiness and sadness of all. I am lucky enough to have found that in my family too. I have never felt alone.

~ 7 ~
Japan

So many people have asked me the same question.

'But David, *why*?'

Why hunt, acquire, own, research, restore, display? Why *collect*? I don't know if I can answer this. Of course, there's the memory of my father, all those visits we made together to galleries, museums and private houses in Tehran and beyond, the love for and curiosity about works of art and the stories that trailed behind them. Even then, there was the excitement of not knowing what you might find in the next room or cabinet, the possibility of some undiscovered treasure going beneath notice round the next corner. And later I would feel the adrenalin of pursuit, tracking a piece from artist to patron to collector, and being there to meet it when it emerged into the public space of gallery or saleroom. There was the sheer pleasure I took in close-up encounters with these objects, the technical virtuosity of the great makers and the force of personal expression that could drive through metal, wood, silk, wool, glass and clay. There was the sense of

camaraderie among collectors, art historians, researchers, dealers and collectors. And I suppose I have wanted to convey something about my view of the world – that there is something in us that transcends the demarcations of borders and centuries, and that art is a universal value.

I got going in New York in my early twenties. Quickly I found I had a gift for making money through buying and selling, and it wasn't a big leap for me to apply that talent to other kinds of investment, especially property. Even as a teenager, researching and writing those hundreds of short biographical portraits, I'd had a voracious hunger for knowledge, and serious determination. Those energies have powered me through half a century of collecting. I've always been looking for the unexplored territory, those areas of art history that seem to me insufficiently noticed beyond their local centres – such as enamellers, or Swedish textiles, or damascene metalwork. My operating method has been to identify such areas and then try to shine a light on them. This has called for a combination of endless curiosity, an independent mind, a wideness and elasticity of knowledge, and deep trust in my own eyes, ears and mind.

As a student in New York in the early 1970s, I'd bought several pieces of Japanese earthenware produced during the Meiji era (1868–1912) and was overwhelmed by the quality of the artisanship, the technical skill, the almost microscopic attention to detail. Strangely, there was something deeply familiar about the art that emerged from this pocket of time: the poetry, the devotion to the natural world, the close observation, even the humour – all these I recognised from the Persian art

I grew up with. The finest potters are alchemists who transform the four base elements – water, earth, wind, fire – into the sublime, and to my eye these Japanese artists excelled above all others. But still, comparing one to the other made me re-evaluate everything I knew about art. And this was the case in every medium – lacquer, textiles, enamels, metalwork – whatever it was, the Japanese Meiji masters seemed to have done it better than anyone else.

In brief: during the Edo period (1603–1867), Japan had largely cut itself off from the outside world. Fearing instability and foreign conquest, the nation's shogunate (high-ranking military leaders and landowners, who ruled Japan from the eleventh century to the late nineteenth century) heavily restricted international trade, expelled many foreigners, and banned Japanese citizens from travelling abroad. Things changed in 1854, when the US Navy Commodore Matthew Perry arrived in Japan and opened it up to trade with the West under the Treaty of Peace and Amity. Just over a decade later, in the spring of 1867, a 15-year-old boy named Mutsuhito was crowned emperor.

To this point, the imperial family and nobility had been considered for the most part as symbolic figureheads, with little political power. Now the shogun government was overthrown, imperial rule was restored and the Meiji ('enlightened period') era began. The newly formed Meiji government did its best to create a 'new Japan': forward-thinking and open.

Art and culture became powerful tools in this mission. As Japan came out of isolation and made itself known to the world, art became a symbol of national pride, and an instrument of political and social capital. Funding for the arts surged as the Meiji government pushed

for the nation to shine at international exhibitions, such as those at Vienna in 1873, Paris in 1889 and Chicago in 1893. In 1876 the Japanese government committed $600,000 to their pavilion for the Centennial Exposition in Philadelphia, the largest sum of money of any of the 30 nations taking part. This was a smart move, as these events were unrivalled showcases – the Paris Exposition Universelle alone drew 32 million visitors.

Encouraged by this explosion in government funding and imperial patronage, Meiji artists experimented like mad, refined their skills, and raised Japanese art to ever higher levels of perfection. During the coming decades, Japanese art became an international sensation, this 'Japan fever' reaching its peak in the 1870s and 1880s, with European and American art lovers paying huge sums for the finest Meiji pieces, as Japanese artists responded ingeniously to the Western hunger for their technical wizardry and unfamiliar subjects such as dragons, sea gods and demon hunters. By one estimate, Japan's decorative artworks were so popular that they accounted for 10 per cent of the nation's exports from the late 1870s to the early 1890s.

By the time I started collecting Meiji pieces in the 1970s, the art of this period had fallen out of fashion. That didn't put me off. On the contrary, it spurred me on. As always, I plunged into research, reading everything I could find about Meiji artists and history. And I looked out for any exceptional Meiji piece that came to market, greatly assisted by specialists such as Barry Davies, Malcolm Fairley and Tsumugi Shoji – not only exceptionally knowledgeable but just as passionate about Meiji art as I was. Slowly the collection took shape: a pair of bronze samurai figures, so lifelike you could hear the stomping of

hooves and the clanging of swords when you looked at them, bought after they narrowly escaped from me by a wealthy Japanese business-man who wanted them for the entrance of a golf club – I had kept my eyes on them and after he passed away they were put up for sale again, and I was able to reunite with them. A pair of enamel screens, which I brought together after they were separated over 80 years previously – a process which in itself involved diligent research of around 15 years – designed by the renowned Shin Shinwoda, known as Shioda, and made by the imperial court artist Ando Jubei for the Liège Universal and International Exhibition of 1905. A cypress cabinet covered in gold lacquer, with phoenixes, peonies, lions and waterfalls showing in relief, formally presented as a gift in 1921 by Japan's Crown Prince Hirohito to the Prince of Wales, later King Edward VIII – led by Harui Komin, it had taken ten men more than seven years to finish this cabinet of wonder.

Often you can sense the hum of workshops and ateliers, but par-ticular talents such as Shioda and Komin keep standing out. I'm thinking of Shibata Zeshin, the sublime lacquerer of nineteenth-century Japan, the ceramicist Miyagawa Kōzan, enamel masters Namikawa Sōsuke and Namikawa Yasuyuki, and bronze-casters such as Suzuki Chokichi, who made an immense bronze koro, or incense burner, that towers over most other pieces in the collection. Made in 1880, almost 3 metres tall, the koro's held up by a trio of crouching demons and topped by an eagle: it's said that Chokichi lived with an eagle for three years so he could observe the movements and character of the bird at close range before attempting to capture them in bronze. We traced the koro back to a German museum that was bombed in

the Second World War: lacking funds, the museum paid for the refurbishment with the koro instead of cash; the builder's son later sold it to Japanese dealer Barry Davies, who sold it to me. Story after story after story.

Sometimes I can hardly believe the way metalworkers can take a material such as bronze, which you might associate with hardness and solidity, and shape it to conjure wind or waves, all kinds of flow and motion. We have this bronze group piece by another master, Otake Norikuni, in which a fabled warrior in Japanese mythology called Susanoo receives a sacred jewel from the god Ame-no-akarutama, posed with his attendant on a rock busy with sea creatures, wind and waves crashing all around them. Susanoo had been in competition with his sister, the sun goddess Amaterasu; the god was giving him the jewel to aid him in the contest. But the story is secondary to the force of detail – the seaweed, fish and scales all over Ame-no-akarutama's robe and helmet that link him to the sea; the vividness of Susanoo's clothing, expression and hair; the wind that blows through and across the whole scene, making the clothes and the ritual banners called *gohei* ripple and fly.

Bronze-casters such as Chokichi and Norikuni had to be smart businessmen as well as artists to thrive in an era of such social and economic change. In 1868, the Meiji government issued the 'kami-Buddha separation order' to differentiate Shinto from Buddhism, followed by a series of policies designed to downgrade Buddhism and lift Shinto into a position close to a state religion. This prompted the so-called *haibutsu kishaku* – the persecution of Buddhists and the destruction of Buddhist property on a large scale, including the

melting down of items such as bronze bells and cauldrons. I find all such examples of religious persecution incredibly sad, but I'm struck by the pragmatism of the bronze-casters, who'd been dependent on Buddhist temples for their trade and now had to switch to commercial and imperial commissions instead, ending up creating these astonishing decorative pieces.

In fact, it's a great example of what the Austrian economist Joseph Schumpeter called 'creative destruction' – a surge of adaptation and growth following unanticipated loss. Similarly, when in 1876 the Meiji government abolished the right of Japan's 2 million samurai to wear swords, metalworkers who specialised in making sword fittings had no choice but to reinvent themselves. Once again, many survived by turning to decorative art for export and private commissions, and the collection includes many examples of works by former sword-fitters. One of my favourite pieces of all is a figure of an elephant created around 1890 by former sword-fitter Shoami Katsuyoshi. The elephant carries a small dragon on its back; the dragon, in turn, carries a flawless crystal ball: the essence of Buddha's teachings.

European and American buyers loved all things Meiji in the late nineteenth century, but they were particularly charmed by the ceramics known as 'Satsuma' ware, which became hugely popular after the 1867 Paris Exposition. I fell under their spell, too, and they were some of the first objects I bought in those early New York days. These delicate enamelled and gilded earthenware objects show just the kind of superb craftsmanship that makes Meiji art so special. They're distinc-

tive in their warm autumnal colours: gold, orange-red, creamy white, delicate browns.

The greatest Satsuma pieces came from the Osaka workshop of Yabu Meizan. Born in 1853, he opened his workshop when he was 27 and became a successful artist and businessman. There's a brilliant account by the American collector Charles Parsons, who visited Meizan's workshop in 1894. 'He had 17 men and boys at work, all decorating,' Parsons wrote.

'He makes the designs and watches them carefully in executing the work. Some are very wonderful workers. All is order, neatness and silence, no words spoken.'

Perhaps I'm imagining it, but it's almost as if that silence and order has solidified into these earthenware objects. One of my personal favourites is a painted and gilded rectangular vase, with landscapes showing farmers at work against hazy but precisely rendered mountains. It's characteristic of Meizan in its celebration of nature and everyday life in Japan, and when I look at it, I feel transported to a hill nearby, watching the scene in the golden twilight, hearing the breeze rustling through the grass, the murmur of flowing water. It's magical; I lose myself when I look at it.

You can see the same extraordinary attention to detail in Meiji enamels, among the most prestigious items produced at the time, and a source of immense national pride. In the catalogue for our major exhibition in the US, *Splendors of Imperial Japan*, Joe Earle, former keeper of the Far Eastern Department at the V&A, wrote that

'by the 1880s Japanese enamels were already one of the wonders of the world, and during the first decade of the twentieth century they outstripped anything that had been achieved before in the medium.'

In most countries, enamellers would usually use three to five layers of enamel for each colour: in Japan they used up to 40 layers, returning the object to the kiln time and time again, working with near-infinite patience. I can't help believing that this level of dedication can ultimately be felt in the objects themselves, and I'm reminded of a line from Rumi: 'The beauty of careful sewing on a shirt is the patience it contains.'

The best-known masters are probably Namikawa Yasuyuki, Namikawa Sōsuke and Ando Jubei, who produced some of the most sublime enamels ever seen. I could give so many examples. But instinctively, I can think of two pieces that represent their skills perfectly. One is a delicate and stunning tray Sōsuke created around 1905–10, which used *musen* enamels to show a goose flying through the night sky. *Musen* was a Japanese technique through which colours could appear next to each other smoothly, without interruption or borders – often referred to as a 'wireless' technique. And here Sōsuke's virtuosity transforms the weight and hardness of glass into the weightlessness of mist at night, the goose gliding through it against the full moon. The rich yellow-browns of the beak and plumage sing out of the pale grey and white of the sky and mist. It is pure enchantment. The other is a *musen* panel made by Ando Jubei and exhibited at the World's Columbian Exposition in Chicago in 1893, showing the snowy peak of Mount Fuji through clouds, like a rendering of the famous haiku by Bashō:

In the misty rain
Mount Fuji is veiled all day –
how intriguing!

Japanese Meiji pieces of the highest quality are now exceptionally rare, sadly, but still I try my best to find them, trace their histories and give them a place of honour in the collection. If a piece seems to be flying too solo, as it were, I try to find out if something is missing, and then, if possible, bring the lost brothers and sisters back together. This is done by a combination of instinct and research, which dedicated collectors develop over time. One of my proudest moments in this vein was when we were able to find a missing enamel vase, part of a massive and legendary garniture, which I'd been tracking for decades. And that was one hell of a story.

The garniture had last been seen in its complete original form over 120 years ago, at the World's Columbian Exposition in Chicago, which attracted 27 million visitors – at the time close to half of the American population. Over 2 metres tall, the garniture consisted of two immense vases flanking a centrepiece. The work had been commissioned by Shin Shinwoda, the special councillor for arts of the Imperial Commission to the Exposition, with the responsibility for making it given to Shirozayemon Suzuki of Yokohama and Seizayemon Tsunekawa of Nagoya. The greatest artisans of the period were engaged – it was a collaboration like no other, an all-star team of the most celebrated artists of the day including Araki Kampo (1831–1915) and Oda Kyōsai (1845–1912) overseeing the designs. Nowadays, books and books are dedicated to each one of them. The three components

took five years to make, and when they were completed, the emperor reviewed them ahead of the exposition. They were to be placed at the very entrance to the Japanese pavilion, to make a lasting impression on anyone who visited. That impression must have been unforgettable indeed: here was 'the largest examples of cloisonné enamel ever made' – three vases decorated in sequence with a dragon, the sun and chickens, and eagles, not just to represent the values of wisdom, honesty and strength respectively but also to stand for different nations. So the dragon represented China; the sun and chickens represented Japan and Korea; the eagles represented Russia. A separate bronze eagle mounted on the central vase represented the US. Meanwhile, the chrysanthemum handles represented the Japanese imperial family, and the American stars and stripes touched the handles to indicate the special relationship between the countries.

Somehow, after the expo the three pieces were dispersed. I found the first vase in the early 1990s in Los Angeles, where I became aware of their incredible story. I have an appetite for a quest, and few stories were as likely to move me to action as this one. Over the course of the next three decades, I looked everywhere, determined to put the garniture together again. The centrepiece eventually surfaced in Japan in early 2000, after years on loan at the Tokyo National Museum. When the loan expired, the owners decided to sell: I got up at 4am to bid for it at auction. The location of the last vase remained a mystery for nearly 20 years until finally it came to light in the most unlikely of settings: Spenger's Fish Grotto restaurant in Berkeley, California. It had sat there for years, like a celebrity in hiding. Apparently, the vase had been bought in Chicago and brought to the California Midwinter

International Exposition of 1894, where it was bought by Frank Spenger Sr, the son of the restaurant's founder. The Spenger family put it to auction in 2019, I made my move and, after 120 years apart (and nearly 30 years of my own quest), the three parts of this extraordinary work were together again.

As I've said, one of the things that drive me as a collector is a sense of mission – to bring these particular fields of human creativity and virtuosity to wider view, whether through exhibitions or through the commissioning of research and publications. Calouste Gulbenkian talked about the artworks in his collection as his 'children' – he wanted to hold them close, barely letting them out of his sight. But I feel differently. I feel more like an evangelist, my own enthusiasm so giddy I can't help but share it – I want to celebrate these works with other people, and look after them on behalf of other people, whether now or in the years to come. This can be ascribed to my temperament and personality, but as is often the case, it's also probably because of my childhood – I always want to bring all the geniuses together, see how they interact and influence each other. I walk the earth and observe the connections we share across borders and continents, just as, when I was little, I observed my home, my parents, my friends, art and historic relics of the past. And I can feel that zest coursing through me as I describe one object or another, giving these quick tours of collections I have spent half a century putting together. Sometimes I find myself wanting to apologise or ask forgiveness, knowing how excited I become, still the boy with Dr Mehran's pen box, wanting to tell everyone about it, wanting everyone to see how beautiful it is.

Still, without apology, there's one more aspect of the Meiji I must mention. Alongside metalwork, ceramics, lacquer and enamels, Meiji artists excelled in the production of decorative textiles. I've already sung about the glories of the Swedish textile tradition, and haven't even got to the Islamic ones, but the Japanese were in a league of their own. And it's true that from an early age I was drawn to cloths and tapestries – even the idea of weaving itself, the way it comes into everyday language when we speak of weaving spells or dreams, themes or patterns weaving through stories. I loved the ritual aspect of weaving and understood its importance in religious art and history. The Meiji textile producers, centred mainly on Kyoto, showed the same technical virtuosity and artistic flair of their metalworking and ceramicist contemporaries: their resist-dyed silks and velvets, their tapestries and appliqué work captured the imagination both domestically and at the international fairs, mesmerising not just collectors but also other artists across Europe and the Americas.

And what a journey of discovery that was – learning, for example, about the *oshi-e* technique, unique to Japan, a way of using paper or silk wadding covered with dyed and painted fabric then pasted onto a background of silk or paper to create rich relief designs, a subtle and intricate practice that required great patience and skill. Among over 400 textile works in our Meiji collection there's one *oshi-e* I particularly love. Here is a scene of farming in a village – nothing special, you might think, but there's something both joyful and meditative about it: the patience and attention invested in each character and element seem to charge the whole scene with its own force of gravity, as if the days of slow, quiet work have somehow woven themselves into the material.

Like *ikebana*, tea ceremonies and embroidery, *oshi-e* was regarded as a 'feminine' pursuit and there has been surprisingly little research published on it, yet it is exactly the kind of intimate, everyday art I love to highlight. One of its loveliest aspects is the astounding attention to detail – characters in *oshi-e* often wear garments such as kimono, printed with patterns reflecting real-life examples. Due to the miniature, however, these must have been pieces of cloth made or painted especially for the purpose, with miniature versions of patterns seen on their regular-sized companions. It can't help but make you smile and laugh in admiration.

Then there's the better-known *yūzen* technique – a refined and complex process which produces textiles that look like the most delicate paintings. I was used to seeing amazing feats of embroidery, where rich landscapes emerge from visibly interwoven threads. But *yūzen* is different. Used in decorating kimonos as well as panels, it involved the so-called 'resist dyeing' method that used rice paste to prevent colour reaching certain parts of the handmade, hand-cut silk velvet. While these *yūzen* pieces look like scenes painted on canvas, they're in fact produced through myriad fine stages, achieving a subtlety of tone impossible by any modern-day means, and often mistaken for painting. One example blew my mind when I first saw it – a large textile with a stunning view of Mount Fuji, presented in all its glory rising behind a serene lake shaded by trees. One can feel that any moment now the wind will blow leaves across it and ripple the placid waters of the lake. Usually, these textiles weren't signed, but this particular piece is firmly attributed to the Takashimaya workshop, one of

Pair of samurai figures by The Miyao Company, circa 1890, bronze, thick gilding, silver and Shakudō (gold and copper alloy), height 223 and 226 cm (overall), 99 and 104 cm (figures)

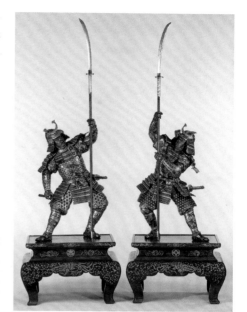

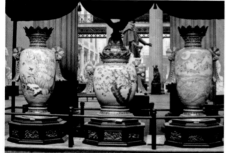

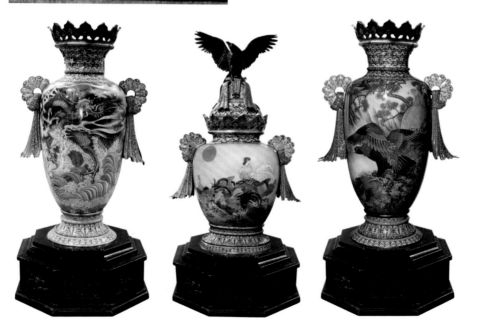

Japanese garniture, shown at the Chicago international exhibition of 1893 (top), and reunited in our Japanese Collection, showing the reverse decorations (bottom). cloisonné enamel, bronze, silver wires, wooden stands. Approx. 215 cm tall inc. bases.

Bronze mythical
group, made 1881
by Otake Norikuni,
bronze and rock
crystal, 99 x 80 cm

A vase by Yabu Meizan,
made 1890, earthenware
and gilt, height 37cm

A large Yūzen (resist-dyed) silk and cut velvet panel showing Mount Fuji, attributed to Takashimaya, circa 1900, 168 x 132 cm

A panel of oshi-e (padded silk) textile (one of four) showing rice cultivation, signed Sekka and with a red seal, late 19th century, 50cm x 83cm

Embroidered silk panel depicting a waterfall, with the original label of Nishimura Sozaemon of Kyoto, circa 1900, 76 x 51.5

Tapestry, with silk and metallic thread, Kawashima Jinbei II for the Kawashima Textile Company, circa 1908, 230 x 362 cm

Ando Jubei, cloisonné vase with plum blossoms, Nagoya, circa 1900, 43 cm height (above), which is surprisingly similar to Van Gogh's 1890 work *Almond Blossom*

With His Majesty King Charles III at the opening of Treasures of Imperial Japan at the National Museum of Wales, 1994

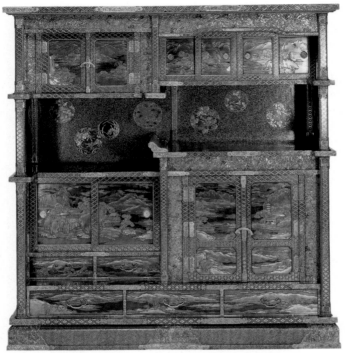

The Harui Komin
lacquer cabinet,
circa 1904-1911,
wood and lacquer in
various techniques,
110 x 51.5 x 103 cm

Pages of original
handpainted
patterns, part of the
Kimono collection,
circa 1900

Silk outer kimono for a woman with scenes from the Ise Monogatari, late Edo period, 165 x 124.5 cm

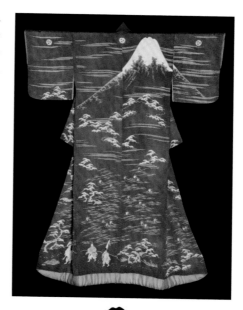

Silk Juban for a man showing cabaret dancers, Taishō – early Shōwa, 1920s-early 1930s, 130 x 130 cm

Silk outer kimono for a young girl with cranes, turtles, pine, bamboo and plum, late Edo period, 151 x 128 cm

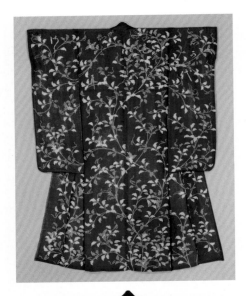

An elegant silk summer kimono, with hidden characters from the Kimigayo, late Edo period, 161 x 123.5 cm

Cotton Fireman's Hanten, depicting a hot air balloon, Shōwa period, 97 x 120 cm

Silk kimono for a young girl with falcons on a stand, Meiji period, 155 x 123 cm

the most celebrated makers of textiles during the nineteenth century. It was established in Kyoto in 1831 by Iida Shinshichi I (1803–74), considered a true master of the form. Takashimaya was very successful at national exhibitions held in Kyoto and Tokyo, eventually becoming a supplier to the Imperial Household Agency, and winning medals at the 1888 Barcelona Universal Exposition, the 1889 Paris Exposition Universelle and the Chicago World's Columbian Exposition in 1893. *Yūzen* really was taking the art world by storm: textile scholar Hiroko T. McDermott tells the story that the celebrated actress Sarah Bernhardt was so taken by a *yūzen* textile made by Iida's workshop at the 1900 Paris International Exposition that she took it home without paying, just to see how it looked on her wall.

Meiji artists brought their characteristic distinction to silk embroidery too. We have a dream-like panel made by the Nishimura Sozaemon company, another giant who made works for the imperial household. This family company was established in the sixteenth century, and its descendants are still trading today. Sozaemon produced stunning embroideries and *yūzen* pieces and developed new techniques, such as the dyeing of threads containing copper wires. At the 1889 Paris Exposition Universelle, his firm won an astonishing number of awards: 18 grands prix and 33 gold medals. Unsold pieces were then brought straight back to the Tokyo National Museum – such was the esteem in which the Japanese held their best textile makers. Our embroidered panel shows a waterfall, so lifelike I feel I'm hearing the splash of water. I remember the question posed by Polish-French painter Balthus: 'Time mastered: isn't that perhaps the best definition

for art?' Works such as this Sozaemon panel make me feel the truth of his perception, because the waterfall seems both captured in a single instant and yet falling continuously, without end.

Far from being rivals, the textile manufacturers of Kyoto worked closely together, and in fact the daughter of Iida Shinshichi III (1852–1909), Taka, was married to the adopted son of Nishimura Sozaemon XII (1855–1935). I love the closeness of these artists working together, like one great family.

There was a third major company in the Kyoto textile scene of the late nineteenth century, forming a trio of artisan families whom artists and academics alike admire to this day. That was the Kawashima company, led by Kawashima Jinbei II (1853–1910), who travelled to Europe in 1882 and studied European textiles in depth, then brought his new knowledge back to Japan where he developed his techniques, creating marvellous textiles for the imperial household, and in fact becoming the second person to be named an 'Imperial Court Artist' under Meiji in 1898, receiving the lifelong pension that goes with the title. We have an extraordinary, rare piece by Kawashima Jinbei II, a massive tapestry showing peacocks and trees in bloom, an alternate version of one of the panels in a set commissioned by the Japanese government for The Hague Peace Palace, which opened in the Netherlands in 1913, a year after the end of the Meiji period, and which to this day houses the Permanent Court of Arbitration, the United Nations International Court of Justice and The Hague Academy of International Law. During the Second Hague Peace Conference of 1907, it was decided that each country represented at the conference would contribute materials and pieces for the building of the Peace

Palace, which was then under construction. The Japanese offered nine vast textiles, made using a technique called *tsuzure-nishiki* ('polychrome tapestry'), which involved the delicate weaving of silk with other threads, in this case gold and silver. As The Hague website puts it

'This technique is one of the most refined, complex and rare weaving techniques in the world. For nearly five years in a row, 48,600 people worked day and night to produce this magnificent work of art.'

The influence of all these Meiji magicians on the art of the West cannot be overstated, and sometimes I feel the urge to shout about it from the rooftops. One of the most memorable of our exhibitions of Meiji art was at the Van Gogh Museum in Amsterdam in 2006. It featured more than 200 of our Meiji pieces alongside works by Van Gogh, who was deeply inspired by this exquisite art as it became better known during the nineteenth century in Europe. Van Gogh's love of Japanese art was expressed by him in many letters to his brother Theo, as in this one from 1888:

'Isn't it almost a true religion which these simple Japanese teach us, who live in nature as though they themselves were flowers? And you cannot study Japanese art, it seems to me, without becoming much happier and more cheerful.'

And in another: 'All my work is based to some extent on Japanese art'. He showed his love for Japanese objects directly, by painting a Japanese

enamel flower vase gifted to his mother by Theo, and you only have to look at his painting *Almond Blossom* next to an Ando Jubei cloisonné vase decorated with plum blossoms to see the kinship and correspondence, as if the two artists are waving to each other across the west–east hemispheres.

This was a period when the craze I previously mentioned for Japanese style – usually referred to as *Japonisme* – was sweeping the West. Van Gogh often visited a shop belonging to Siegfried Bing, the most prominent and influential Paris-based dealer in Japanese art of the Meiji era, later describing the treasures he saw there in letters to his brother. It's clear how these masterpieces of metalwork, porcelain, lacquer and enamel – nature and myth coming alive in vivid colours and shapes – captured his imagination. And not just Van Gogh – the imagery, decorative themes and artistic styles we see on Japanese Meiji objects are also apparent in the work of other celebrated modern painters such as Whistler, Degas, Manet, Toulouse-Lautrec, Schiele and Klimt.

Somehow I feel that the inspirational relationship Van Gogh and other European artists had with Japanese objects such as vases and screens and lacquerware seems to this day to be a neglected subject, with attention usually given to the inspiration of woodblock prints. Here again, I feel a sense of mission as a collector, and currently I am working towards future exhibitions and publications that will elaborate and celebrate this extraordinarily rich artistic dialogue still further.

These are only glimpses, of course. Since those early forays in New York, our Meiji collection has grown to include over 1,500 pieces, only comparable in terms of quality and size to the collection of the Japanese imperial family. The collection first went on show at the British

Museum in 1994: Dr Robert Anderson, then director of the museum, said at the opening that the 'feat' of amassing this collection 'could not possibly be duplicated or even approached by any museum in the world today'. In the years since then the Meiji collection has travelled to museums all over the world, including Japan, and it has been wonderful to see so many visitors falling under the spell of Meiji art, which had been so unfairly overlooked for decades. At the 2018 exhibition at the Guimet Museum in Paris, the Japanese ambassador said what a privilege it was for him to be in the presence of such objects, and an even greater pleasure to know that they formed part of his own heritage. I couldn't believe how popular this exhibition turned out to be – 50 years after I started collecting these pieces, they drew daily queues around the block.

And yet, I was never really surprised by people's reactions to these objects. Japanese artists and artisans were always, in my view, more accomplished than any other. They embodied an extraordinary combination of artistic sensibility – a gift for observation, design and form – and technical virtuosity, a scientist's expertise in glass, metal, temperatures, humidity, compounds and processes. But even that doesn't really explain it. I stand in front of the Kawashima tapestry and I don't know if I am looking or dreaming. The colours and textures of each blossom on the shrubs and trees, the peacocks making their way from right to left, the body of water, the landscape rising in drifts of pale green and yellow – it seems to capture a particular moment in time and yet it could be outside time altogether, and all this has been conjured up by the careful interweaving of silk and metallic threads. Suddenly, I am in Iran, I am in India, I am in Japan. It fills me with wonder, even awe.

~ 8 ~

Kïmono — An Interlude

Sometimes one enthusiasm sparks off another, like a new torch being lit from a fire that's already burning brightly. And sometimes this has led me along lanes of enquiry and collecting I would never have expected before the fire caught. So, if you had told me as a teenager or young man that I would become utterly fascinated by and passionate about the kimono I think I would have laughed, disbelieving. Still, it happened.

My early encounters with Meiji objects in New York led me to Meiji textiles and then into the whole phenomenon of *Japonisme* – the way Japanese art swept into Western culture in the nineteenth century. And once you start exploring *Japonisme*, you really can't avoid some pretty serious encounters with kimonos – best of all in Van Gogh's painting *The Courtesan (after Eisen)* from 1887. Based on a woodcut by Keisai Eisen that featured on the cover of *Paris illustré* magazine the previous year, Van Gogh's courtesan looks at us over her left shoulder against a panel of the brightest yellow-gold, her hair heaped on top of her head in a great rust-coloured bun or *mage* and stabbed through

with an array of elaborate blue hairsticks and combs. The courtesan in the original print, Hanaogi of the house (brothel) of Ogi was an *oiran*, a high-ranking courtesan and arguably the most famous of her time. The *oiran* were a kind of celebrity, and thus usually dressed in the most elaborate and spectacular kimono. While their history, and the history of 'comfort women' in general, is controversial, they left behind a rich legacy that is still debated today. Spectacularly clad, the *oiran*'s extraordinary kimono looks as though it's not just part of her body but part of her *being*, a riot of colours and shapes – green, red, gold, black, clashing off each other like a percussion section. The gold panel floats in a background of water and bamboo, water-lilies and cranes, a white-bellied frog looking out with a leer from its lily plinth beneath the courtesan's feet, and the kimono itself might be a form from nature too, creature-like in its shape and aliveness.

Monet had painted his wife Camille in a vibrant red kimono in 1875, and there's a beautiful painting by the Dutch artist George Hendrik Breitner from 1894 of a girl in a white kimono, lying back on a daybed, looking as though we've come across her in the middle of a daydream, travelling in her imagination to a world of blossom and snow-capped mountains. Perhaps there's no better indication of how fashionable the kimono had become in Europe at that time than the fact that the celebrated actress and socialite Lillie Langtry posed for a portrait photograph in 1884 dressed in a kimono, with gorgeous white cranes in flight across the wide black belt. This T-shaped national dress of Japan was becoming iconic, already on its way to being a cliché of Japan – something that, like everything else that's deeply familiar to us, we stop looking closely at or being curious about.

Kimono – An Interlude

Kimono are quintessentially Japanese, but their roots go back to robes worn by Chinese nobles in the ninth century. During that time, known as the Heian period (794–1185) in Japan, the robes were adapted with some alterations for the use of the Japanese nobility, eventually becoming known as *kosode*, meaning 'short sleeves'. Working men and women picked up the fashion from the ruling class, the main difference being that nobles' robes were usually made of silk, while the more common *kosode* were made from plant fibre. By the sixteenth century, the term *kimono* – which means 'the worn thing' – had become a popular replacement for *kosode*, and the main item of clothing for Japanese men and women of all classes.

As we've seen, towards the end of the nineteenth century, as Japanese art and culture flooded into the sensibility of Americans and Europeans, many Western women adopted the kimono. After the constriction of the corset, such a loose, silken garment quickly turned the kimono into a symbol of something bohemian, escapist and risqué. But even in Japan, the kimono was more than just a functional and decorative piece of clothing. It could also be liberating to women, a form of self-expression, a way to convey status and personality, a view of the world.

That's to say, the kimono became an art form. To me, these garments are art in its purest form – commonplace objects, part of daily life, delighting the mind and eye when you least expect it, surprising you with a maker's vision and virtuosity. Very quickly, I felt the kimono deserved a place in the history of art, not just the history of fashion.

Once again, I started to read, and look, and learn. I started to collect, buying the occasional exceptional kimono here and there. Then, as sometimes happens, I got lucky. In the early 2010s, a superb

group of Japanese kimono put together over 43 years by the celebrated American collector Jeffrey Montgomery became available. Based in Switzerland, Jeffrey was well-known for his collection of Japanese folk art, including kimono and other textiles, ceramics, metalwork and sculpture. In 2005, the V&A had held an exhibition of some of his kimono and published a book about them called *Fashioning Kimono: Dress and Modernity in Early Twentieth Century Japan*. Like many collectors in their seventies, Jeffrey had begun to think hard about how to safeguard these pieces he so cherished. Looking for a home for his kimono collection, he asked me if I'd like to carry on his legacy. I was absolutely thrilled. By adding Jeffery's kimonos to what I'd already acquired, we would be well on the way to building the most outstanding collection of kimono outside Japan.

I looked everywhere, benefiting greatly from expert advice and the help of specialist dealers, keeping an eye on every auction and sale no matter the size, and taking special care that we choose different kinds of work, so that the collection would cover all the major periods, techniques and styles of this remarkable form. The collection now contains more than 450 objects, with examples of the sophisticated designs of the imperial court, samurai aristocracy and wealthy merchant classes of the Edo period (1603–1867); the surprising style changes and new colours of Meiji (1868–1912); and the bold and modern kimono of the Taishō (1912–26) and early Shōwa (1926–89) periods, which used innovative techniques and took inspiration from both past traditions and the modern world.

The basic T-shape and construction of the kimono have stayed the same for centuries, with the back usually used as the canvas on which

designers and weavers could express themselves. The evidence of surviving examples and eighteenth-century pattern books show the back as the main aesthetic focus of kimono made for women, while men's kimono were usually very plain, with next to no decoration, as the public dress codes allowed men little room for originality and flair. For men, well into the Meiji period and even afterwards, such creativity was relegated to the linings of underkimono (*juban*) and jackets (*haori*).

I've always felt drawn to art inspired by the natural world, and many of the kimono in our collection celebrate natural forms – swallows, carp and turtles, rendered with love and wit; elegant peonies, wisteria and cherry blossom, each looking so vibrant and lovely you can almost smell them. Sometimes there's a symbolic aspect – bamboo, which never breaks, representing perseverance; plum trees, the first to blossom each year, representing renewal. And then there are mythical creatures, like the hō-ō birds flying over and nestling between the branches of paulownia trees on a gorgeous Edo-period kimono. Phoenix-like, these birds were said to appear at times of peace and prosperity and were used as symbols for the Chinese and Japanese imperial households, often depicted with the paulownia, which, according to legend, was the only tree on which they would land.

One of the best examples of a late-Edo kimono, and a particular favourite of mine made in the *yūzen* technique, takes inspiration from the *Ise monogatari* (The Tales of Ise), a tenth-century literary classic. In the scene shown on the back of the kimono, a poet-courtier and his companions stand in amazement at the foot of Mount Fuji, the great symbol of Japan, and admire its unusual and unseasonal covering of snow, saying,

Fuji is a mountain
that knows no season
What time does it take this for
That it should be dappled
With fallen snow?

I love the humour in that, that the mountain should be addressed like a misbehaving teenager (What time does it take this for?!), so that you feel the personality of the artist even as you wonder at the beauty of the scene and the skill of the *yūzen* technique. The five family crests (known as *mon*) spread across the top of the kimono indicate that this charming piece probably belonged to a woman of the merchant class.

Or look at this formal outer kimono, known as *uchikake*, dating from the first part of the nineteenth century, also made using in my favourite *yūzen* technique, this time with figured satin silk (*rinzu*). This kimono, elaborately woven with gold and silver, is decorated with cranes in flight – oh, how lovely and clear they are as they race across the red skies. It's like watching a scene from a film, so beautiful and exciting. I love the way cranes are both real and mythical creatures in the Japanese imagination – symbols of longevity and good fortune, described in Japanese folklore as living for a thousand years and making their home in the land of immortals. They also mate for life, and are a powerful symbol of love. In Japan, cranes are celebrated in many ways, and in fact the Ainu tribes of northern Hokkaidō even have a dance dedicated to and inspired by their movement.

Early on, as I was building the collection, I realised we were short of Edo and early Meiji examples (before and after 1868), so I contacted my faithful and reliable dealer Tsumugi Shoji, who'd helped me find many treasures in the Japanese collection and was my main source for kimono. Tsumugi made it her mission to find dealers and auctions across Japan, and, after much time and effort, she found us a real masterpiece – an elegant Edo-period summer kimono, with beautiful scattered Japanese characters embroidered on it. With some diligent research, it turned out these were from 'Kimigayo', a poem in the tenth-century *Kokinshū* anthology of verse, which had been adopted as the lyrics for Japan's national anthem in 1888. The figures are embroidered in gold and hidden between white kudzu plants, with details picked out in *shibori* tie-dye, and silk and gold embroidery against an indigo-blue background. It's just beautiful, so subtle and delicate.

Subtlety, in fact, is something I have come to associate with kimono. Throughout its history, the garment had been used as a medium for bold statements and subtle hints of belief and inclination, whether political, personal or social. These nods might include tributes to other traditional Japanese arts, either through copying *ukiyo-e* prints and traditional Japanese paintings (known as *nihonga*) onto the back of richly dyed women's kimonos, or depicting such items as lacquer boxes, armour, fans and masks on them – decorative objects becoming symbols in their own right, alongside the hō-ō birds, dragons, cranes and bamboo. I love to think of these works of art being smuggled into daily life via the back panels of dresses, so that even on a trip to the market you might unknowingly rub shoulders with a

masterwork. It makes me think of how much beauty and skill moves among us in our day-to-day lives, even without us noticing.

Kimono evolved in ways that powerfully reflected the changes in Japanese society. In the earlier parts of the twentieth century, during the Taishō and early Shōwa periods (1912 up to the Second World War), women were inspired to wear even bolder and more daring designs, taking inspiration from European art movements such as Art Nouveau and Art Deco, as well as Expressionism, Futurism and Cubism. Competing with the popularity of Western dress, which became very dominant because of all the social and industrial changes happening across Japan, kimono were becoming cheaper, more innovative and fashion forward. The introduction of the inexpensive machine-made *meisen* silk in the 1920s, which allowed for faster production and used stencil printing and chemical dyes to create dazzling effects, allowed the kimono to develop in the direction of an everyday, durable and appealing item which attracted the contemporary urban classes. There are many fun examples of *meisen* in the collection, from a kimono that has the traditional chrysanthemum motif, enlarged and repeated in bold colours, combining the traditional and the modern, to kimono that feature skyscrapers or abstract designs that reference jazz rhythms. They were kimono made for young, sophisticated modern women with a bit of *chutzpah* ('cheeky audacity' in Yiddish) as us Jews call it.

In fact, the kimono gave scope for a freedom of expression not available in other types of clothing, and gave the wearer or the buyer (in case of children's kimono) the opportunity to express feelings of national pride and sophistication. Trains, cars, aeroplanes, film and music became

symbols of modern, progressive Japan. I love these kimono. I love the way they use art to promote ideas, and to celebrate achievement. There's something so innocent about it. You want to celebrate how amazing you think the modern world is, so you wear it! It's like wearing a T-shirt with your favourite band logo on it or a reference to a TV show. The collection has a large section dedicated to the exploration of what are commonly known as novelty *omoshirogara* (meaning 'amusing patterns') and propaganda kimono of the period. From women and men's *haori* jackets decorated with elegant cityscapes and powerful military images to children's kimono showing cartoon characters and visions of battleships, these objects chronicle an incredible period of excitement and hopefulness before the mighty and dark storm of the Second World War.

One of my favourite examples is a fireman's jacket from around 1930, made of heavy, thick cotton and decorated with the image of a hot-air balloon and a man waving victory flags from inside. These type of jackets, known as *hikeshi hanten* (literally 'fireman's jacket'), had been worn as far back as 1601, at the time of the great Edo fires. The city of Edo (present-day Tokyo) was known for having many raging fires during the seventeenth century, not least because most buildings were made of wood and paper. The fires were so common that, with their reds, yellows and oranges, they were jokingly referred to as 'autumn leaves'. And so, the ruling shogunate families established what is arguably the first known fire brigades in the world, known as the *hikeshi*. This was at least 60 years before the first organised Western brigades were introduced after the Great Fire of London in 1666.

The *hikeshi* were an interesting crowd – tattooed tough guys who were very colourful and very brave. Each brigade had its own banner

or *matoi*, and would wear the heavy cotton *hanten* with the decorated side kept hidden, as a lining, and the outer plain side usually showing only a name or a *mon* (crest). These kimono jackets were made from thick layers of cotton and could absorb large quantities of water, which would be thrown on the fighters before confronting the fire. While probably very heavy to wear, the soaked jackets provided decent protection from the flames. Once the fire was extinguished, the *hikeshi* would turn the jackets inside out, revealing the fancy design for all to see in celebration. They would then do a sort of victory lap round the taverns and streets of the town, with the jacket design not only marking their achievement (they usually depicted heroic battles or symbols of longevity) but also indicating to the residents that the danger had passed. After the overthrow of the shogunates during Meiji, the *hikeshi* were absorbed into the police force, but continued to wear the *hanten*.

Which brings me to our *hanten* from 1930, with its surprising symbol of a hot-air balloon in place of the traditional illustrations of fighting warriors and mythical scenes. Still, the intention is the same, simply put into a modern context. The wearer wanted to inspire pride and signify victory (the hot-air balloon implies the triumph over the natural force of gravity, just as the *hikeshi* had triumphed over the natural force of fire), choosing an image representing the success of modern Japan.

After the war, which saw the defeat of the Japanese following the horrific bombings of Hiroshima and Nagasaki, many in the country were left traumatised and struggling to adjust to their new circumstances. In this crisis of national identity, Western dress became more prominent, and the kimono was seen, to some extent, as an unpleasant reminder of the past. Art historian Seiroku Noma wrote in the

1960s that the Japanese 'are not proud of their kimono. Instead, they regard it as a burden left over from old Japan'. The kimono became an item worn mainly for ceremonial occasions, or by those who worked in official or religious positions or the hospitality industry.

It took a new generation, and great efforts on the part of the Japanese government to establish a system that celebrated individuals as official holders of 'Important Intangible Cultural Properties' (or, as they are more popularly known, Living National Treasures), to reignite interest in these fantastic items. Today, the kimono is adapting to life in the twenty-first century, being redesigned and discovered by younger people who are learning to appreciate its artistry all over again, and it is being offered as a bright and unusual alternative to everyday clothes. One of the most unusual pieces in our collection, and by far the newest, is a stunning kimono by one of Japan's Living National Treasures, Kunihiko Moriguchi, which even has a title: *Beyond*. Giving a title to a kimono is significant, of course, suggesting that we approach it as a unique work of art, rather than (or as well as) an item of clothing. The piece, produced in 2005, bravely shows how a kimono can move beyond 'the thing worn' into the realm of symbol and artistic statement, with twenty-first-century self-awareness.

As I've said, it still takes me by surprise that I've become so deeply interested in the art and history of the kimono. I suppose in part it's to do with my passion for textiles and the art of weaving. And then there's my commitment to highlight and celebrate areas of artistic endeavour that I don't feel have quite received their proper due. I hope that our kimono collection will stand as a comprehensive review of this extraordinary art form, and I haven't held back in adding pieces that put the

garments themselves in context: several albums with over 3,000 hand-painted kimono patterns from the late nineteenth to early twentieth centuries; a painted screen that shows kimono hanging on stands (displayed at the V&A as part of its 2020 exhibition *Kimono: Kyoto to Catwalk*); a lacquered kimono stand, like the ones on the screen; several obi (the sash usually worn with a kimono); and woodblock-printed kimono pattern books dating all the way back to the early 1700s.

To research the collection we recruited a team of world-class scholars from Japan, the US and the UK, headed by Anna Jackson, keeper of the Asian Department at the V&A. In 2015, we put these great minds to work and produced *Kimono: The Art and Evolution of Japanese Fashion*, which stands as one of the fullest accounts of the history of kimono currently available. With its dazzling images, I hope that this beautiful book alongside the collection itself will inspire a new generation of designers and artists. In fact, I think it's an obligation for us older ones to help and equip those who come after us on their journey. And it does us good, too: the person who lifts their child onto their shoulders in a busy crowd can see better ahead, as their child will guide them where to go.

Finally, I have to say that the ultimate and best way of looking at a kimono is while it is being worn by a human being – a living, breathing, moving work of art. Marion has worn them sometimes to formal events and occasions involving the Japanese collections, and it has made me catch my breath, to see such elegance and beauty and feel my love for her all woven together. And me? No, I haven't started wearing and walking about in them – I'm not there yet.

But believe me, I'm tempted.

~ 9 ~

The Islamic World

I still remember the first time I took the subway from Queens into Manhattan. I'd never experienced such a crush of people, all of them rushing and squeezing to get into the carriages when the train pulled in. I stood back; I didn't mind waiting. I asked someone when the next train was due.

'Two minutes,' he said.

Two minutes! Given that mad rush for the doors, I'd imagined there wouldn't be another train for at least an hour. Over 50 years ago, but I remember that moment so clearly, how I stood on the platform with a sense that this was a nation in a hurry, and it wouldn't be my home forever – our clocks would always be ticking at different speeds.

The day after I met Marion I rang my mother. Even in New York, where I was studying and working with such passion, beginning to make my way, I used to call my mother often. We spoke almost constantly.

'How are you feeling?' she asked me, and then, without having told her anything, she said: 'And who is this girl you've just met?'

She was like that, my mother. So I told her about Marion.

She said that last night in her dream she'd seen a girl coming out of the sky carrying a lantern, and a voice was saying, 'This is the girl for your son. This is your daughter-in-law.'

I was used to this sort of thing. Before I was born my mother told her father-in-law Eliyahu about a dream she'd had. She was standing next to a great fountain. Water was shooting up to the sky but not falling. My grandfather looked at her with a very serious expression on his face.

'Do not repeat that dream to anybody!' he said. He told her that she was pregnant, and that she was going to have a son, and that she would call him Nasser.

Almost every summer I'd fly back home to the house in Tehran. I'd bring pieces left over from my activities and sell them to dealers I knew through my father. Of course, there was the happiness of being with my parents, my brothers Yuel and Avner and Shahin, my sister Banou, the breakfast table groaning with bowls of feta and honey, bread straight from the oven, the basket of radishes, mint, spring onions, parsley, the shabbat eggs cooked over seven or eight hours in chicken broth flavoured with turmeric and cardamom. But I was in thrall to a passion now, searching out works of art to buy and then sell so I could search out more works of art to buy and then sell . . . So even on these 'holiday' visits I would hit the road, touring pretty much every antiques shop and dealer in the city. My dad might have warned them, 'Nasser's coming!' – and they'd have put their best objects out ready for me for my Islamic and other growing collections, in all the antique shops of the Ferdowsi and Manouchehri neighbourhoods,

where the dealers had often known me since I was boy, when Dad used to send me in ahead of him to scout for treasures.

He and I would take the TBT buses together and I'd be back in the thick of the country I loved, sitting among people with chickens and even lambs on their laps, and after 30 minutes everyone would be talking together, about the weather, family, courtships, sharing stories. Between me and Dad there were two conversations on these trips – poetry and art – and we would just jabber away about pieces we'd seen or dreamed of, we'd pass quotations from Hafez and Ferdowsi and Rumi back and forth, one finishing a verse the other had started, until it was time for the next antique shop or dealer, old friends at every turn.

But in the mid-1970s in Tehran I could tell that something was brewing, and that feeling grew more intense as each year passed. People were really beginning to struggle financially, and the air was tense. I've always thought that extreme inequality makes some kind of explosion inevitable – the gulf between rich and poor becomes intolerable, and the consequence is either total collapse or revolution.

By the time the Ayatollah took power in Iran in 1979, I was already encouraging my family to leave the country. When my parents came to our wedding in London in 1978, just before the revolution, I told them not to go back to Tehran but to go to Israel instead, as we didn't know what was going to happen. The rest of my family followed through soon after. To this day, those summer visits through the 1970s are my last memories of the beloved country of my birth.

Though we were a family of observant Jews, of course in Tehran I grew up among Muslims and developed a deep feeling for Islamic art.

The Art of Peace

From an early age, I was fascinated by objects Dad brought home, those delicately painted lacquer pieces, the manuscripts full of stunning calligraphy and illuminations. They were an everyday part of our lives and at the same time spoke of a far-off history, a world of kings and warriors and stories, which set my young imagination spinning. They left a mark. Later, in my twenties, I visited museums, auction houses and galleries obsessively across Europe and America, looking out for collections of Islamic art, hungry to see and learn more. But the more I learned, the more I felt the subject had been treated as a sort of 'minor art' in the West, its contribution to world culture largely overlooked. While some categories – architecture, carpets, miniature painting and Iznik pottery, for example – had received attention by Western art historians, huge provinces of Islamic art were barely talked about. Publications on these subjects were few and far between. This absence ignited a new fire in my mission as a collector, and I have now spent half a century collecting, conserving, researching, publishing and exhibiting the various forms of Islamic art, hoping to bring their splendour, diversity and technical brilliance to wider view. I have been building an encyclopaedia, an archive unseen in scope of this magnificent art in modern times.

The way I see it, Islamic art isn't the art of a religion as such, but more the art of distinctly different civilisations brought together under the banner of Islam – the religious, philosophical and cultural influences that exist underneath, and which ultimately led to a shared artistic language. As a result, a large proportion of what we consider to be Islamic is in fact not religious at all: objects made to be used in daily life, in palaces and homes alike. These are objects we can all

relate to, which is perhaps what today gives Islamic art such a wide appeal.

One of the first examples that jumps to my mind is a large ceramic dish decorated with a brilliantly coloured, stylised peacock (I know, I can't help myself!) which was made in Raqqa, northern Syria, at the beginning of the thirteenth century. It's a piece of exquisite fineness, not to mention rarity. To me, it looks like a Picasso – it feels so modern despite being over 800 years old. And if nothing else, it shows how a particular aesthetic can infiltrate the subconscious of artists for generations.

Strangely enough, when the dish was first sold it was heavily over-painted. Recognising its unique shape and realising that the dish may have been over-restored to hide some damage, the dealer who bought it had followed gut instinct. His gamble paid off. When the overpainting was removed, the dish turned out to be in excellent condition, with nothing but a few cracks that were easily fixed by his restorer. The biggest surprise, however, was how the coloured original glazes were as bright as the day they were fired. When it eventually made its way to me and I heard the story, I was overjoyed – I had been trying to find a good example of this type of ware for years, and I couldn't have dreamed of a better one. It seemed as fresh as the day it was made. Objects such as these, which somehow have survived in that pristine state for centuries, are one of the greatest thrills of collecting – it's an instant teleport to the past, like having your own private time machine.

The Raqqa dish is made of stonepaste (also known as fritware), a type of ceramic pottery thought to have been invented in Iraq in the ninth century, and decorated in the so-called *laqabi* technique – a great

Muslim innovation in which bold designs, usually including animals and birds, were deeply carved before the coloured glazes were applied, stopping the colours from running into each other during firing. Sadly, despite the spectacular results, *laqabi* ware was short-lived, which explains the rarity of surviving pieces.

How come a piece from thirteenth-century Syria came to remind me of a Picasso? Long essays could be written about the multiple reasons why that might be. But connections are everywhere. Over years of learning I have encountered quite a few of those. One which comes to mind, for example, is how the famous blue-and-white aesthetic we recognise mainly from Chinese fifteenth-century exports probably had its origins in the Middle East – while cobalt was used as a glaze colourant during the Tang period (618–907), during the ninth and tenth centuries the Chinese started using it in a painterly way similar to the pottery coming from the region, probably due to traders bringing in the cobalt through the Silk Road and examples of works made with it.

Islamic art involves, as you would expect, work made mostly by Muslim artists, generally for Muslim patrons, in lands that fell under the influence of Islam over a period of over 1,400 years. But as we have just seen, the story is much wider than that, with many different twists, turns and hidden corners of delight. Given that Islam through history had covered such a huge area – from China to Andalusian Spain and beyond – and so many different cultures and languages, it's not surprising that its art is so rich and varied. As the collection grew, I was drawn, in ever widening circles, to every medium of Islamic art, to every geographic region that Islam had touched, and to every era since the birth of Islam: I wanted the collection to illustrate the full

artistic legacy of the Muslim world. But equally important for me was that each medium was represented well enough to count as a collection in its own right: standalone collections within one comprehensive collection.

By the time I moved to London in 1978, I'd already acquired many important Islamic objects, including pieces I'd encountered during my first trip to India with Nuri in 1971. I'd remained enchanted by Mughal art. We have an early eighteenth-century enamelled gold *huqqah* (hookah), or water pipe, from the city of Mewar in Rajasthan, its gold surface decorated with winged angels, birds and flowers executed with astounding delicacy in champlevé, cloisonné and painted enamels in shades of green, blue, yellow and white. Dazzling in the truest sense of the word, the pipe is believed to have been made for one of the Rajput rulers at a time when smoking was a symbol of high status among India's ruling elite. Rajput (from Sanskrit *raja-putra*, meaning 'son of a king') rulers were a type of Indian clan-based warrior ruling class commanding territories in mainly central and northern India. During the Mughal Empire they were associated with and served the emperors, and our hookah hints at a royal association. Many Rajput rulers were shown smoking in miniatures while engaged in all sorts of activities, from receiving guests to elephant and even horse riding. Mewar, where the hookah comes from, played a big part in Rajput history as the home of one of the most distinguished dynasties, the Sisodia.

Meanwhile, the love of Mughal emperors for gems is legendary, the splendour of their collections of precious objects unmatched by

any other ruling dynasty. One fantastic example from our collection is a small, seventeenth-century gold box set with 103 perfectly matched emeralds. A brilliant diamond sits on the top of its lid, and even the underside of the box is delicately decorated and enamelled in a translucent emerald green. It looks like a song of the ocean, framed in gold, and it's possible – given the luxuriousness of the materials and the quality of the workmanship – that the box was made for a royal patron such as Shah Jahan or a member of his immediate household. This masterpiece was yet another sleeper, as it was originally offered at a Sotheby's pre-Columbian sale misidentified as glass, not emerald, when it was bought by a dealer I knew who specialised in jewellery. He offered it to me for many times the paying price, which was fair enough – he'd had the talent to recognise something special that others had overlooked: I commended him for his discovery, and paid in full.

In 1980, I bought a painting showing Shah Jahan looking through the 'viewing' window in the Red Fort at Agra during his lunar birthday celebrations, 23 October 1632. The anonymous painter created such a wonderfully vivid image – you can almost feel the rich, joyful atmosphere of celebration, as the shah looks down on aristocrats, ambassadors and noblemen watching an elephant fight, his favourite sport. Talk about a bespoke birthday party . . .

Originally it was an image from the celebrated *Padshahnamah*, a beautifully illustrated manuscript outlining Shah Jahan's reign (a complete set of 44 paintings is currently in the Royal Library at Windsor Castle), and it stands as a perfect example of Mughal miniature painting at its most refined. When I give lectures on Islamic art, I often

show a detail from it in which Shah Jahan's face is enlarged so that it fills the screen. I ask the audience, 'How big do you think it really is?' and almost every time the audience imagines a painting on a grand scale, then gasps as I zoom out to show the complete image, holding up my little finger and saying that the shah's face is in fact smaller than my fingernail. The level of detail is genuinely hard to believe.

One day in the mid-1990s I received a call from a distinguished friend, Nawab Khomrodin Khan, an exceptionally learned man who knew all about my passion for Mughal art. He'd come across a rare seventeenth-century illustrated *Falnamah* or 'Book of Omens', used for divination. It dated from around 1610–30 and was produced in the Indian city of Golconda. Featuring 37 full-page miniatures in water-colours, gold and silver, it's one of the few complete or near-complete books of divination of this quality to have survived anywhere in the world, and the only known illustrated copy from India. It would once have been used to make decisions about business deals, long trips, marriages and other important issues. Refined and bursting with colour, its paintings show historical and religious figures from a variety of nations and faiths, including Moses, Jesus, the Prophet Muham-mad, Alexander, Plato and Shah Tahmasp (1514–76). The text includes tips on how to overcome predictions of bad fortune – not least by giving to charity. It wasn't just that the paintings were so beautiful – all those figures loomed so large in my inner world, and the mingling of the spiritual and the everyday struck such a chord with me. I was over-joyed to add it to the collection.

Sometimes it feels almost magical, the way the paths of these objects through space and time suddenly and without warning cross

my own. On a visit to India with Marion, the trip brought back wonderful memories of my first visit there as a young man. One day, we met our guide early in the morning so we could see the Taj Mahal at its most serene and have it almost to ourselves, nothing but the breeze and the birds to disturb the silence. Afterwards, back in the car, I chatted with the guide about my collection of Mughal art, and how we were fortunate to have a miniature from Shah Jahan's *Padshahnamah*. This led to a discussion of a legendary calligraphy album owned by Awrangzeb (or Aurangzeb, 1618–1707, the son of Shah Jahan, and a strict Muslim who preferred calligraphy to painting); our guide told us he'd also heard rumours of such an album but that no one knew where it was or if it even existed. I felt that familiar treasure-hunter itch, all the antennae tingling – how I would love to find Awrangzeb's album . . .

Several months later, I was sitting in my office in London with our eldest son Daniel when a call came through from Oliver Hoare, one of the most well-known Islamic art dealers at the time. We'd known each other for decades, and Oliver had played an instrumental role in helping me buy some of the major objects in the collection. I hadn't seen him for a while, so I assumed he was calling just to check in and catch up. But he told me he had something I had to see. I asked when would suit him for a visit.

'Come now,' he said.

We jumped in the car and headed to Oliver's gallery. He showed us to a table with a thirteenth-century silver-inlaid bronze candlestick on top of it – a beautiful thing, but we had several of these in the collection already: why would Oliver be making a fuss about it?

'Actually, I invited you here for this,' he said, pointing at a large leather-covered box. He opened the box and pulled out an album. I started browsing through it, blinded by page after page of the most exquisite calligraphy and illumination. The quality was extraordinary. It was obviously Mughal, and there was no doubt in my mind that it was meant for royalty. And then I remembered that conversation in the car after our early-morning visit to the Taj Mahal. Was I looking at Awrangzeb's lost album? Was it really possible?

I bought the candlestick and the album, barely containing my excitement as I brought this treasure to my research team and unwrapped it in front of them, telling them what I thought it might be. We spent a few weeks studying the album, researching it thoroughly, checking it in forensic detail. It was composed of 60 folios with samples of work by several calligraphers active during the reign of Awrangzeb, some even known to have done work directly commissioned by him. The two exceptions are famous calligraphers from the thirteenth and fourteenth centuries whose work was in high demand even as late as the seventeenth century. The panels are mounted on double-page spreads stunningly decorated with jewel-like patterns taken mostly from Mughal enamels or *pietra dura* work – a type of inlay or mosaic created using coloured stones. Hardly any two spreads in the album are the same – page after page of words flowing like water, a landscape of waterfalls.

Without a commissioning notice, the only clue to the identity of the patron was a mysterious note written on the flyleaf. It mentions that the album was put together for Jahangir Beg, Jansipar Khan, who was appointed first permanent governor of Hyderabad by Awrangzeb.

The note also suggested that this was done at the recommendation of Jahangir Beg's own painters. In this context, and given the album's many other connections with Awrangzeb, it seems highly likely that this magnificent book was presented by Jahangir Beg to his emperor in gratitude for the appointment.

Over the years, I'd built strong working relationships with many dealers who understood what I was after, and often came to me first if they had important pieces, just as Oliver had done with the calligraphic album. Then there were the big sales and auctions, which I would wait for and scan like a hawk. At a sale at the London branch of Christie's in 1989, how dazzled I was by the image on the cover of the catalogue: a beautiful early thirteenth-century bronze casket, richly decorated with lively silver-inlaid scenes showing a prince and his attendants drinking, carousing, with musicians, a lancer and a falconer – a joyous scene of courtly life. Even the underside of the casket was decorated – it really was a riot for the eyes. Among the decorations are standing figures who are most likely Christian priests, one of them holding a cross. Christian scenes are found on some Mosul metalwork of this period: it's been suggested that perhaps such pieces were made for Christian patrons. This coexistence of Islam and Christianity made the casket particularly appealing to me.

Under the growing threat of the Mongol invasion in the early thirteenth century, many Persian craftsmen moved westwards, among them a group of metalworkers specialising in gold- and silver-inlaid brass who established themselves in Mosul, northern Iraq, and later in Damascus and Cairo, where they made some of the most beautiful

Islamic metalwork ever made. The casket was a brilliant example of such Mosul work. But what made it especially rare and exciting was that it still had the remains of a kind of combination lock introduced to the West by the thirteenth-century polymath Isma'il ibn al-Razzaz al-Jazari. Only four other Islamic caskets with this type of lock are known to exist. The mechanism was described in al-Jazari's *Book of Knowledge of Ingenious Mechanical Devices*, which he illustrated with detailed drawings. Considered to be one of the earliest fathers of robotics, and admired for his inventive mechanical engineering, al-Jazari is often compared with (and perhaps even influenced) Leonardo da Vinci.

Muslim metalworkers were hugely inventive and made extremely sophisticated scientific instruments. I made a point of acquiring the best examples of these I could find, like the massive, dazzling seventeenth-century Indian astrolabe, inscribed in Arabic and Sanskrit, which I bought in the early 1980s. When I first saw it, my jaw dropped at the sheer size of it – most astrolabes are much smaller – and I was even more impressed by the superb, refined quality of its workmanship. We didn't know much about the history of the astrolabe, but a seasoned collector must rely on their accumulated knowledge, eyes and senses. Yes, you must look for and listen to the best advice you can find, but sometimes you have to trust your instincts. In this case, my instinct was that such a superb instrument could only be a royal commission – specifically, I thought, for Shah Jahan.

In 2015, an eminent Indian scholar, who was in the process of working on a publication dedicated to Indian astronomical instruments, concluded that the astrolabe must indeed have been made for

Shah Jahan and that it was made by a member of a famous Lahori family of instrument makers, most likely Diya' al-Din Muhammad Lahori. He also noted that the Sanskrit inscriptions lacked the neatness and accuracy of the Arabic ones and that they were probably added later, when the astrolabe was acquired by a Hindu from Delhi. It was during this reworking that any inscription naming the original patron and the maker must have been effaced.

For a long time I kept quiet about the scope of the Islamic art collection. Discretion is a cardinal virtue in an art collector. There's a famous Jewish anthology of teachings and proverbs, part of the *Mishnah*, the first major work of Rabbinic literature. It's called *Chapters of the Fathers* (*Pirkei Avot* in Hebrew), and it's full to the brim with ethical and spiritual guidance. I'm especially fond of the line: 'Silence is a fence around wisdom.' This is an essential rule in collecting. Sometimes keeping things to yourself is wiser than talking about them to all who will listen.

Many people, knowing my background, assumed at first that perhaps my Islamic collection was mainly Persian. So, it came as a shock when *Empire of the Sultans* – the first exhibition drawn entirely from the collection, which opened in Geneva in 1995, before moving on to London and Jerusalem, and then a four-year tour of venues in the US – was on Ottoman art. To this day, there is an assumption that the collection contains mostly Persian objects – but this is simply not true. In all my years of collecting, the scope of the collection came to encompass all corners of the Islamic world. Still, naturally it's true that when pressed to name my favourite objects in the collection,

something in me gravitates to Persia, specifically to two manuscripts – masterpieces not only in terms of Islamic art, but of world history and art in general.

These are Rashid al-Din's *Jami' al-tawarikh* (*Compendium of Chronicles*) and the ten folios we have from the copy of Ferdowsi's *Shahnamah* (*Book of Kings*) made for Shah Tahmasp. The collector in me cannot but admire their beauty and brilliance, yet – on a more personal level – I relate to them both as an Iranian and a Jew.

Written in Tabriz in 1314, the *Compendium of Chronicles* was originally commissioned as a history of the Mongols by Mahmud Ghazan Khan, the Mongol ruler of Persia who took the throne in 1295 and converted to Islam. However, at the request of Ghazan's successor Oljeytu, the work was enlarged to make up the earliest known universal history. Rashid al-Din Fadlallah Hamadani, author of the *Jami' al-tawarikh*, was the son of a Jewish apothecary. Born around 1247 in the town of Hamadan, an important centre of Jewish culture in western Iran with a large Jewish community, Rashid al-Din converted to Islam when he was about 30. He was a thoroughly talented man, with a comprehensive knowledge of theology, agriculture, horticulture and history, a deep familiarity with the Old Testament, and, it was said, a fluency in Persian, Arabic, Turkish, Mongolian and Hebrew. Rashid al-Din initially entered the service of the Ilkhan Abaqa as a court physician and rose quickly up the imperial bureaucratic ladder, becoming deputy vizier (deputy prime minister) to Sultan Ghazan in 1298 and later vizier under Oljeytu, securing his position as one of the leading statesmen of his time. He had serious administrative power and managed to amass a small fortune, endowing many charitable

institutions throughout the Ilkhanid realm. The most splendid of these was the Rab'-i Rashidi, a multifunctional complex built on the outskirts of Tabriz. Besides a mosque that housed his tomb, it included a hospice for Sufis, a hospital, a guesthouse, a library, and a scriptorium where copies of his works were made.

It was in this scriptorium that the first copies of the *Compendium* were transcribed. This huge work, composed in Persian and translated into Arabic, was divided into four volumes, practically all of which are now sadly lost. Rashid al-Din stipulated that two copies were to be made each year, one in Persian and one in Arabic, and these were to be distributed throughout the Ilkhanid realm. Despite this, our manuscript, together with another in the University Library, Edinburgh, are the only two parts to survive from the earliest Arabic copy of the book, which was transcribed in 1314. They come from the second volume, which originally would have had at least 400 pages and around 110 illustrations painted by a team of artists working under Rashid al-Din's supervision. The paintings in the *Compendium* give us an extraordinary window into the culture in which they were made. Tabriz, an important trading post for travellers along the Silk Road, was unusually cosmopolitan, and this can be seen in the style of the paintings – a rich mix of artistic influences, from Chinese scrolls to Christian manuscripts. The subjects chosen for illustration also give an insight into what Rashid al-Din thought of as important moments in history: long stretches of the text were never meant to be illustrated at all.

Our section of the manuscript begins with part of a chapter on the history of the Prophet Muhammad, illustrated with three paintings.

This is followed by a chapter on China. accompanied by brilliant por-
traits of Chinese emperors, from the first Shang emperor to the nine
emperors of the Jin dynasty. There are nine miniatures in a chapter
on India, including scenes from Indian epics the *Ramayana* and the
Mahabharata, as well as some from the life of the Buddha. The final
chapter – on the history of the Jewish people – has eight paintings that
illustrate the stories of Noah, Jacob, Joseph, Moses, Saul and Jonah. I
particularly love the way Noah is shown there, dressed in robes and a
turban, reclining on the deck of the ark, which is based on the dhows
that sailed the seas in the early fourteenth century. And I love the
painting showing grim-faced Jonah emerging from the mouth of the
whale, looking pretty much as you'd expect for a guy who's just spent
three days in its stomach.

Despite his exceptional contribution to the cultural life of Mongol
Persia, Rashid al-Din's own life ended in humiliation. In 1312, he was
accused of plotting to poison Oljeytu and, as evidence, the vizier's
enemies faked a conspiracy letter written in Hebrew. When Oljeytu
died in 1316, resentment against Rashid al-Din bubbled up again.
This time, his rivals accused him of poisoning Oljeytu by prescribing
him the wrong medicine, and on 17 July 1318, after being forced to
watch the execution of his own son, Rashid-al Din was decapitated
with the approval of Oljeytu's successor Abu Sa'id. According to some
accounts, his severed head was paraded around Tabriz for days.

It makes me desperately sad to think about the fate of this extraor-
dinary figure. After Rashid's death, his land and goods were
confiscated. Even the pious foundations he'd established had their
assets seized. A mob looted the Rab'-i Rashidi and his scriptorium

was closed, its painters and calligraphers disbanded. His skull was buried in the mosque he'd built in the Rabʻ-i Rashidi. But even in death he wasn't allowed any peace: his remains were dug up from this grave almost a century later, on the orders of Miran Shah, the son of the Turco-Mongolian warlord Timur. Rashid al-Din's tomb was destroyed, and he was reburied in a Jewish cemetery.

Our copy of the *Compendium of Chronicles* somehow survived this painful history, even though around half of its pages were lost or destroyed over the years. In the fifteenth century, it belonged to Timur's son and successor Shahrukh, who kept it in his royal library in Herat, capital of the Timurid Empire. In the sixteenth century, it passed to India's royal Mughal library when it became part of the collection of the emperor Akbar. In the eighteenth century, the manuscript was split into two parts, sold separately in the early nineteenth century to two employees of the British East India Company. One of them, John Baillie, bought the part that now belongs to Edinburgh University Library. The other, John Staples Harriott, bought a 59-folio section, which later passed to Major General Thomas Gordon, who then bequeathed it to the Royal Asiatic Society in London. Strapped for cash, the Society sold Harriott's part of the *Compendium* at a Sotheby's auction in 1980. It fetched the highest price ever paid up to that date for an Arabic manuscript in a sale.

The buyer, as it happened, was an old friend of mine, Hashem Khosrovani, whom I'd known since my student days in Tehran. The son of a general, Hashem married a cousin of Iran's Empress Farah, and from the 1960s had built up an extraordinary collection of Persian art. By the time he bought part of the *Compendium*, the manuscript was

showing its age. The silver and lead-white pigments used in the paintings were oxidised and darkened, and the gold had become dull. Hashem handed the manuscript to Don Baker, a masterful paper conservator, who did a magnificent job in returning the paintings to their former glory.

I was completely spellbound by this manuscript. I tried to buy it from Hashem, but he was understandably reluctant to let go of such a masterpiece. Thankfully, in 1990, he changed his mind, partly because he was shifting his focus from collecting Islamic to contemporary art. I bought the 59 folios from Hashem's trust for millions, breaking every record for an Islamic work of art. The amount caused a storm, but I was very calm at the centre of it. I had no doubt, deep down, that this was the most important purchase I would ever make. I knew that this was a unique manuscript of astonishing beauty and the greatest historical significance – 'one of the greatest illustrated manuscripts in the world', in the words of Tim Stanley, senior curator for Middle Eastern art at the Victoria and Albert Museum in London.

For me, the *Compendium of Chronicles* was even more precious because I was so moved by the story of Rashid al-Din's life. This brilliant man was born a Jew, converted to Islam, and rose to become the vizier of Muslim kings; then, for no apparent reason, they had turned against him and put him to death. Now, nearly 700 years later, another Jew with a reverence for and deep connection to Islam had become a custodian of his manuscript. His book is a source of infinite delight for me. From the moment it came into our possession, I felt that it was my duty to protect and honour Rashid al-Din's legacy. In 1995 we published *A Compendium of Chronicles: Rashid al-Din's Illustrated History of the*

World. Written by Dr Sheila Blair, a renowned expert on the art of Mongol Persia, the book reproduced all 59 folios of our manuscript in colour. Our pages of the *Compendium* then went on show in exhibitions across Europe, Australia, the Middle East and the US.

In this way, I've tried to keep alive the memory of this Persian giant, who bridged the worlds of medicine and theology, politics and history, Judaism and Islam, as well as honouring the magnificent artists who worked alongside Rashid al-Din to create one of the finest illustrated manuscripts the world has ever seen.

I mentioned a second manuscript: a copy of the *Shahnamah* – the *Book of Kings* – made for the Safavid ruler Shah Tahmasp. Unlike the *Compendium*, many copies of the *Shahnamah* have survived, but Shah Tahmasp's is the most magnificent. The *Shahnamah* is an epic poem by Ferdowsi, born near the Persian city of Tus in the province of Khorasan in *c.*935. He spent more than 30 years writing this mammoth work, which consists of over 50,000 rhyming couplets and relates the history and mythology of Persia from the beginning of time until the Islamic conquest in the seventh century. It was a love song to the spirit of an empire long gone, aiming to remind the Persians of their glorious history in difficult times, and it's a rich and thrilling story, full of heroes and villains, dragons and demons, lovers and assassins, and the eternal battle between good and evil. There's plenty of evidence to suggest that the *Shahnamah* inspired J.R.R. Tolkien and C.S. Lewis, who discussed the epic in Oxford as part of their reading group, the Inklings.

At first, Ferdowsi had suffered a crushing rejection. After completing his poem in 1010, he is said to have presented it to King

Mahmud of Ghazna, expecting 60,000 gold pieces as a reward. The king underpaid him, so Ferdowsi paid him back with a scalding satire. This didn't help, and he never managed to get the recognition he deserved. Ferdowsi died in poverty in *c.*1020, unaware that Persians would cherish his poem as their national epic for the next thousand years. Painters would recreate scenes of heroism from the *Shahnamah* in spectacular miniatures, and Persian rulers would commission beautifully illustrated copies of the poem, using it in part as a propaganda tool to reinforce their legitimacy as successors to the great kings of the past.

The *Shahnamah* made for Shah Tahmasp – often referred to as the 'Houghton' *Shahnamah* – is without a doubt the most celebrated copy of Ferdowsi's text, and one of the most wonderfully illustrated manuscripts the world has ever seen. A correspondent for *Art News* compared opening its pages to 'seeing the Sistine ceiling for the first time'. Scholars have suggested that work began on it around 1522, commissioned by the first Safavid ruler of Persia, Shah Isma'il. He died two years later, but the manuscript was completed around 1540 for his son and successor, Shah Tahmasp. In 1568, Shah Tahmasp gave it as an accession gift to Sultan Selim II, the new ruler of the Ottoman Empire. Shah Tahmasp, who sent 34 camels to Turkey bearing gifts for Selim, apparently was willing to give up his prize manuscript in the pursuit of peace. I can understand that.

Shah Tahmasp's *Shahnamah* was created over two decades in the royal atelier in Tabriz. The project brought together the greatest painters, illuminators and calligraphers of the time, led by famous artists of the day such as Sultan Muhammad, Mir Musavvir and Aqa

Mirak. The large-format manuscript has 759 folios of paper sprinkled with gold and illustrated with 258 magnificent miniature paintings. It is a starlit ride through a dream. According to the estimate of scholars, it was the work of at least fifteen painters, two calligraphers, two or more illuminators, and many other artists who did everything from burnishing the pages to sprinkling them with gold. In 2011, the Metropolitan Museum of Art in New York published the entire cycle of paintings, noting that it is

'universally recognized as the greatest of all Iranian illustrated manuscripts, perhaps of any culture or period . . . [It] remains unsurpassed as both the apogee of Persian miniature painting and a culmination of the arts of the book.'

So how did I come to buy ten folios from this unparalleled manuscript, which had once belonged to the all-powerful rulers of mighty empires? This particular story is quite a tangled one, but it shines a light on the long and winding paths that great works of art sometimes take through time and space.

Sultan Selim died in 1574, but his *Shahnamah* stayed in Turkey for centuries, safely stored in the Ottoman royal libraries in Istanbul. By 1903, it had travelled to Paris, where it entered the collection of Baron Edmond de Rothschild. When Edmond died in 1934 the *Shahnamah* passed to his son, Maurice de Rothschild; he tried to sell it to the shah of Iran, but the shah's advisors failed to appreciate its value. The manuscript stayed in the Rothschild family until Maurice's death in 1957, after which his heirs sent the manuscript to a dealer in New York

in the hope of finding a buyer. It was then that things got complicated. A man named Stuart Cary Welch, a renowned scholar who curated Harvard University's collections of Islamic and Indian art for decades, tried to help find a good home for the manuscript. He showed the manuscript to Arthur Houghton Jr, a respectable figure in the world of collecting, who'd made a fortune in the glass business. In 1942, he'd helped establish Harvard's Houghton Library, which displayed many of the rare books and manuscripts he'd collected since graduating from the university. He also served briefly as curator of rare books at the Library of Congress and sat on the board of the Metropolitan Museum of Art, ultimately becoming its president and chairman. It's easy to see why Welch placed his trust in Houghton, and perhaps hoped the manuscript would end up being donated to the Met. But this was not to be.

Houghton bought the *Shahnamah*, paying $450,000 for it in 1959. Later, under intense pressure to pay outstanding taxes, he tried several times to sell the manuscript to the Iranian government, hoping this time around they would be interested, after they'd rejected Maurice de Rothschild's offer years before. Houghton offered it for $2 million, which at the time was a record price, but still reasonable for one of the finest and most precious objects that Iran had ever produced. There were many delays in closing the deal and, after a long correspondence, the Iranian government sent a well-known expert to America to authenticate the manuscript. On returning to Iran, the expert – a friend of my father's actually – strongly recommended the purchase, but the government still refused to buy it. So, Houghton offered the book to the US government in lieu of his taxes. The government

rejected his offer, apparently refusing to accept his valuation of the manuscript.

Finally, at the US government's suggestion, Houghton agreed to break up the manuscript and sell it bit by bit, so dispersing an irreplaceable masterpiece that had remained intact for over 500 years. In return for a significant tax break, he donated 78 out of 258 of its illustrations to the Metropolitan Museum in 1970. In 1976, he sold a few more folios through an auction at Christie's and a London dealer called Agnew's. In 1988, he sold another 14 folios at Christie's. In 1996, four folios went up for auction at Sotheby's. One of the buyers was the Aga Khan, who now has five folios. We bought our first painting from this manuscript at a Christie's sale in 1993. The auction prices were consistently high, with one folio alone fetching $3 million. The Iranian and US governments must have realised what a prize they had allowed to slip through their fingers. There were also private sales. One of the buyers was Hashem Khosrovani, the Iranian friend who sold me our portion of Rashid al-Din's *Compendium of Chronicles* and other rare treasures.

In 1995, Hashem called to ask if we could meet in London, where he lived in a charming house on Eaton Square filled with spectacular Qajar objects. He came to see me in my office in Mayfair and said that he'd decided to sell his collection of miniatures, since his new wife did not share his enthusiasm for Persian art. Sometimes it is the tiniest things that push forward a story. Remembering that our dealings in the past had always been quick and friendly, he came to me first to see if I'd be interested in buying this group of paintings. It was such a treasure trove that I couldn't believe my luck – the group included

about three-dozen major miniatures and nine of the most fabulous folios from Tahmasp's *Shahnamah*. My excitement was genuinely hard to contain. Tapping my feet nervously under the table, some of the greatest ever Persian masterpieces were now within my reach.

Hashem knew that what he had was a real treasure and was willing to sell all these paintings to me on two conditions.

'I'll give you a price,' he said, 'and I'll give you a date when you have to pay me. If you agree to both conditions immediately, then we have a deal.'

I couldn't stand the waiting.

'Hashem, shoot,' I replied. 'Tell me.'

He looked me in the eye and threw out a huge figure – an amount he could not possibly have achieved on the open market at that time – and asked me to pay him within seven days.

I didn't hesitate.

'It's a deal,' I told him, extending my hand. I knew I was paying a colossal sum, but I also knew it was an opportunity I would never have again. We shook hands and, with that, I sealed one of the landmark deals of my life.

I never tire of looking at the paintings in our ten folios from Tahmasp's *Shahnamah*. Four of our paintings are believed to be the work of Sultan Muhammad, the chief painter at Shah Tahmasp's court and the greatest Persian miniaturist of his time. The mastery that Sultan Muhammad showed in the paintings of this *Shahnamah*, wrote one of his peers in 1546, was 'such that the hearts of the boldest painters were grieved, and they hung their heads in shame'. This same chronicler also testifies to the superior skill of two other painters of the Tahmasp

Shahnamah, Aqa Mirak and Mir Musavvir, both represented in our collection, and said to have illustrated the book 'so beautifully that the pen is inadequate to describe their merits'.

There's no question that Houghton's taking apart of the Tahmasp *Shahnamah* was a real tragedy to those of us who see conservation as a sacred duty. The only consolation, I guess you could say, can be found in the fact that by having these folios scattered to so many different parts of the world, many people, artists and scholars could experience their splendour first-hand. But the strange story of the Tahmasp *Shahnamah* did not stop even there. When Arthur Houghton died in 1990, he still had 118 out of the 258 paintings, as well as the body of the text and the original binding. His executors decided to sell these, and I was offered the chance to buy them. It wasn't quite right for me at the time – it was a tough period for the global economy, and it wasn't an easy sale. In the end, Oliver Hoare arranged an unconventional deal between Houghton's estate and the Tehran Museum of Contemporary Art. The 118 illustrations, over 600 folios of text, including some with fabulous illuminations, and the binding were valued at $20 million. Hoare agreed to exchange these for Willem de Kooning's painting *Woman III*, which the Iranian authorities had taken down from display after the revolution, considering it 'un-Islamic'. The swap took place at the airport in Vienna, where a van arrived carrying what was left of the *Shahnamah*. The security was so tight that the van was chained to an unmarked plane from Tehran while both sides checked over the objects. The manuscript was then flown back to Iran, where it has stayed ever since.

Over the next two decades, the market value of paintings from Tahmasp's *Shahnamah* continued to climb. In April 2011, Sotheby's sold a single illustrated folio from it for close to £8 million, which gives a clue to what our ten folios might cost if we were to buy them today. At the time, this was an auction record for an Islamic work of art. As for de Kooning's *Woman III*, it was eventually sold in 1994 to American music and film producer David Geffen through a dealer in Zurich, and in 2006 he reportedly sold it to the billionaire investor Steven Cohen for $137.5 million. It is absolutely fascinating to see the stories artworks accumulate, and the lives of people they touch, as pieces change hands and move around the world.

Do I regret not buying those 118 paintings of the *Shahnamah*? Of course. But I don't dwell on it. There's a rightness to their return home to Iran, where they were made. In any case, we do have other complete copies of the *Shahnamah* in our collection that are historically and artistically important. These include one completed in Shiraz around 1550, which was presented to Prince Murad Baksh, a son of Shah Jahan, sometime around 1646, and stayed with him until his arrest and eventual execution by his brother Awrangzeb, who took away all his possessions. It later passed on to Awrangzeb's son, Shah 'Alam I, and stayed in India until the early nineteenth century. It was eventually sold at Sotheby's in 1935. Another fine *Shahnamah* with 62 illustrations was copied in Isfahan in 1602 but, by 1609, had made its way to the library of the Mughal emperor Jahangir, as a note in his own hand says. It must have stayed in imperial Mughal hands for the better part of the seventeenth century, as it is mentioned in notes

written by various librarians and officials of Shah Jahan and Awrang-zeb. I love to follow the extraordinary odysseys of these works through history.

By now, Marion and I had made our home in Hampstead, London, and soon we would be joined by our sons, Daniel, Benjamin and Raphael. This was a new chapter of life – I'd made a good deal of money in the hurly-burly of those New York days, rushing from gallery to gallery, buying and selling, taking profit where I could, and meanwhile keeping back the best pieces I came across for my own collection. Through the 1980s I invested in other areas, especially property, and gave my energies to family life and my increasingly serious sense of mission as a collector. So, as I've described, I would track and exult in Islamic manuscripts not just for their content, subject matter and origin stories, but also for the quality of their calligraphy, illumination, illustrations and bindings. Nowhere are these qualities more clearly or movingly shown than in copies of the Qur'an.

The earliest Qur'ans were written on parchment, made by curing, scraping, sanding and drying the skin of an animal, typically a sheep or goat. Unfortunately, most of the surviving material from before the year 1000 is in fragments – often no more than a single folio or part of one. They survived because the Qur'an is a divine book, and so couldn't be thrown away. One of our exceedingly early pages, dating from the eighth century, measures an extraordinary 54 by 69 centimetres, and is from the largest-known Kufic Qur'an to have been copied on parchment. It was probably written in North Africa before moving

eastwards – eventually to Uzbekistan – and apparently carried by Arabs as Islam spread into Central Asia.

Given that parchment, like paper, is vulnerable to damage by water and fire, it's not surprising that hardly any complete early Kufic Qur'ans – Kufic being the oldest known type of Arabic script – have survived. For years, I was desperately looking for one without much luck. Then, one day in April 1989, as I was looking through a Christie's sale catalogue, I saw a complete, single-volume miniature copy datable to the tenth century. I was completely thrilled. The manuscript began with a spread giving statistics, followed by a double-page of illumination. Written in black ink and illuminated in gold and watercolour, it was in incredibly good condition considering its age. It had been rebound in Qajar lacquer covers and a missing page had been replaced, but these were minor issues.

Gradually, the format and size of Qur'ans changed, along with the materials used. By the eleventh century, parchment and vellum were largely replaced by paper. Meanwhile, more refined scripts were developed. Calligraphy always held a pre-eminent position in Islamic art. As the medium through which the Qur'an was transcribed, the Arabic script was awarded special status in Islamic society and, without really having religious imagery to rely on in the way other religions have, the written word became the most celebrated form of spiritual expression. Calligraphers used a reed pen, its point cut at different angles depending on the script. The writing was often so beautiful that there was no need for any decoration beyond the script.

The most famous Islamic calligrapher of the late Middle Ages was Yaqut al-Musta'simi. Born in Anatolia in the early thirteenth

century, he was a eunuch who served as a secretary to the last Abbasid caliph in Baghdad. In fact, his name was so legendary, it is said that when the Mongols conquered Baghdad in 1258, they ordered for him to be captured alive. When soldiers ran through the city asking, 'Who is Yaqut?' many raised their hands saying they were him, in a kind of 'I'm Spartacus!' moment. Yaqut (meaning ruby) was incredibly respected for his skill in the Six Pens – *naskh, thulth, muhaqqaq, rayhan, tawqi'* and *riqa'* – which are the six scripts that he helped to establish as the classical styles of Qur'anic calligraphers.

Luckily, our collection includes a superb example of his work, in a section from a 30-part Qur'an that Yaqut created in Iraq in 1282. Very few Qur'ans copied by Yaqut have survived, which makes our section incredibly rare. Additionally, it is the only one that has survived with its original decoration – a frontispiece, which is a stunning example of medieval illumination. The opening and closing spreads are also beautifully decorated, with just three lines of script per page. Yaqut made Baghdad the epicentre of Qur'anic calligraphy, and his version of the Six Pens stayed in use until the seventeenth century.

Qur'ans commissioned by the Mamluks, who ruled over Egypt and Syria from 1250 until 1517, stand out for their size and the bold geometric designs that form part of their decoration. One of our Mamluk Qur'ans was copied and illuminated in gold by a man named Ahmad ibn 'Ali al-'Ajami (meaning 'the foreigner'). This suggests that he may have been originally from Anatolia, drawn to Egypt in search of Mamluk patronage. Its spectacular frontispiece is a careful copy of another celebrated Qur'an, made around 1369–72 for the Mamluk

amir Arghunshah al-Ashrafi, which is now in the National Library, Cairo. Only a few Qu'rans were written in gold during this period.

Great calligraphers were always deeply respected by Muslim rulers and wealthy patrons. One of the greatest Ottoman calligraphers, Sheikh Hamdullah al-Amasi (1436–1520), taught the art of calligraphy to the Ottoman Sultan Bayezid II (1447–1512). As the legend goes, one night, as Sheikh Hamdullah was working, he reached for the inkwell with the tip of his pen to find that his sultan was sitting there holding the inkwell for him.

'Your Majesty, this is a great honour,' Hamdullah said, astonished.

'As long as there are calligraphers like you,' the Sultan answered, 'there should be a sultan holding the inkwell for them.'

It's true that some of the stories associated with these enchanting works might have been told by Sheherazade. Think of the gigantic Qur'an widely believed to have been copied by a calligrapher named Umar al-Aqta for Timur (Tamerlane) sometime around 1400–5. The Timurid dynasty ruled large parts of Central and South Asia, and gave birth to two empires, the Timurid Empire (1370–1507) and Mughal Empire (1526–1857). Wanting to amaze the ruler, Umar al-Aqta presented him with a manuscript so tiny that it could fit under a signet ring. But Timur was not impressed. So, Umar went away and wrote a Qur'an so large it had to be wheeled in on a cart. This time Timur was duly impressed, and the calligrapher was rewarded accordingly. Copied on one side of large sheets of paper, the written area alone (excluding the margins) measures 177 by 101 centimetres – even more remarkable when we remember that Umar al-Aqta had only

one hand, his left: 'al-Aqta' means 'the one handed'. Only a few pages survive from the original, and we're lucky to have a single-line fragment from it in the collection.

One afternoon in 1984, a dealer I trusted came to my office with a catalogue from a private library in Hammamet, a town in Tunisia. He explained that a well-known Tunisian scholar had recently died, leaving his valuable private collection of books and manuscripts to his two daughters. The scholar was a pious man who was said to have visited Mecca about 30 times. His daughters now planned to sell his library.

Most of the items listed in the catalogue weren't suitable for me. But, as I was looking through it, my attention snagged on an interesting reference to a Qur'an copied in Valencia in 1199, the work of a calligrapher from Spain named Yusuf ibn 'Abdallah ibn 'Abd al-Wahid ibn Yusuf ibn Khaldun. Together with the name of the calligrapher and the date of completion, and, unusually for Qur'ans of this date, the information in the two-page colophon (an inscription at the end of a book or manuscript usually with facts about its production) included the name of the city where it was made and that of the Spanish patron who had commissioned it. I had never seen anything quite like it.

I told the dealer we should go, both of us, and straightaway. So we took the first available flight to Tunisia and headed by car to Hammamet, around an hour's drive south-east of Tunis. Next morning, we were browsing the late scholar's library – an impressive collection, containing hundreds of volumes, mostly printed works on a wide range of subjects, with a few handwritten manuscripts. Still, only one

item interested me: the Qur'an. And there was a catch: the scholar's daughters insisted that they would only sell everything as one lot.

Luckily, my dealer was interested in the other items in the library, so we bought the whole lot between us. I took the Qur'an with me to the hotel, and barely slept that night as I stared in admiration at its marvellous calligraphy and intricate illumination. Page after page was magical – the fine Andalusian script, the stunning geometric patterns. Early next morning, I was walking into the hotel lobby, planning to spend the day sightseeing, when suddenly I found myself face-to-face with the two daughters, who had clearly been waiting for me. I panicked, wondering if they'd changed their minds. But these young women spoke with such disarming warmth that I set aside my worries and invited them to breakfast. One of the sisters explained that she had dreamed about her father the night before.

'In my dream,' she said, 'my father told me that the Qur'an which he'd preserved and cherished for so many years had now fallen into the hands of someone who recognised its significance. And he was happy. My father said this Qur'an has gone to a safer place and reached its rightful guardian.'

The sisters seemed disturbed by the dream, not sure why they felt the need to tell me or what to think of it, and probably nervous about what my reaction would be. They weren't to know that I was used to my mother's dreams, which so often got to the heart of things, and that I was entirely open to such messages. I assured the sisters that I would share their father's Qur'an with the world, and that their father was right that his precious book had found its guardian.

*

By 1990, with the number of our Qur'anic materials nearing 500, I was satisfied that my goal of establishing a truly significant collection had been accomplished. But the soul of a hunter never gets tired, and there was one extraordinary Qur'an I still longed to acquire – one of the most important royal Qur'ans to have survived from the sixteenth century, copied in Shiraz or Qazvin in 1552, its large format of 43 by 30 centimetres, together with the splendid quality and richness of the illumination and the fine calligraphy, all indicating that it was a royal commission from the Safavid ruler Shah Tahmasp, of the famous *Shahnamah*. Some parts of the text are written in gold, others in lapis blue, and the pages are delicately decorated with floral scrolls, blossoms and flower chains. This high standard is matched by the quality of the binding, almost identical to that of the glorious *Shahnamah* made for the shah completed shortly before. Incidentally, other than the Qur'an and the folios from the *Shahnamah*, we are also incredibly blessed to possess the royal seal of this great patron, made of flawless crystal and dated 963 AH (AD 1555–6).

The Qur'an was later presented to Mughal emperor Shah Jahan, commissioner of the Taj Mahal, most probably by a contemporary Safavid dynasty shah; a note on one of its flyleaves is even written in Shah Jahan's own hand. Other inscriptions in this Qur'an belong to court officials from the reigns of his son Awrangzeb (who records having inspected the Qur'an himself) and his successor, Shah 'Alam I. Some of these officials had the title of *khwajah*, which suggests they may have been eunuchs and that the Qur'an was kept for a time in the women's quarters of the imperial palace.

It's a work of huge importance both aesthetically and historically, giving us an unprecedented look into the tastes, beliefs and practices of those who ruled the Persian and Mughal empires, and it happened to belong to my friend Hashem Khosrovani. At a time when he was shifting his interests, I approached him yet again and was lucky enough to be able to add this extraordinary manuscript to our collection.

You see, profit was never my objective. Financial considerations seemed irrelevant when put up against my curiosity, love and the feeling of obligation I had towards these great works of art. In the early days, collectors may have revered the Qur'an for religious and cultural reasons, but few seemed excited by the artistic qualities that distinguished the finer manuscripts. The subtle beauty of calligraphy went widely unrecognised, but to me the lines of delicate script were like trails of light, gliding across the pages. While many collectors were slow to recognise the artistic importance of great Qur'ans and other calligraphic treasures in the 1970s and 1980s, I seized the moment. I was lucky, I suppose, that my enthusiasm for these works coincided with such an unusual opportunity. Today, the competition to acquire such rarities is incredibly intense, the market full of deep-pocketed private collectors, distinguished institutions and museums from the Muslim world and beyond. Meanwhile, the pool of genuinely great Qur'ans and other objects has proven to have been even smaller than many realised. As a result, the prices have gone up extensively over the years and it's virtually impossible for anyone, even those with almost unlimited budgets, to find decent pieces – let alone put together a body of material like that in our collection.

Some people wonder why as a Jew I should have dedicated so much of my time and effort to collecting the absolute best examples of Islamic art – 28,000 objects now, ranging from Qur'ans, rare manuscripts, miniature paintings, calligraphy and Arabic papyri, to carpets, textiles, carved stones, metalwork, arms, armour, scientific instruments, ceramics and glass as well as lacquer, jewellery, coins, seals and talismans. Growing up the way I did, in the peaceful coexistence and tolerance of Tehran in the 1950s, I've always felt a profound kinship with and reverence for the spirituality of my Muslim cousins. I have such a strong sense of being members of the same Abrahamic family. And perhaps I feel a particular sense of obligation towards these Qu'rans, my cousins' holy book, and the heart of the Islamic collection I have built up over half a century. Every part of the Islamic world and every period are represented in our Qur'an selection: from the Middle East, Indonesia and China in the Far East through to Spain, the Balkans and Sicily; from the early eighth century to the late nineteenth, when printed copies became more readily available.

I'm haunted by the story of the burning of Islamic manuscripts in Granada by Francisco Jiménez de Cisneros, a Spanish cardinal who took a hard line towards the Muslim community of the city in 1499. Cisneros was a former lawyer of Roman law, and a favourite of Pope Pius II, before giving up his worldly possessions and becoming a Franciscan monk during the reign of Isabella I of Castile. He was famous for his strict character and tough discipline, and was appointed as confessor to the queen in 1492. It was a tumultuous moment: the Jews of Spain were expelled the same year; Columbus set sail on his first voyage; the Inquisition was at full strength; Granada was reconquered

by Isabella I from Muhammad XII, ending hundreds of years of Muslim rule in the city by the Nasrid dynasty. Granada was one of the last safe havens of non-Christian traditions left in the country, but this changed when Isabella decided to bring the Inquisition to Granada in 1499, headed by Cisneros, now Archbishop of Toledo. Apparently to encourage mass conversions, and perhaps as a brutal show of strength, Cisneros ordered the public burning of around 5,000 Arabic manuscripts, holding back only some medical texts. Who knows what wonders we lost in that fire, in addition to the dream of a multi-faith city like the one I grew up in?

~ 10 ~

The Art of Pilgrimage

Over the years, in the process of collecting Islamic art, I'd acquired many objects related to Hajj, the annual pilgrimage to Mecca, birthplace of the Prophet Muhammad, a journey all able-bodied Muslims are expected to make at least once in their lives. Hajj is a great gathering of human beings. Dressed in their white ritual garments, the pilgrims stand shoulder to shoulder, toe to toe, equal before God, regardless of sect, race, gender, wealth or rank: this is Islam at its most harmonious and pure. It's extraordinary to think of this vast gathering of people – over 3 million were recorded in 2012 – converging from all regions of the Earth, all united in their faith and their shared sense of meaning and duty.

During my years in New York, I'd bought a beautiful textile embroidered with Qur'anic verses, and although I hadn't known this at the time, it turned out to be a panel from a four-sided covering to the Maqam Ibrahim ('Place of Abraham'), a shrine in Mecca that houses the stone Abraham is said to have stood on while working on

the holy site. The Maqam stands next to the most sacred building in all of Islam, the Ka'bah, and the story behind this piece of woven cloth I'd chanced upon inspired me to continue collecting whatever I could find relating to Hajj and the two holy cities of Mecca and Medina: Qur'ans, illustrated manuscripts, rare books, scientific instruments, textiles, coins, paintings, prints and postcards, as well as archival material, unique historical documents and examples of the work of some of the earliest Muslim photographers of the Hajj – a trove of wonders.

A personal favourite among these, and one which also demonstrates the crossover between our main Islamic collection and this one, which formed out of it and is dedicated to Hajj, is a sixteenth-century miniature painting from our *Shahnamah*, showing Alexander the Great kneeling humbly beside the Ka'bah. With his hands outstretched in prayer, we see his soldiers standing in a circle around him, facing the Ka'bah, their backs to us. 'It's so moving,' former director of the British Museum, Neil MacGregor, says of this painting: 'the supreme worldly, earthly power submits and respects a higher power. It's an acknowledgement by the most powerful man on earth of a higher, more significant power.'

Alexander predates Islam by almost a thousand years, but the Ka'bah was in fact a place of worship before the birth of Islam itself. According to the Qur'an, Abraham of the Old Testament played a crucial role as the restorer of a monotheistic faith that would centre on a sacred building in the barren valley of 'Bacca' – or Mecca, as it later became known. One of the Psalms (84:6) grants blessings to those 'who have set their hearts on pilgrimage. As they pass through

The emerald box set with 103 stones, Mughal India, circa 1635, gold, emerald, diamond, enamel base 4 x 5 cm

The Prophet Muhammad's night ride, known as mi'raj, upon his fabled horse Buraq, and the Al-Aqsa mosque in Jerusalem (left) and The Queen of the fairies in Paradise (below right), India, probably Golconda, circa 1610-30, 30.5 x 21 cm each. Shah Jahan (below left) on his lunar birthday in 1632 at the Red Fort, with elephants fighting, Mughal India, circa 1640-45, watercolour and gold on paper, 33.5 x 20.5 cm

Pages from Awrangzeb's 'lost' album, India, late 17th century, 40.5 x 32 cm

Laqabi-ware dish with peacock,
Raqqa circa 1200, stonepaste,
coloured glaze, 6 x 29.7cm

A monumental planispheric astrolabe made for
Shah Jahan, made in 1648-58, Punjab, Lahore,
brass and silver-inlaid, diameter 52.6 cm height
60.2 cm (excluding shackle and suspension ring)

Illustrations from the Compendium: From the top: Noah, reclining on his arc;
Jonah emerging from the whale; and the Death of Moses;
Tabriz, Iran, 1314-15, 10-14 x 25.5 cm each

Our hookah, from Mewar (Rajasthan), India, circa 1700, gold and champlevé enamels, height 43cm, 3.5 kg

Early 13th century brass and silver-inlaid casket with the remains of a combination lock, Jazira, northern Iraq, 20.5 x 19.5 x 16 cm

Faranak, mother of mythical king Fereydun, sends gifts to her son, (right) and The musician Barbad conceals himself in a tree (below) from Firdawsi's Shahnameh made for Shah Tahmasp, Tabriz, Iran, 1520s, 37.4 x 17.5 cm

Page from a large, 8th century North African qur'an, 54 x 69 cm

Single-volume
Mamluk Qur'an,
written in gold,
Cairo, 1382-3,
43.1 x 30.6 cm

Spread from the 'Shah Tahmasp'
Qur'an, Iran, Shiraz or Qazvin,
dated Sha'ban 959 (July –August
1552), 20.5 x 13 cm

Seal of Shah Tahmasp
made of flawless crystal,
Qazvin, Iran, dated 963 AH
(1555–6 AD), rock crystal,
3.1 x 2.4cm

Pages from a qur'an by Yaqut al-Musta'simi, Baghdad, 1282, 24.5 x 17 cm

A line from the exceptionally large 'Baysunqur Qur'an',
Herat or Samarkand, circa 1400–05 AD, 24 x 96.5cm.

Pages from the Valencian Qur'an, dated 1199–1200, 17 x 16 cm

Curtain for the door of the Ka'bah, Cairo, Egypt, dated 1606, black silk, with coloured silk appliqués, silver and silver-gilt wire 499 x 271cm

Qiblah Compass, Istanbul, Turkey, 18th century, engraved brass plate on a wooden base, watercolour and gold on paper, 20.2 x 18 cm (overall)

the Valley of Bacca . . .' In the Qur'an too, 'Bacca' is described as 'a blessed place; a source of guidance for all people' (Surah Al 'Imran, verse 96), and we learn how Abraham was instructed specifically to make this place a point of pilgrimage, sanctuary and peace:

'We showed Abraham the site of the House, saying "do not assign partners to Me. Purify My House for those who circle around it, those who stand to pray, and those who bow and prostrate themselves." (Surah al-Hajj, verse 26)'

Abraham, in other words, was a key figure in the construction of this sacred building, the Ka'bah, and in making it a centre of pilgrimage and the worship of the One God. Abraham becomes *Ibrahim Khalil Allah* – the most cherished friend of God – and scholars referred to Mecca as 'the City of Abraham'. Abraham even established the core Hajj rituals: Hajj had been performed by pilgrims for centuries, and even after the Jews left Mecca and stopped visiting it, descendants of Isaac continued to regard the Ka'bah as a holy temple. Such a story resonates so deeply with me as a Jewish person who grew up among my Muslim brothers and sisters in Tehran; most of the set rituals of Hajj recall episodes from the life of Abraham and his son Ishmael, and here again were the stories of Jews and Muslims interwoven so closely you could hardly begin to unpick the threads.

Muslims have been performing what we know as Hajj since 632 – the year of the Prophet Muhammad's death and of his first and last officiating of Hajj rituals in what is called the Farewell Pilgrimage. Today, the most iconic image of the Hajj is probably a huge mass of

pilgrims moving round the Ka'bah, majestically dressed in its gold-embroidered black cloth, the *kiswah*. The structure itself is simple, and surprisingly small – strange, compared to the architectural wonders of other religious buildings. But this humility is part of the Ka'bah's power and magic.

The Prophet Muhammad was the first person to place a *kiswah* over the Ka'bah. Since then, a new cover has been draped over it at least once a year. Caliphs, sultans and kings took great pride in the responsibility of providing the *kiswah*, and no expense was spared in the production of this gift to the House of God. When the textiles were replaced, the old ones were divided up and distributed to pilgrims by the Bani Shayba, an Arab tribe whose role as custodians and key holders of the Ka'bah was laid down by a verse in the Qur'an and a *hadith* of the Prophet Muhammad: 'Take the key, O Bani Talha, eternally up to the Day of Resurrection, and it will not be taken from you unless by an unjust, oppressive tyrant.'

For years, finding embroidered textiles relating to Mecca and Medina was extremely hard. I bought what I could find, through auction houses and individual suppliers, but one only came across such pieces haphazardly, often not even knowing their connection to the Hajj. Except for a selection of textiles in Istanbul's Topkapı Saray Museum, there was little research to speak of, or chance to view these works of such religious and cultural meaning. But I persevered, quietly and steadily building up our collection of these magnificent textiles over five decades, until today we have close to 350 of them, making ours the largest and most significant collection of such material in private

hands. Our group of 34 Ka'bah door curtains represents every known style and type made between the early seventeenth century and the modern day. Heavily embroidered in silver and silver-gilt wire, these are by far the most spectacular of the pilgrimage-related arts. I can only imagine (and often do) the effect of seeing these textiles dazzling in the sunlight after a long and draining journey. I think of the pure awe they would inspire, and the power of religious art to bring together eye, mind, soul and God.

Since the second half of the twentieth century, the *kiswah* has been made in Mecca, craftsmen spending approximately a year to produce the iconic gold-on-black *kiswah* of Saudi Arabia with a combination of modern technology and ancient craft, the new cloth containing 700kg of silk and 120kg of gold and silver thread. Historically, though, the textiles presented to the Ka'bah and the Prophet's Mosque were commissioned by whoever had sovereignty over the holy places, and were mostly made in Egypt and Istanbul, and sent to the holy site with the caravan of pilgrims. These caravans (sometimes described as 'cities on the move' – I love that) set out from Damascus and Baghdad as well as Cairo, and included pilgrims from much further afield. A caravan from Cairo lit up the imagination of many European observers via descriptions from the late nineteenth-century British explorer Sir Richard Burton, who conjured a Cecil B. DeMille vision of 'Seven thousand souls on foot, on horseback, in litters, or bestriding the splendid camels of Syria . . .'

The head of the caravan, the Amir al-Hajj, was responsible for the pilgrims and their safety, and he had a generous entourage that included judges, bakers and even vets. On the way were watering holes and inns,

called caravansaries, to provide the pilgrims not just with refreshments but also rest, safety from attack and shelter from heat. A *muwaqqit* (timekeeper) accompanied each caravan, responsible for announcing the hours when daily prayers were due and indicating the direction of the *qiblah* – the correct orientation of Mecca – so that the ritual prayer was conducted properly. Sophisticated instruments were developed in order to help in the task: we have several in the collection, including some beautifully decorated compasses.

From the thirteenth to the mid-twentieth centuries, the Egyptian caravan was distinguished by the *mahmal*, a wooden structure covered with a richly decorated textile and balanced on an equally decorated (and pampered) camel. As well as being a shining beacon of colour, and a symbol of blessings, the *mahmal* was more than anything a symbol of political sovereignty. First the Mamluks and later the Ottoman sultans sent a *mahmal* to accompany the new *kiswah* so as to emphasise their role as rulers over the Hijaz – the western region of Saudi Arabia – and protectors of the two Holy Sanctuaries. The *mahmal* was paraded through the streets of Cairo along with the textiles that were being sent to Mecca, before leaving the city with much fanfare and celebration, well-wishers touching it to receive a blessing. The *mahmal* would then formally accompany the pilgrims along the dangerous and difficult journey. Unlike the *kiswah*, the *mahmal* was not renewed every year, but repaired and reused over several years. Because of this, very few have survived, and we are fortunate enough to have seven of them in the collection.

Hajj had always been a massive event that needed a huge amount of organisation, administration and logistical genius. We have a won-

derful group of objects relating to the Hijaz Railway, which aimed to carry pilgrims directly from Damascus to Medina. Work on the line started in 1900 and took eight years. (The line from Medina to Mecca was never completed.) The railway operated until 1916, when parts were destroyed by Bedouin tribes inspired by T.E. Lawrence, and we have an album with 50-odd photographs showing the line in all its glory. The photos were taken by J.H. Halladjian, an Armenian photographer who travelled in Palestine, Jordan, Syria and the Hijaz in order to capture images of the railway and places along its route between 1905 and 1908, and each one is a little dream of modernity in the service of religious feeling.

Before arriving in Mecca, pilgrims put on the *ihram* clothing – two pieces of unstitched white cloth for men, and a long robe and head covering for women – and renounce all everyday pleasures and comforts: the change of clothes marks a transition to a pure state of being. Entering Mecca in *ihram*, pilgrims finally come face-to-face with the Ka'bah. Embedded in the eastern corner of the Ka'bah is the Black Stone (al-Hajar al-Aswad), which pilgrims must try to touch or salute while circling the Ka'bah seven times. There are many legends and speculations surrounding the stone (some have claimed it is a meteorite, and some that it is an agate) but, ultimately, it's revered by Muslims as the Prophet Muhammad revered it himself, as a part of the building erected by Abraham.

According to Islamic tradition, after being instructed from the heavens, Abraham travelled to Mecca with his eldest son Ishmael and the boy's mother Hagar, who, having been left alone, ran a course between two hills in search of water to quench her son's thirst. This

story is remembered when pilgrims perform the *sa'iy* Hajj ritual at Mecca – running between the two hills of Safa and Marwa, re-enacting a mother's search for water for her son. It was during Hagar's attempts to find water that the spring of Zamzam was discovered at Ishmael's feet, and it may be that the existence of this source as well as the sanctuary that developed around the Ka'bah is part of the reason why Mecca became such an important place of visitation, although for Muslims the benefits of Zamzam are not only that it satisfies thirst. A saying of the Prophet Muhammad states that it is 'beneficial for whatever aim it has been drunk for', and many use the water for spiritual healing as well as in burial rites. Zamzam has been the source of water for pilgrims visiting Mecca ever since, and now the King Abdullah Zamzam water project produces about 200,000 bottles a day.

When the pilgrims leave the Masjid al-Haram – the Great Mosque of Mecca, which surrounds the Ka'bah – the Hajj rituals continue with visits to sacred locations around the city: Mount Arafat, the plain of Muzdalifa and the valley of Mina. At Arafat, they perform the *wuquf* or 'standing' – the culmination (but not the end) of the Hajj. This simple act of standing on the plain of Arafat facing Mecca is the most important ritual of the whole pilgrimage: if pilgrims are delayed and don't get there in time, their Hajj will be null and void. Arafat in Islam also plays an important part before Abraham, as some Muslims believe it to be where Adam and Eve were reunited and forgiven after the fall from Heaven, hence the alternative name *Jabal ar-Rahmah*, 'Mountain of Mercy'. Following some additional rituals at Muzdalifa and Mina, the Hajj is complete, and the pilgrim is given a new

title: *Hajji* for a man and *Hajja* for a woman. Now they are free to return home.

Before the birth of photography and film, pilgrims who returned from the intense and glorious experience of Hajj had only stories and memories to share with their families and communities. And so, an entire rich artistic tradition developed, including immersive written accounts, all inspired by this great gathering at Mecca. Special manuals or guidebooks known as *Manasik* explained the complicated but necessary steps to be taken in a specific order and at specific dates for the Hajj to be performed correctly. The pages of an early sixteenth-century guidebook, the *Kitab Futuh al-Haramayn* ('Revelations of the Two Sanctuaries') by Muhyi al-Din Lari brim with colourful stylised representations of the different stations of pilgrimage, and sacred places to visit in the surrounding areas of Mecca and Medina, but almost always without showing the pilgrims themselves. That's not the case in the equally stunning guide *Anis al-Hujjaj* ('The Pilgrims' Companion') by Safi ibn Vali, who performed his Hajj in 1676–7 – a *Manasik* in many ways, with great advice to the reader on many different aspects of the journey from South Asia, including which ships to choose, how to stay healthy, which places to visit, which rituals need to be observed, and what kind of people the reader is likely to meet. Our copy is one of only five known to survive.

What makes this manuscript particularly special are the 18 illustrations that focus on the pilgrims themselves rather than the pilgrimage sites. Views of the ports of departure and arrival – Surat on the western coast of India, Mocha in Yemen, and Jeddah on the Red Sea – are shown instead of the usual depictions of the Holy

Sanctuaries. Pilgrims are shown on their way to the Hajj through the Sea of Oman, or performing daily tasks in caravan encampments, carrying out Hajj rituals, praying at holy sites near Mecca not usually associated with the Hajj. Two gorgeous paintings in the manuscript show official ceremonies that Safi ibn Vali saw himself – there's a wonderful feeling of an individual sensibility and mind, so that we experience these great events through the eyes of one man 400 years ago, thanks to art's time-overcoming magic.

It wasn't until the arrival of photography in the mid-nineteenth century that the pilgrimage and the holy cities were documented precisely as they are. The earliest images of Mecca, Medina and the Hajj were taken by the Egyptian photographer Sadiq Bey in 1861, 1880 and 1881, and we're lucky to be the proud owners of a complete set of these photographs, just as our collection contains examples of the work of pioneering photographers who came after him. But my favourite image of the Hajj isn't a photograph. One day in 2007, I received a phone call from Edward Gibbs at Sotheby's: he had something he was sure I'd be interested in. He was right: the most spectacular panoramic eyewitness view of Mecca I had ever seen. I couldn't believe it: the sheer size, the bright and fresh colours, the accuracy and likeness, the details, the composition. The painting was signed by Muhammad 'Abdallah, a relative (possibly a grandson) of Mazhar 'Ali Khan, who'd been commissioned by the sharif of Mecca to illustrate the sacred monuments of his realm. Muhammad 'Abdallah must have accompanied Mazhar on his travels, making his great painting of Mecca, around 1845, the second earliest known accurate eyewitness record of the city, after an oil painting of around 1713, now in Uppsala, Sweden.

From the vast to the miniature – I treasure a rare gold medallion which on one side shows Mecca with the *Masjid al-Haram* and the Ka'bah, and Arafat, Mina and Muzdalifa in the background, and on the other shows Medina with the Prophet's Mosque at its centre, and other holy sites outside the city walls. Made around the same time as Muhammad 'Abdallah's widescreen panorama, the medallion is only 3.7 centimetres in diameter yet still it conveys the impression of these sacred places in vivid detail.

Early in 2011, during a meeting at the British Museum to discuss loans to their forthcoming Hajj exhibition, Venetia Porter, the museum's curator of Islamic art, mentioned a talismanic shirt at the Topkayı Saray Museum, which, in addition to the Qur'anic text normally found on such shirts, also had illustrations of Mecca and Medina. I remember experiencing a little inward sigh, wishing such a piece could be part of our Hajj collection but knowing how desperately rare such things are. Months later, I was going through a Sotheby's Islamic sale catalogue and found – as if the force of my wishing had put it there – just such a talismanic shirt, inscribed with prayers and passages from the Qur'an as well as illustrations of the two Holy Sanctuaries. Made in India sometime in the fifteenth or early sixteenth centuries, it was most likely worn by a noble warrior under his armour to ensure protection and victory in battle. I shared the good news with Venetia. She examined the shirt, then looked at me with a smile.

'David,' she said, 'nothing surprises me any more about the things that happen in your collecting life!'

Our Hajj collection has grown to include around 5,000 objects, ranging from the eighth to the twenty-first centuries, from China and

India and around the globe to Morocco and the United Kingdom. A selection of these pieces featured in our *Arts of Islam* exhibition, which opened in Abu Dhabi in January 2008. The opportunity to display the collection more fully finally came up when I was invited by Venetia and Neil MacGregor to discuss the loans to their forthcoming exhibition. And so, in January 2012, *Hajj: Journey to the Heart of Islam* opened at the British Museum to great reviews and astonishing popularity. I have rarely been so proud. This landmark exhibition – hailed by the *Guardian* as 'one of the most brilliant exhibitions the British Museum has put on' – attracted 140,000 visitors in less than three months. It was truly thrilling. The pieces we lent to the British Museum, and to the Hajj exhibitions which followed at the Volkenkunde Museum in Leiden, the Institut du Monde Arabe in Paris and the Tropenmuseum in Amsterdam, were only a small portion of the collection, but nevertheless represented its scope and richness, and showed the combination of mesmerising visual beauty and powerful sense of religious and spiritual meaning that I had always found especially moving. Non-Muslims, who are restricted access to Mecca or participation in the Hajj, could finally connect with the experience of one of the five pillars of Islam, and one of the most powerful gatherings of human beings on the face of the planet. Finally, people of all faiths and none could encounter the spirit of Hajj.

~ II ~

Aramaic — An Interlude

My mother Hadassah was named for the Jewish heroine Esther, whose story I'd known since childhood – how King Ahasuerus, ruler of the Persian Empire, chose the Jewish orphan Esther as his bride; how she hid her Jewish heritage; how the king's spiteful advisor Haman plotted to eradicate all the Jews from Persia after Esther's kind, loyal uncle Mordechai refused to bow to him; and how Esther finally revealed her Jewish identity to her husband, securing protection for the Jewish people through her bravery and wisdom.

Ahasuerus is commonly identified with Xerxes I, one of the kings of the Achaemenid or First Persian Empire, the vast and powerful domain established by Cyrus the Great in 559 BC, centred on Iran but spreading to Europe and the Indus Valley, famous among other things for its advanced postal system, water irrigation technologies, air conditioning, sophisticated forms of refrigeration, teaching hospitals, the first declaration of human rights (on the so-called 'Cyrus cylinder') and even the first ever animated image: a leaping goat painted on a

bowl. (Famous also for its conquest by Alexander the Great in 331 BC.) Cyrus's rise to the throne of Persia brought in a period of tolerance to religious minorities, including the Jews, as alluded to in the wonderful tale of Esther. Being a truly international empire, the Achaemenids used several languages for book-keeping and correspondence. The main language used throughout the Persian Empire, however, was Aramaic.

Aramaic – even the word was clothed in magic. I remembered hearing a bit of it spoken as a boy on a visit to north-western Iran. It was the language of the Talmud (the central text of Rabbinic Judaism) and the Zohar (a set of books dedicated to Jewish mystical thought). It was the language of Moses, of Jesus and his Apostles.

Back in the early 1970s, I'd noticed ancient Aramaic documents surfacing on the art market, and heard that a shepherd or farmer had come across them in a cave in Afghanistan in the 1960s. (Afghanistan had been considered a cultural hub of the ancient Persian Empire.) As both a Persian and a Jew, I was curious. What light could these documents throw on life in the Persian Empire around 2,400 years ago? I chased them relentlessly for over a quarter of a century, buying them piecemeal from dozens of dealers and collectors around the world. I recruited a team of leading experts to conserve and study them, including professors Joseph Naveh and Shaul Shaked, leading scholars in the field of ancient languages. It felt like a kind of sacred duty, putting together the puzzle of the past.

What we had was a group of about 30 letters written in Aramaic in or near Balkh (in modern-day Afghanistan), the capital city of Bactria, between the years 353 and 324 BC – roughly 20 years before and

6 years after the death of Darius III, which signalled the end of the Achaemenid Empire. Unusually, these documents are written on leather, which makes them extremely rare: the only other known group written on leather is currently kept at the Bodleian Library in Oxford – a brilliant selection of Achaemenid documents written in Babylonia in the fourth century BC and discovered in Egypt in the 1930s.

Most of the letters are dispatches from a Bactrian satrap (a provincial governor in the ancient Persian Empire) called Akhvamazda, who was in charge of the administrative district of Bactria, addressed to another satrap called Bagavant, governor of an area within the district called Khulmi. Anointed by the king, satraps were usually members of the Persian nobility or even the royal family; though they held great power over their provinces, they were subjected to harsh inspections and management by the king. But the power dynamic between Akhvamazda and Bagavant is clear. In one letter, Akhvamazda tells him off: 'You have not done well by acting in disobedience and by not acting according to my law.' In another, written in 353 BC, he reprimands him for imprisoning some camel-keepers 'against my decree', imposing an improper tax, and confiscating from them a bull, 2 donkeys and 34 sheep. Akhvamazda ordered the rogue Bagavant to return their property, warning him: 'When you come [to me], you will be interrogated.'

Cheeky Bagavant did win at least one small victory against his exhausting boss, getting him to postpone building some fortifications around a town called Nikshapaya. Bagavant needed the troops for a more urgent problem: protecting local crops from locusts. (I love this glimpse into the priorities and compromises of empire management . . .)

Another letter in the collection simply records a long list of supplies distributed from a public warehouse over three months, including wheat, barley and wine. Not such a big deal, except the letter is from 324 BC, the seventh year of Alexander's reign, and these goods are going out into a world reeling from the collapse of empire: history is suddenly at our fingertips, in our mouths and noses, not just an abstraction of numbers and names.

Of course, anything connected with Alexander the Great was guaranteed to excite my curiosity. I had revered him since childhood, hearing my father tell stories of his triumphs, that unprecedented military campaign through Asia and north-east Africa, so that by the age of 30 he'd created one of the largest empires of the ancient world, stretching from Greece to north-western India. Walking around the ruins of Persepolis with my father, I felt so close to Alexander and Darius and Xerxes that they were more than historical figures to me. Two of our Aramaic letters have a direct connection to Alexander's reign. One of them, quite unbelievably, has survived in its sealed form and is still bound with the original seal impression. (We only allowed it to be unbound once, in the process of writing *Aramaic Documents from Ancient Bactria*, published in 2012: it was examined, photographed, then resealed.) It's incredibly rare to find an object like this in its original form. The seal impression is Alexander's, and it dates from 'Year 1' of an unspecified reign – Alexander's, 330 or 329 BC, around the time of the defeat and murder of Darius III, the destruction of Persepolis, one empire giving way to another. The letter deals with the dispatch of sheep, and once again these vast historical shifts are grounded in everyday life.

Another letter dates from the seventh year of Alexander's reign, corresponding to 8 June 324 BC. His name appears clearly as *Alexandros* on the top right, and this marks the earliest known occasion in written history where his original Greek name appears in Aramaic, through the addition of the 's', as opposed to the Eastern version, Iksandar, which in Aramaic became Lksndr. Alexander ended up as Iksandar because of the similarity of the Greek *Aléxandros* to the sound of the Arabic definite-article prefix *al-*. An Arabic speaker would have heard *Al-Lksandar*, hence *Al-Iksandar*, and the Aramaic hybrid *Lksndr*. The fact that his Greek name was beginning to appear on such common-place letters as this shows how his myth was growing and spreading throughout the empire: I love the way the tiniest detail can be a window into the landscape of the distant past.

According to Professor John Maxwell O'Brien, 324 BC was also the year Alexander discovered that the tomb of Cyrus the Great had been robbed and his bones scattered across the floor. Out of respect, Alexander is said to have returned the remains of this Persian king to his golden sarcophagus, restored the tomb and had its inscription translated into Greek. Plutarch records it: *Mortal! I am Cyrus son of Cambyses, who founded the Persian empire, and was King of Asia. Grudge me not then my monument.*

I have carried this with me for decades. The dignity of remembering. The way works of art, including monuments, give us a new way of being in time. This speaks to the heart of my sense of mission as a collector: I am trying to *preserve*. So these extraordinary, fragile pieces of ancient leather are kept in specially made boxes, in the dark, packed in special materials to ensure their condition stays at its best for

the generations to come. We can't reverse the effects of time, but we can work to keep these objects as close to their original condition as possible, in the hope that they might go on making people wonder at and dream of how our ancestors lived, and how our stories have unfolded.

I get the same kind of time-travel excitement from the 18 wooden sticks used as tallies to record debt, which sit alongside the Aramaic documents as a window into life in Bactria in the age of Alexander. Each stick is inscribed in ink, with notches carved into it – a form of basic book-keeping quite common in antiquity. Short sticks would be broken in two, the creditor keeping one half as a receipt until the debt was repaid. Our 18 tallies record provisions sent out from the satrap's stores in the third year of the reign of Darius III: grocery bills.

More than two millennia have passed since the Achaemenid Empire fell to Alexander: you can read about it in books, but nothing compares to the physicality of an object – a letter about sheep, written on leather, found in a cave – handled by people just like us, breathing, striving.

~ 12 ~

Making a Mark

If I am only known as simply having been wealthy when I'm gone, I would find that to be a real shame – I had the knack of making money; I know I've been lucky in that. But I don't see that as the same thing as success. Sometimes people ask me the secret of success, and my answer often confuses them. I say that the secret to gaining is giving. The more you share – knowledge, money, expertise, effort, time, love – the greater your success. Giving is not only how we succeed, but how we survive.

I'm not going to pretend that collecting, researching, conserving, publishing and exhibiting haven't been a source of immense personal pleasure, satisfaction and pride. But there is so much more to it than that. I always felt that I wasn't just doing it for my own behalf, but for future generations too – all those who might one day encounter these objects in museums and galleries, and find themselves inspired or delighted or enriched. I think of the Jewish tradition of *Tzedakah*, matched by the Islamic term *Sadaqah*, both of them equivalent to the 'charity' that St Paul named as one of the three spiritual virtues (the others being faith

and hope). The act of giving brings with it an abundance of blessings. When I was still a boy, my father would tip waiters generously in a restaurant in Tehran, then lean over and say quietly to me, 'We bring nothing into this world, and we take nothing from it. What's better than to give?'

From the very beginning of my collecting life, I have been committed to a vision that has now come to be known as 'Cultural Philanthropy' – the act of giving and sharing not just through conventional financial means, but also through the production and distribution of cultural knowledge. Beyond sharing their collections with the wider public through exhibitions and loans, I believe that a true collector has a responsibility to enrich our knowledge of the works they collect. Enabling and celebrating the pursuit and publication of scholarly research have been integral to my life as a collector. Planned for completion by the end of 2024, our enormous publication efforts will culminate in over 100 volumes of extensive scholarship relating to our eight collections. I want this knowledge to be as accessible as possible: as well as donating books to institutions all over the world, we regularly upload videos, websites, texts and images for Creative Commons use, and have collaborated with Wikipedia, Google Arts & Culture, Museum With No Frontiers and other organisations devoted to the widest possible access to art and culture. I've become increasingly convinced that digitisation is a central component of a collector's duties, alongside conservation, exhibition, research and publication.

My passion for art scholarship goes beyond our own collections, and I've done my best to encourage a new generation of art historians, especially in the field of Islamic art. In 1988, we made a significant endowment to establish the Khalili Chair of Islamic Art at the School

of Oriental and African Studies (SOAS) University of London, and in 2005 we made an endowment to the University of Oxford for the establishment of the Khalili Research Centre for the Art and Material Culture of the Middle East.

Our collections hold artworks from such a diverse range of cultures, places and periods, and my vision is to celebrate such diversity, removing barriers wherever possible – all those barriers that perpetuate suspicion of the 'other' and get in the way of an open-hearted appreciation of unfamiliar heritages and forms of creative expression. As such, we made the decision to support efforts that promote cultural diversity more widely. I quickly realised that the way we could have the most impact globally is by not re-inventing the wheel and by working with international organi-sations to create an amplified impact. So in 2021, in order to promote the World Day for Cultural Diversity, we produced a landmark book, with an introductory message from António Guterres, Secretary-General of the United Nations. This book marked the 20th anniversary of the UNESCO Universal Declaration on Cultural Diversity and included essays from the world's foremost thinkers and practitioners on the subject, including Peter Gabriel and Jimmy Wales, founder of Wikipedia. We ensured this book was distributed freely to students, scholars and decision-makers worldwide. For example, the UK Secretary of State for Education sent a copy of the book to university Vice Chancellors across England – with many university libraries subsequently housing it – and it was gifted to 54 Heads of Government during the Commonwealth Heads of Govern-ment Meeting (CHOGM) in 2022.

The book was so well received that it inspired the creation of the World Festival of Cultural Diversity – a year-round global campaign

or "meta-festival" that we have proudly continued to support in association with UNESCO. This has included several initiatives such as a year-long webinar series in partnership with the Aspen Institute titled 'Designing for Diversity', a UK-wide roadshow in collaboration with The Prince's Trust providing young people a platform to discuss diversity, a digital content campaign powered by Europeana and a major event at the Royal Institution spotlighting the global story of science.

Many institutions worldwide joined the Festival including major museums and cultural centres from Haiti, Peru, South Africa, Vietnam, Indonesia and Australia, just to name a few. Cultures represented included indigenous groups such as the aborigines of Australia, the Sami people of Norway, as well as nomadic communities such as the Roma people. It was a proud moment for me to see the Festival culminating in a grand event at the UNESCO HQ in Paris which saw a confluence of many of these beautiful cultural traditions through performances, artistic workshops and food from around the world. The event also screened a documentary film we produced with UNESCO called "A Thousand Colours", celebrating the diversity of creative expressions.

Naturally, I have many more plans to continue spreading the word of unity through culture for many years to come. Early in life I learned, as the proverb goes, that time waits for no man. I remember a story I heard many years ago and which is dear to my heart: a butterfly wanders through the forest, marvelling in the beauty of creation. Soon he encounters a resting bear and lands gently on his nose. Opening his eyes, the bears looks at the resplendent colours of the butterfly. The butterfly then says to the bear "you are such a curious creature

with such wise eyes, they seem to contain the knowledge of all creation. I'd love to learn your story". The bear then replies, "thank you small friend, you have all the colours under the sky and you can fly anywhere, and I'd love to hear your story too, but unfortunately, I am too tired, this is the time of hibernation for us bears after all", and saying that he fell into a deep slumber. And so, he missed out on the treasure of the butterfly's mind, as he did not know butterflies only live for a short while. In life, we should never waste any time because we never know what we might miss. And so I press on, try and put in motion new plans and ventures to better the realm of humanity. I cannot do this on my own, however, and I work hard to partner up and connect with many institutions around the world to achieve this dream. At the time of writing, I'm particularly excited about our new partnerships with the University of Cambridge and the United Nations Alliance of Civilisations.

The promotion of cultural diversity is natural to me given how vividly this manifests in our own collections. But to me, a key part of this is the diversity (and underlying unity) of faiths. I've felt this with particular urgency when it comes to the three Abrahamic faiths – Judaism, Christianity and Islam. I grew up as a Jew in a Muslim country, and have lived most of my adult life in predominantly Christian countries, so I feel those three great rivers running through me. In our Islamic collection we have a unique miniature, probably the frontispiece of a manuscript entitled *Tales of the Prophets* – a trove of stories from across history, featuring Jewish, Christian and Muslim prophets, figures of myth and legend. Commissioned by a Muslim patron and painted by a Muslim artist to celebrate the connection

between the three Abrahamic faiths, our miniature dates from the fifteenth century and shows Moses striking the giant Uj while to the left the young Jesus sits on the Virgin Mary's lap; in the foreground, you can see the Prophet Muhammad, his face veiled as tradition requires.

Why have those three traditions become so split off from each other in the modern world? Art teaches us the unity of the thoughts and feelings of humankind. Inspired by such thoughts, in 1995 I established the Maimonides Interfaith Initiative of the Maimonides Foundation, named for the great Jewish philosopher, astronomer and physician, who to me exemplified the spirit of interfaith harmony. He was born in Córdoba in 1138, towards the end of the golden age of Muslim rule in Spain – a golden age for the Jewish minority too, marked by such prodigies as Abraham ibn Ezra, Judah Halevi and Samuel Ha-Nagid, and a great flourishing of literature and music, until in 1148 a Berber dynasty called the Almohads conquered Córdoba and abolished the state protection of non-Muslims in the city. Maimonides chose exile with his family, and wandered around southern Spain for years, crossing over to North Africa to settle briefly in Fez and Morocco, before finally establishing himself in Fustat, a city which ended up becoming part of Cairo. There, he eventually became the personal physician to Salah al-Din Yusuf ibn Ayyub commonly known as Saladin – famous, amongst other things, for capturing Jerusalem in 1187 and weakening the hold of the Crusaders throughout the region – who was also the first sultan of both Egypt and Syria. Being exposed to such a variety of traditions, faiths and practices, Maimonides was famous for his open-mindedness. Unlike many

others, he never claimed that true prophecy belonged to the Jews alone. 'You must accept the truth from whatever source it comes,' he insisted. Still, it is worth mentioning that Jews thrived in Spain even after the golden age in different places and under different reigns – right up to the end of the fourteenth century. The dedication and perseverance of Jews in Spain has always been an inspiration to me, and in fact there is a particularly touching piece in our Islamic collection which relates to this, from around the year 1300 – a hundred years after the passing of Maimonides. It is an astrolabe made in Spain, inscribed with Hebrew and Arabic characters, which makes it extremely rare, as only three other astrolabes with Hebrew characters are known. The Hebrew characters here represent Arabic words in a form of script known as Judeo-Arabic, established by the great tenth-century rabbi Saadia Gaon – who was a prominent rabbi during the Abbasid Caliphate, and spent his life around Palestine and the Hijaz. Judeo-Arabic was in fact the written language of Maimonides and many other Jewish thinkers and philosophers of the period. This makes the astrolabe, and the language it employs, a proof of coexistence in uncertain times like no other.

I'd also grown up in an environment of happy coexistence. In Tehran in the 1950s my friends and I were never divided by religion or background: some were Jewish, some Christian, some Muslim, some Zoroastrian . . . We were interested in one another, and wanted to know more about each other's cultures and beliefs. I was proud of my Jewish heritage, but I knew that we were born as human beings first, before inheriting our religious traditions from our parents and grand-parents. Growing up in Iran, I had this strong sense of Jews and

Muslims as cousins – a family with shared ancestry, descendants of Abraham. And perhaps it was in that atmosphere of peaceful mixing and mingling that a fundamental conviction was forged: that no single religion, spiritual path or way of life has a monopoly on truth. I like the Hindu proverb: 'There are hundreds of paths up the mountain, all leading to the same place.'

How I love seeing the way those paths cross and link and weave. Naturally, all religions have their differences, otherwise they'd all be the same and the world would be boring. Still, I find it fascinating to explore our shared histories and the places we cross over, tracing similarities and differences, and drawing connections. One great example, which I had been thinking of for years, is how Abraham, the father of these three monotheistic faiths, established the Ka'bah as the first religious sanctuary, and how the Prophet Muhammad then firmly established it as a holy place for God's worship. This connects Jews and Christians to Islam in a very powerful way. Likewise, all three religions share the Old Testament, and books such as Psalms are recited and studied on all sides. The Prophet Muhammad regarded Moses and Jesus as God's prophets, along with Adam, Isaac, Jacob, Joseph, David and many other holy figures who are also revered in Judaism and Christianity.

Truly, it is incredibly interesting to think about the connection our religions share. Another great case to consider is that of the *tefilin*. In the Jewish tradition, we are required to wear *tefilin* (also known as phylacteries), which are small, black, square leather boxes laced with straps and attached to the arm and head, mostly on weekday morning prayers. One box is bound to the forehead while the other is bound to

the weaker arm of the wearer, pointing towards the heart. The head *tefilin* is divided into four compartments, each containing a written parchment with a passage from Exodus and Deuteronomy, all of which are variations on instruction to wear 'a sign for you upon your hand' and 'a memorial between your eyes'. The arm *tefilin*, however, contains all these four passages written within one scroll and kept inside the hollow of the box.

This idea – not only of wearing holy scripture upon the body but also of highlighting the connection our earthly bodies have with the divine – is found across pretty much all religions. The Qur'an has a stunning passage that reads: 'Those who believe, and whose hearts find satisfaction in the remembrance of Allah: for without doubt in the remembrance of Allah do hearts find satisfaction.' In the Gospel of Matthew, Jesus is challenged with the question 'which is the greatest commandment in the Law?' to which he replies 'Love the Lord your God with all your heart and with all your soul and with all your mind.' References to respecting, loving and remembering God through one's mind and one's heart can be found everywhere. And while in the *tefilin* this instruction takes on a unique physical form, we can also compare it to religious clothing and amulets – the talismanic shirt in our Hajj collection, or the wearing of a cross, for example.

Jews – known as Ahl al-Kitab (People of the Book) in the Islamic tradition – are highly respected as keepers of revealed scriptures. In fact, the Qur'an stresses the community of faith between the inheritors of these earlier scriptures and the followers of Islam. As Abraham is considered the father of the three monotheistic religions, it is no surprise that he is given special reverence by Muslims, who supplicate

for him, as well as for the Prophet Muhammad, as a fundamental part of each of the five daily ritual prayers.

This important devotional custom in Islam, of calling for peace and blessings on the Prophet Muhammad, which is undisputedly followed by all practising Muslims, also accordingly includes prayers for all the true followers of Abraham. It originates, according to an authentic tradition, from when a companion of the Prophet asked him the best way to call on Allah to bless him. The Prophet responded with a version of the following prayer:

اللَّهُمَّ صَلِّ عَلَى مُحَمَّدٍ، وَعَلَى آلِ مُحَمَّدٍ، كَمَا صَلَّيْتَ عَلَى إِبْرَاهِيمَ وَعَلَى آلِ إِبْرَاهِيمَ،
إِنَّكَ حَمِيدٌ مَجِيدٌ،
اللَّهُمَّ بَارِكْ عَلَى مُحَمَّدٍ، وَعَلَى آلِ مُحَمَّدٍ، كَمَا بَارَكْتَ عَلَى إِبْرَاهِيمَ، وَعَلَى آلِ إِبْرَاهِيمَ،
إِنَّكَ حَمِيدٌ مَجِيدٌ

O Allah! Send Your Mercy on Muhammad and on the
family of Muhammad, as You sent Your Mercy on
Abraham and on the family of Abraham, for You are the
Most Praise-worthy, the Most Glorious.

O Allah! Send Your Blessings on Muhammad and the
family of Muhammad, as You sent your Blessings on
Abraham and on the family of Abraham, for You are the
Most Praise-worthy, the Most Glorious.

As many Muslim friends have told me, you can't love the Prophet and not love his extended family. But there is something deeper here

too. Most religions tend to focus inwards. This prayer is one of the most profound in history in that it is one which includes all other monotheistic religions. All children of Abraham are included, and the Prophet is encouraging his followers to pray for their extended family. It is a resonating message of love. *This* is the Islam the world should know about.

And so, this became the mission of the Maimonides Interfaith Initiative – to promote this shared Abrahamic heritage, especially to young people via programmes such as our Interfaith Explorers curriculum resource, which has been made freely available to over 18,000 primary schools across the UK. When we launched Interfaith Explorers in 2012 at the London Central Mosque in Regent's Park, I quoted one of my favourite poems, in which the fifteenth-century Sufi mystic Jami celebrates both our diversity and our unity. He saw human beings as 'essences':

The Essences are each a separate Glass
Through which the Sun of Being's Light is passed.
Each tinted fragment Sparkles in the Sun
A thousand colours but the Light is One.

In a recorded message, the late former Chief Rabbi Lord Jonathan Sacks explained the Jewish belief that God is within all of us, regardless of our faith and background. I quoted the Nobel Peace Prize winner, friar Dominique Pire, who stated in his Nobel lecture of 1958, 'men build too many walls and not enough bridges', and explained that our goal with Interfaith Explorers was to 'bring down the walls of

misunderstanding' so that people of different faiths learn to 'see one another as good human beings'.

I know that religion is all too often at the heart of disunity, hatred and violence. I also know that this conflict almost always derives from misunderstanding, ignorance and prejudice. So we must tell each other our stories – not just in our classrooms, but through our libraries and museums and galleries.

In 1998, to echo the tradition of expressing religious unity through art, I initiated a project that I called the House of Peace. It involved commissioning the outstanding British artist Ben Johnson to create five large paintings that will offer different views of the holy city of Jerusalem in all its diversity, in the hope they remind all who look at them of our shared heritage within its walls.

Three of the paintings show holy sites in the city, namely the Western Wall, the Christian Quarter including the Church of the Holy Sepulchre, and the Dome of the Rock. The fourth, which is the largest painting, presents a spectacular panoramic view of Jerusalem. Over 3,500 helicopter photos were taken to create this view, which arguably is one of the most accurate aerial views of contemporary Jerusalem in existence. The fifth painting, which was based on a design I submitted, is the Circle of Peace: a kaleidoscope of the word 'Peace' in Hebrew, English and Arabic. The circle centres on the eternal light surrounded by the name of the Almighty in these three languages. Simply and directly, I wanted this last paining to be a sort of healing mandala, something which could spark reflection.

More recently, since 2005, I had been committed to the promotion of an idea that had been dear to me since childhood, and that I like to

Alexander visits the Ka'bah, 16th century, Shiraz, Iran, ink, gold and watercolour on paper, 37.5 x 24.2cm

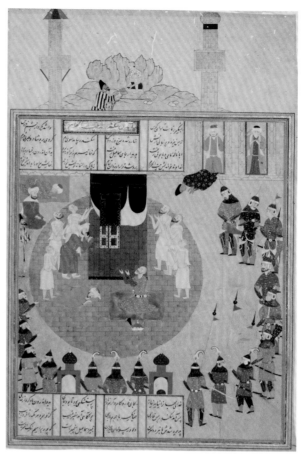

A complete cover for a Damascus Mahmal, Istanbul, Turkey, 1656-7, green silk, silver and silver-hilt wires, copper finials, 355 x 190 x 174 cm (assembled)

Pages from Safi ibn Vali's Anis al-Hujjaj ('Pilgrims' Companion'),
India, 1677-80, 27.4 x 14.7cm each

Panorama of Mecca, by Muhammad 'Abdallah, Mecca,
Saudi Arabia, 1845, 62.8 x 88 cm

Talismanic shirt with depictions of the Two Holy Sanctuaries, Mughal India or the Deccan, 16th or early 17th century, 69 x 90 cm

The document which shows the spelling of 'Alexandros' for the first time in history, on the year 7 of Alexander, corresponding to 8 June 324 BC, ink on leather, 29 x 49.6 cm.

Example of the front and reverse of a tally in the Aramaic collection. The top with inscription which reads, 'With Taitaka, from Gauza, in the year 3 of Darius the King', and the reverse below with notches representing the debt. This is one half of the tally with the second half held by the creditor/debtor. Bactria, year 3 of Darius III, corresponding to 334 BC, 2 x 19.7cm.

The early 15th century miniature which depicts Moses, Jesus and Mary, and the Prophet Muhammad (and his family and companions), from the Tales of the Prophets, Iraq (Baghdad) or Iran (Tabriz), 38 x 24.4 cm

The planispheric astrolabe inscribed in Judaeo-Arabic, Spain, circa 1300, brass and silver, 22cm (height, excluding shackle and suspension ring)

Being given the honour of UNESCO Goodwill Ambasador in 2012,
with the then Director-General of UNESCO, Irina Bokova

With Sir David Attenborough, 2019

At an audience with
Pope Francis in 2013
at The Vatican

With His Majesty King Charles III

A family photograph, taken after the
investiture ceremony presided by His
Majesty King Charles III at Winsdor
Castle, November 16th, 2022

Inlay pattern designs were hand drawn for the restoration project at No. 18
Kensington Palace Gardens and was used by the artisans at Nour Palace

An indoor view of the swimming pool

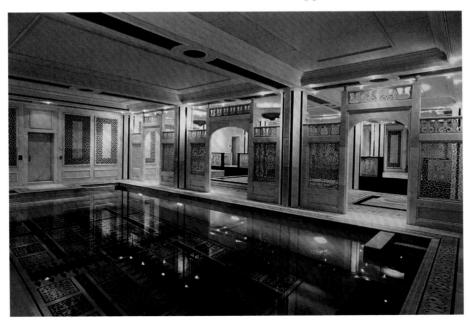

A view of the atrium of Nour Palace

The exterior of the completed Nour Palace

call nowadays 'Cultural Philanthropy' – the idea that through learning and understanding each other's cultures, and by being generous with our cultural gifts, we can heal those rifts that divide us. In 2005, as my gift to the world on the occasion of my 60th birthday I wrote and published *Visions of Splendour: The Timeline History of Islamic Art and Architecture*. The book included many illustrations and historical highlights in an accessible way, and it was received very warmly by all the institutions we shared it with. It was launched in the presence of Lord Adonis, the parliamentary under secretary of state to the Department for Education and Skills, as well as dignitaries including many ambassadors from Muslim and non-Muslim countries. For the first time since the Iranian Revolution in 1979, the ambassadors of Iran and Israel attended an event together as a mark of respect to the initiative. In fact, the Iranian ambassador insisted on giving a speech in which he had declared me a 'cultural ambassador of Islam'. I was incredibly overjoyed to have accomplished yet another milestone in the journey to understanding. We decided to distribute 20,000 free English copies of the book to schools in the UK and internationally to popularise Islamic culture in the non-Muslim world. Additionally, we arranged for the distribution of 20,000 free Arabic copies to schools in Muslim countries (including the Palestinian Territories) for the purpose of inspiring the next generation.

In a way, all our work in fostering interfaith harmony culminated in our next big partnership. In 2016 on a flight to London I had a serendipitous encounter with the Rt Hon Baroness Patricia Scotland QC, previously Attorney General of the United Kingdom and now Secretary General of the Commonwealth. She saw me walking down the aisle and immediately said to me: 'What a coincidence! I had in mind

to contact you. This might be fate.' Once I sat down, she continued: 'I know you have been active for decades to promote harmony between different faiths, do you think you might be interested in working with us and supporting our work?' I knew that with her immense contribution to the Commonwealth and her strong commitment to her faith, she would be an incredible partner. Moreover, the Commonwealth represented a vast and diverse group of countries and multiple faith traditions that could benefit from our experience, network, and resources. I replied without hesitating: 'Our vision is the same, of course I would be happy to help!' and that was that. Based on this mutual aspiration and shared values, from then on we began working on designing curricula, delivering workshops and building networks in several countries across East Africa, South Asia and the Caribbean. Today, we have even more ambitious plans to take this initiative to the next level.

Culture, religion and the people of this dear planet of ours, however, are not the only focus of mine and my family's endeavours. This green and blue marvel of ours is dear to me in its own right. Since my childhood in Tehran, staring wide-eyed at the sky, the clouds, the trees, the animals with so much love and wonder in my heart, I have been committed to do all I can to preserve this precious creation of God. Over the years I have surrounded myself with as many of nature's gifts as I possibly can, building bird sanctuaries, planting trees, taking care of animals, and regularly taking long walks in its embrace. But myself and my family have also been proactive in making sure others can enjoy nature's gifts.

In this, we decided to lean on one particular person to help us on our way – the shining light and national treasure that is Sir David Attenborough, the most iconic natural historian of our time. Working closely with him, we have been deeply humbled and privileged to be able to take part in some of his initiatives. We are enthusiastically involved in his efforts, with our sons taking on the mantle through a wide range of activities of their own to ensure our planet is protected for their generation and the ones to follow. The inspiring voice of the new generation, Greta Thunberg, said in her 2019 UN Climate Action Summit speech, quite rightly, that 'The eyes of all future generations are upon you.' It is a plea we as a family take seriously, and we will do all in our power to honour it.

It is important to me at this point to also mention how invested my whole family is with our charitable endeavours. It is a family affair, after all. Our sons, with their endless support for the environment, have added deeper layers to existing activities at the Khalili Foundation. They take great pride in giving back to the world as much as it has given them, and for that, I couldn't be prouder. My wife Marion also shines brightly in her work. She regularly supports various charitable organisations close to her heart, such as animal protection, humnanitarian aid and social welfare as well as contributing her invaluable knowledge and wisdom to our foundation as an indespensible partner. In recognition of her work, she was made Dame of the Pontifical Equestrian Order of St Sylvester (KSS) by His Holiness Pope Benedict XVI in 2004.

The Khalili Foundation is now the consolidated umbrella

organisation for many of the charitable activities that myself and the family have been involved with over the years. It has been quite the journey and I am especially grateful to the many honours and recognitions that have come our way in recognition of the impact that we have had. From being knighted by two popes to receiving the Légion d'Honneur in France, I am truly humbled and moved by each and every one. But I wish to mention one, in particular, that really formed a defining moment in my life. That is, the honour of receiving a knighthood on my seventy-fifth birthday, from Her Majesty's Government here in the UK for services to charity and interfaith relations. And this is especially poignant as, while writing this book, this magnificent woman, Her Royal Highness Queen Elizabeth II, whom I had admired so much all of my life, passed away and has been lost to us. The grief I still feel is immense, which makes this honour all the more important to me. I was only a newborn when that doctor in the hospital predicted my fate would be tied to the British nation forever. And here was a coda to this prophecy.

My most lingering memory of the Queen is when, one morning in April 2007, I received a call from Buckingham Palace inviting Marion and me to stay the night at Windsor Castle as guests of Her Majesty. We and other guests would be hosted at a royal dinner party that evening, accompanied by the Duke of Edinburgh and the Earl and Countess of Wessex. We were sent a list of our fellow guests, which included an intimate group of distinguished individuals from the world of art, diplomacy, business and faith.

As the guests assembled, it was clear that we were all equally overwhelmed by the occasion. The Queen arrived a few minutes

later to join us and, with her characteristic charm, put Marion and me at ease instantly, stating that she knew about me and my cultural activities.

Having visited Windsor many times before, I was familiar with the Royal Collection, which consists of more than a million objects held in trust by the monarch for their successors and the nation. After dinner, I was escorted to the Queen and reintroduced to Her Majesty as a well-known scholar and collector, and the custodian of some of the world's largest collections. I immediately seized the moment to suggest that, if Her Majesty wished, it would be an honour for me to give her a tour of her own collection. She accepted without any hesitation. For the next hour and a half, we strolled side by side through the castle, revelling in the beauty of her treasures.

I was familiar with some objects, which were like objects in our own collections. But my passion for art runs so deep that I could also speak knowledgeably about many other items in the Royal Collection too. One of the major Mughal objects we discussed was the Royal Collection's *Padshahnamah*, given to King George III by an Indian nawab. I spoke with the Queen about the exquisite miniatures in this Mughal manuscript, explaining how Shah Jahan's court artists painted it with brushes made of the finest squirrel hair. I talked about the history of such objects, how they were created, why they were so important, and why nobody could replicate them today.

The Queen seemed mesmerised and, likewise, I was no less spellbound by her collection. It was clear that the collection spoke deeply to her. We carried on while the rest of the guests were following us at a distance during the tour.

The Art of Peace

At the end of the tour, the Queen bid goodnight to all her guests. As we gathered to thank Her Majesty for her royal hospitality, she kindly turned to me, shook my hand, and remarked to the group: 'It's scary how much this gentleman knows about art.' This memory will forever be engraved on my heart.

~ 13 ~

The Dream Palace

The art collections, the publications, the university chairs and research centres, the Maimonides Interfaith Initiative and Khalili Foundation – these were all ways of making a mark, presences in the world that I hoped would thrive and give benefit to others long after I was gone. But there had been another itch in me for many years, something nagging at me – I couldn't tell what it was, at first, and then slowly an idea came into focus. Maybe it was because I'd been so close to so many wonderful works of art over the decades . . . maybe it was because I was so transported by the *idea* of a work of art, that the vision and images in one person's mind could be expressed in language, stone, clay, metal, glass, paint, and so travel into the minds of unknown others, transcending time and space . . . what a miracle that was! That, then, was the itch: I wanted to do it too. I wasn't an artist, I was a celebrator of artists. But I did have an eye, and I had a deep reservoir of knowledge, and I had passion, and ambition – certainly ambition!

I wanted to make something. A house. A dream palace – a building that channelled something of the enchantment I still remembered from that first visit to the Taj Mahal with Nuri all those years ago. But this palace would be in London, the city I had made my home, the city I had come to cherish above all others. Luckily, I already had experience in property development, having made many investments in property to support my collecting efforts. In the early 1990s, I made a string of good investments in shopping centres in England and Scotland, as well as in prime London real estate, including the purchase and renovation of a Mayfair mansion that had been home to, among others, the Duke of Queensberry, the Marquess of Anglesey and the Bank of England. Our property company also co-developed Sixty London, a 13-floor building in Holborn Viaduct with 212,000 square feet of office space that later became the London headquarters of Amazon.com.

This time, however, I wasn't thinking about profit. I was thinking about making something original and beautiful, something that was already growing in my imagination, something that nobody else would make if I didn't make it myself . . . I'd already set my eyes on one of London's most iconic locations: Kensington Palace Gardens, the famous half-mile-long avenue, sometimes called the most expensive residential street in the world, its 35 mansions owned by royalty, business magnates and foreign governments. Laid out in the 1840s, it formed part of the Kensington Palace grounds, originally bought by William III from the Earl of Nottingham in 1689, and the freehold is still owned by the Crown Estate. During and after the Second World War, the street lost much of its shine: the cost of maintaining these

buildings was colossal. In the late 1980s I was especially struck by the dismal state of numbers 18 and 19 – occupied for decades by the Soviet Diplomatic Mission and the Egyptian Consulate, these two great buildings had slowly sunk into disrepair, like wrecks.

It was sad to see such a state of decay; I suppose that's when the wheels in my brain began to turn. A fence divided the two buildings back then, but what if you could join them together? Wouldn't that make a new palace, if only someone were mad enough to dream of it . . . ? The trouble was, nobody could face the headache of refurbishing the two buildings. It wasn't just the (huge) costs, it was the prospect of an endless entanglement with the Crown Estate, the Victorian Society and English Heritage. When I arranged to visit the two properties, the interiors were in a terrible state, completely run down, not fit for purpose in any way. But I remember thinking then of a poem by Victor Hugo I particularly love:

> *Be like the bird, posed for a moment*
> *Upon a branch that is too frail*
> *Feels the branch bend, yet sings in enjoyment*
> *Knowing its wings can set sail!*

I had that bird's confidence. Numbers 18 and 19 were designed in the style of an Italian palazzo by the office of Sir Charles Barry, an English architect best known for rebuilding Britain's Houses of Parliament after it was ravaged by fire in 1834. One of the leading architects of his time, Barry also remodelled Trafalgar Square and Highclere Castle. In 1845, the plots for numbers 18 and 19 were bought by

Thomas Grissell, whose construction firm worked with Barry on the restoration of the Houses of Parliament, as well as the Reform Club, the Lyceum Theatre and Nelson's Column. While building the houses, Grissell used some of the stone left over from reconstructing the Houses of Parliament. He then became the first occupant of no. 19, along with his family and their nine servants. After Grissell, the house was occupied by Gustav Christian Schwabe, a German financier, shipowner and art collector. Schwabe was born Jewish in Hamburg but was forcibly baptised into the Lutheran church as a boy. He moved to London in the 1820s, along with many other Jews in search of a more liberal environment, and duly became a shipping and textiles magnate before retiring to the beautiful no. 19, where he died in 1893.

Next door at no. 18, one legendary occupant was Baron Paul Julius von Reuter, founder of the Reuter's news agency. The son of a German rabbi, he was originally called Israel Beer Josaphat, but converted to Christianity and changed his name to Reuter soon after moving to England. Reuter – who famously used carrier pigeons to relay stock-market news before becoming a pioneer in telegraphic communication – lived in the house from 1867 until his death in 1899. Lionel de Rothschild, who'd inherited his family's banking empire at 28, moved into no. 18 in 1912. Lionel's father, Nathan Mayer Rothschild, had lived in Frankfurt's Jewish ghetto before moving to England. But the Rothschilds became the world's richest family: Lionel personally arranged to lend Britain the millions required to buy a stake in the Suez Canal. After winning election to Parliament, Lionel wasn't allowed to take his seat because he refused to swear an oath on 'the true faith of a Christian'. This requirement was eventually waived,

and – after an 11-year stand-off – he assumed his position as the nation's first Jewish Member of Parliament. After Lionel, no. 18 was owned by Arthur Lee, 1st Viscount Lee of Fareham, who'd established the Courtauld Institute of Art with the University of London, the first institution to offer degrees in the history of art in Britain. He bought Chequers in 1909, restored it, and donated it to the nation in 1917 to be a country estate for future prime ministers.

And now a Jewish immigrant from a Muslim country was determined to restore these two houses to their former glory and beyond . . . The first building I was able to buy, in the 1990s, was no. 19. This purchase alone took me more than a year to complete. After much negotiation with the Crown Estate, I was eventually able to buy no. 18 too, but only after the Crown Estate had successfully negotiated to relocate the Russian government employees then in residence. Meanwhile, I started putting together a team of first-rate architects and contractors, and submitted a complex plan to turn these two properties into one. We undertook extensive research to establish what the houses looked like at the time Sir Charles Barry started his project, so we could stay faithful to the original buildings even as we created something wholly new. This was a delicate balancing act.

It was a massive undertaking with no room for mistakes. The smallest detail could derail the whole. But there's something in me that runs towards such challenges. I wasn't daunted. I was the 14-year-old who'd written a biographical encyclopaedia simply because I believed the world should contain such a book – I'd never been deterred by the thought I couldn't do something or that it was beyond me, and I wasn't going to start now. I'd even given these conjoined houses a name in my

mind: Nour Palace. 'Nour' meaning 'light' in Hebrew, Persian, Arabic and Turkish – a beautiful word. We would spend over £45 million on the renovation, which would involve 400 craftsmen over almost five years. In terms of scale and expense alone, the restoration was rivalled only by the four-year, £36.5 million renovation of Windsor Castle following the fire in 1992. In addition it had cost nearly £40 million for our company to buy the leasehold for the two buildings and extend the lease for a century. For the first time ever, and not without effort, the Crown Estate had allowed two listed building to be combined into one. The project would ultimately consume all my time for five years. And, by the time it was done, our total costs would amount to a mammoth £87 million.

I spent countless hours on site, going down each day to supervise the work, trying to be available for even the tiniest detail, talking to everyone, learning about their backgrounds and skills. I wanted everyone to feel we were working together towards a common goal, that this was more than just the restoration of a property, it was an artistic enterprise with an enduring legacy. I took inspiration from all of our collections, but especially from the work of Islamic, Indian and Japanese artists. I based all of the inlaid and carved marble decorations on Islamic and Japanese patterns, and worked with professional draughtsmen to incorporate a design from a classical Persian carpet adorned with carp, waves and flowers into the floor of the swimming pool. The courtyard was inspired by the Alhambra Palace in Granada and included fountains, ornamental stonework and decorative landscaping.

Above all, I thought of the Taj Mahal. We located the very quarry in India from which marble was extracted to build the Taj in the

seventeenth century. All in all, about 3,200 square metres of carved and inlaid marble were imported for Nour Palace, and we found craftsmen who carried out traditional marble work in a similar fashion to those who had worked on the Taj Mahal over 350 years ago. In fact, the whole project was a showcase and celebration of such artisanal traditions, the quality of the craftsmanship so high that our stonemasons even won a prestigious award from the Worshipful Company of Masons of the City of London.

Nour Palace showed East and West in a dance together – Islam and India and Japan meeting and combining with the buildings' particular Victorian heritage. Following strict guidelines from the Crown Estate, we painstakingly restored the original features of the two houses, including no fewer than 40 Robert Adam fireplaces. All of the original plasterwork and cornices were kept and restored, and where replacements were needed, we took care to install them as seamlessly as possible. In every respect, we worked to preserve the buildings' integrity, even if this meant such extraordinary measures as the creation of massive steel structures that lifted and held the two houses in mid-air so we could work on rebuilding the basement and installing the swimming pool . . .

By the time our mission was accomplished, Nour Palace had almost every imaginable luxury, from an exquisitely renovated ballroom and an oak-panelled picture gallery to a Turkish bath, a gym, a hairdressing salon, a courtyard, a sauna, not to mention a vast kitchen, designed by one of London's top chefs, which could easily cater for up to 600 guests. Many of the Palace walls were inlaid with semi-precious stones. Over 20 cars could be parked in a specially designed car park

underneath the Palace, which required detailed excavations and delicate structural workarounds. We installed the best security systems, and a state-of-the-art underground generator to service the house in case of a blackout. The Palace had 11 suites in all: the master bedroom suite was linked to the pool area by a private lift and had two bathrooms, one with a lunar theme (shades of blue and pearl to evoke the stillness of the night), and the other with a solar theme (celebrating light, the sun and the colours of dawn). The atrium consisted of 12 intricately handcrafted panels representing the months of the year, inlaid with semi-precious stones and topped with a beautifully crafted glass roof.

I saw a pair of ghost buildings and imagined a palace. It was a call that I simply had to answer. The word *palace* conjures a sense of sumptuousness and splendour, and I genuinely believe there are few buildings in Europe that match what we made at 18 and 19 Kensington Palace Gardens. Five years' work, a labour of love, and I hope an enduring legacy. Maybe I got carried away – it's true that the project kept growing. At first, I'd expected Nour Palace to be 33,000 square feet; then it had expanded to 40,000 square feet; finally, it had swelled to 55,000 square feet – the same size as the White House, with its 132 rooms. My initial idea of having it as our home became increasingly unrealistic. When my wife, Marion, saw how gigantic Nour Palace had become, she told me in no uncertain terms that we couldn't possibly live there – even if we closed three-quarters of it, it would still be too big. I knew deep down she was right.

The five years' work on Nour Palace had drained me. In many respects, it had taken over my life. I missed having the time and

freedom and energy to devote to the collections and to my family. I was ready to move on. Thankfully, I wasn't under any financial pressure, so I could have held on to the Palace indefinitely as an investment if I wished. But I wanted some sort of closure, and I hated the idea of the place standing empty. I began to investigate selling it, and even though I feel nowadays this was one of my greatest mistakes, I try not to worry about it. The market for houses in this price range was narrow, but Nour Palace – at that time probably the largest private house in central London after Buckingham Palace – would clearly be of interest to a number of wealthy individuals. But I wasn't just thinking about financial gain. I wanted to pass on Nour Palace to someone who would appreciate its vision, and care for it, as I tried to care for the many works of art in my collections. This I tried in earnest, for better or worse, and eventually the place was sold. I lost a fortune.

When I began work on Nour Palace, Kensington Palace Gardens was not primarily a residential area. We were the first to pay a substantial sum for the long lease, and this was instrumental in the Crown Estate changing its approach, generating more revenue. Since then, the street has attracted a stream of private buyers who could afford to live anywhere but want the glow of such a prestigious address. In 2006 Hasbro, the producers of Monopoly, recognised this transformation of Kensington Palace Gardens by making it the priciest square on the board: it replaced Mayfair, which had reigned supreme since the 1930s. On a personal level, the experience of creating Nour Palace enriched my life immeasurably. I think of the nights and days we'd all spent working together so that, stone by stone, the marvellous glimmer in my mind's eye became a tangible thing in the world, a twirling

together of East and West, traditional and modern, art and technology, and an enduring contribution to the cultural and architectural landscape of the country in which I have made my home. Do I regret selling Nour Palace? In a way, yes. But still, a dream became a fact. I had finally made a mark on the landscape, which I hope would last. Along with the collections and the charitable work we do, ultimately, I hope the legacy of intertwining cultures, of beauty, and of sharing something precious, of making dreams manifest, will last long after I'm gone. I will never forget Nour Palace, and I hope its legacy will remain throughout the centuries.

~ 14 ~
Collecting

My father told me a story when I was young about a famous king who was touring his kingdom, visiting all the towns and villages to learn more of the local history and the lives of his people. One day, he was escorted to a small cemetery where the gravestones read: *Lived for 6 years* or *Lived for 9 years* or *Lived for 12 years* and so on. The king was shocked and saddened, and turned to his companion, the wise village elder.

'This is a children's cemetery,' the king said. 'Why did you bring me here?'

'Oh, great king,' replied the elder, 'but this is an adult cemetery. While those buried here *existed* for many more years than written on their gravestones, the people of this village only wished to be remembered for the years they considered themselves to have *lived*.'

I always loved that story. I wanted to *live*. From the age of 14 when I found success in writing a book about great men and women across history, to the age of 78, with so many more books and exhibitions and

projects behind me, I have always plunged in. No half measures – I have pledged my full heart to the day. It turned out that I had the knack of making money, and a passion for beauty and craftsmanship. More than that, I found an almost religious faith in the power of art. I believe, as Tolstoy puts it, that art 'is a means of union among men, joining them together in the same feelings, and indispensable for the life and progress toward well-being of individuals and of humanity'. That ethos came to underpin my mission as a collector. Half a century on from my beginning in those far-off New York days, our eight collections comprise around 35,000 objects, and we have published over 100 volumes of research, and I hold to that Tolstoian insight more than ever: the language of art is universal, and has the power to be a unifying force for humanity.

Collectors are occasionally given a bad name for hording treasures that should be publicly accessible, and/or commoditising them for personal gain. There are indeed some individuals that have this unfortunate agenda, but they're not really collectors. A *true* collector doesn't just acquire for the sake of gratification, wealth or prestige. To qualify, they must meet five essential criteria: they must collect, conserve, research, publish and exhibit. In doing so, they fulfil their responsibility of democratising their cultural capital and honouring art's potential to serve humanity. In any case, I see 'ownership' as an illusion – we collectors are but temporary custodians. These lines are attributed to Rumi:

دنیا همه هیچ و اهل دنیا همه هیچ
ای هیچ برای هیچ بر هیچ مپیچ

Collecting

The world and the earthly people are nothing but naught,
O naught! Do not engage with naught, seeking naught.

I learned this message when I was very young, and have carried it in my heart. People, even civilisations, come and go, but works of art endure. They are always there, humanity's messengers – teaching us, delighting us.

Every single work of art in our collections has its own story: the context in which it was created, the personality of its maker, the lives and minds that it affected, not to mention its journey across the centuries from one custodian to another. Gathered together, such works of art have extraordinary transformative power. I think of the great international expositions of the nineteenth century: when over 32 million people flocked to the Paris Exhibition in 1889, the entire population of France was around 38 million. Aside from the famous religious festivals and pilgrimages – the Kumbh Mela in India, the Shalosh Regalim in Jerusalem, the Hajj in Mecca, the pilgrimage to Lourdes in France, the Osun-Osogbo in Nigeria, the Shikoku Pilgrimage in Japan – what occasions fire the public imagination in this way? It could be argued that art has the same potential for inspiration, meditation and bringing people together. And, of course, art and religion themselves share a long history: Hindu temples filled with sculpture, Catholic churches adorned with murals, mosques decorated with calligraphy – all places of artistic appreciation as much as of spiritual devotion.

Why does art command such power? A whole branch of philosophy (aesthetics) devotes itself to such questions. But as a patron and

collector I feel an immense responsibility. Art is a technology of connection – it links us with other minds, other ages. In widely exhibiting the collections, I hope to open people's hearts to other cultures and ways of being in the world, each exhibition a space in which we can experience both the extraordinary variousness of human ingenuity and creativity and the common humanity we share with those who came long before us, or far away from us. Jews, Christians and Muslims – such diversity in these different traditions, but the three Abrahamic faiths in truth a family: three siblings under Father Heaven and Mother Earth. Look at the Great Synagogue in Budapest, the Vank Cathedral in Isfahan, the Cappella Palatina in Palermo, the Rüstem Pasha Mosque in Istanbul – whatever our faith, we can know wonder and gratitude in the presence of such places.

Art is the most universal language we have. We must treasure it and share it; we must celebrate it. That has been the mission flowing through me and flowing through these pages. Sometimes, remembering, I've felt as if I were moving through the rooms of an enchanted museum, encountering days and moments I hadn't visited for many years – stepping with Nuri into the inner chamber of the Taj Mahal, or off 57th Street into the wonderland of Lillian Nassau's gallery, or off Bond Street into the jewellery shop where Marion kept raising her arm across her face to hide her sneezes. The world turns, and we're standing at the window watching our three boys play hide-and-seek in our Hampstead garden. I'm with Rasson, approaching the mountain village in Qazvin with our army kitbags slung over our shoulders, kettledrums beating. Or I'm diving head-first into some new passion, years learning everything I possibly could about Russian

enamelware, or kimonos, or textile weavers in nineteenth-century Sweden, or the Spanish masters who made metal come alive in their hands. My mother brings out the dish of shabbat eggs and the basket of herbs and radishes we'd feed on like rabbits. My father leans to rest against a column in the ruins of Persepolis, both of us dreaming of Darius and Alexander.

According to the ancient Egyptian legend, a person dies twice: once when the soul departs the body, and a second time at the death of the last person to mention their name.

I hope mine would linger on, and in this spirit all of us, myself, my family, and our foundation, hope that all the collections will one day find themselves a suitable home after us, where they will be cherished and loved in the same spirit of commitment and guardianship we have lived for. Wonder and gratitude, always.

International Exhibitions drawn exclusively from the Khalili Collections

5 July – 1 October 2017

Beyond Imagination, Treasures of Imperial Japan from the Khalili Collection, 19th to early 20th century, Moscow Kremlin Museums, Moscow, Russia

8 November 2011 – 29 April 2012

Metal Magic: Spanish Treasures from the Khalili Collection, Auberge de Provence, Valetta, Malta

11 December 2010 – 17 April 2011

Passion for Perfection: Islamic Art from the Khalili Collection, De Nieuwe Kerk, Amsterdam, Netherlands

8 December 2009 – 18 April 2010

Enamels of the World: 1700 – 2000 from the Khalili Collection, The State Hermitage Museum, St Petersburg, Russia

6 October 2009 – 14 March 2010

The Arts of Islam: Treasures from the Nasser D. Khalili Collection, Institut du Monde Arabe, Paris, France

22 January – 22 May 2008

The Arts of Islam: Treasures from the Nasser D Khalili Collection. Gallery One, Emirates Palace Hotel, Abu Dhabi, UAE

22 June – 23 September 2007

The Arts of Islam – Treasures from the Nasser D Khalili Collection,
Art Gallery of New South Wales, Sydney, Australia

25 February – 3 June 2007

Meiji-Kunst & Japonismus, Aus der Sammlung Khalili, Kunsthalle
Krems, Krems, Austria

7 July – 22 October 2006

Wonders of imperial Japan: Meiji art from the Khalili Collection, Van
Gogh Museum, Amsterdam, Netherlands

September 2004 – February 2005

Splendors of Imperial Japan: Masterpieces from the Khalili Collection,
Israel Museum, Jerusalem, Israel

28 November 2003 – 8 February 2004

Empire of the Sultans: Ottoman Art from the Khalili Collection,
Frick Art and Historical Center, Pittsburgh, Pennsylvania, USA

Aug – Nov 2003

Empire of the Sultans: Ottoman Art from The Khalili Collection,
Museum of Arts and Sciences, Macon, Georgia, USA

May – August 2003

Empire of the Sultans: Ottoman Art from The Khalili Collection,
Frist Center for the Visual Arts, Nashville, Tennessee, USA

2 April – 31 August 2003

Plácido Zuloaga: Meisterwerke in gold, silber und eisen damaszener –
schmiedekunst aus der Khalili-Sammlung, Roemer und Pelizaeus
Museum, Hildesheim, Germany

International Exhibitions drawn exclusively from Khalili Collections

20 February – 27 April 2003

Empire of the Sultans: Ottoman Art from the Khalili Collection, Oklahoma City Museum of Art, Oklahoma City, Oklahoma, USA

September – October 2003

A Monument to Love: Swedish Marriage Textiles from the Khalili Collection, Boston University Art Gallery, Boston, Massachusetts, USA

August 2002 – January 2003

Empire of the Sultans: Ottoman Art from the Khalili Collection, Museum of Art, Brigham Young University, Provo, Utah, USA

Oct – Dec 2002

Ornaments de la Perse: Islamic Patterns in 19th Century Europe, Leighton House Museum, London, UK

1 June – 22 September 2002

Splendors of Imperial Japan: Arts of the Meiji Period from the Khalili Collection, Portland Art Museum, Portland, Oregon, USA

May – July 2002

Empire of the Sultans: Ottoman Art from the Khalili Collection, North Carolina Museum of Art, Raleigh, North Carolina, USA

February – April 2002

Empire of the Sultans: Ottoman Art from the Khalili Collection, Milwaukee Art Museum, Milwaukee, Wisconsin, USA

October 2001 – January 2002

Empire of the Sultans: Ottoman Art from the Khalili Collection, Bruce Museum of Arts and Science, Greenwich, Connecticut, USA

August – October 2001

Empire of the Sultans: Ottoman Art from the Khalili Collection, Asian Art Museum of San Francisco, San Francisco, California, USA

16 May – 30 September 2001

El Arte y Tradición de los Zuloaga: Damasquinado Español de la Colección Khalili, Real Fundacion de Toledo, Toledo, Spain

27 January – 8 April 2001

Empire of the Sultans: Ottoman Art from the Khalili Collection, Portland Art Museum, Portland, Oregon, USA

February – April 2001

El Arte y Tradición de los Zuloaga: Damasquinado Español de la Colección Khalili, Alhambra Palace, Granada, Spain

29 November 2000 – 11 March 2001

Shibata Zeshin: Masterpieces of Japanese Lacquer from the Khalili Collection, Roemer and Pelizaeus Museum, Hildesheim, Germany

October 2000 – January 2001

Empire of the Sultans: Ottoman Art from the Khalili Collection, The Albuquerque Museum of Art & History, Albuquerque, New Mexico, USA

May – August 2000

El Arte y Tradición de los Zuloaga: Damasquinado Español de la Colección Khalili, Museo de Bellas Artes, Bilbao, Spain

International Exhibitions drawn exclusively from Khalili Collections

July – October 2000

Empire of the Sultans: Ottoman Art from the Khalili Collection, Detroit Institute of Arts, Detroit, Michigan, USA

May – July 2000

Marvels of the East: Indian Paintings of the Mughal Period from the Khalili Collection, Tel Aviv Museum of Art, Tel Aviv, Israel

March – May 2000

Textiles de Scanie des XVIII et XIX Siècles dans la Collection Khalili, Swedish Cultural Centre, Paris, France

February – April 2000

Empire of the Sultans: Ottoman Art from the Khalili Collection, Society of the Four Arts, Palm Beach, Florida, USA

10 April – 6 October 1999

Splendors of Meiji: Treasures of Imperial Japan, First USA Riverfront Arts Centre, Wilmington, Delaware, USA

October – November 1999

Shibata Zeshin: Masterpieces of Japanese Lacquer from the Khalili Collection, Toyama Sato Art Museum, Toyama, Japan

May – June 1998

Shibata Zeshin: Masterpieces of Japanese Lacquer from the Khalili Collection, Mishima Taisha Museum of Art Treasures, Mishima, Japan

30 May 1997 – 11 January 1998

Plácido Zuloaga: Spanish Treasures from The Khalili Collection, Victoria and Albert Museum, London, UK

18 April – 1 October 1997

Shibata Zeshin: Masterpieces of Japanese Lacquer from the Khalili Collection, National Museums of Scotland, Edinburgh, UK

December 1996 – June 1997

Empire of the Sultans: Ottoman Art from the Collection of Nasser D. Khalili, Israel Museum, Jerusalem, Israel

July – October 1996

Empire of the Sultans: Ottoman Art from the Khalili Collection, Brunei Gallery, School of Oriental and African Studies, University of London, UK

February – March 1996

Swedish Textile Art: The Khalili Collection, IK Foundation, Pildammarnas Vattentorn, Malmö, Sweden

July – September 1995

Empire of the Sultans: Ottoman Art from the Khalili Collection, Musée Rath, Geneva, Switzerland

25 October 1994 – 29 January 1995

Treasures of Imperial Japan: Ceramics from the Khalili Collection, National Museum of Wales, Cardiff, UK

September 1994 – January 1995

Japanese Imperial Craftsmen: Meiji Art from the Khalili Collection, British Museum, London, UK

Loans to Museums and Galleries

October 2023 – March 2024

Parfums d'Orient, Institut du Monde Arabe, Paris, France

November 2021 – May 2022

Fabergé in London: Romance to Revolution, Victoria and Albert Museum, London, UK

July 2021 – January 2022

Tokyo: Art and Photography, Ashmolean Museum, Oxford, UK

February 2020 – February 2025

Kimono: Kyoto to Catwalk, Victoria and Albert Museum, Touring exhibition: London, UK, Museum of World Culture, Gothenburg, Sweden, Musée du Quai Branly, Jacques Chirac, Paris, France, Museum Rietberg, Zurich, Switzerland, V&A Dundee, Scotland, UK

February 2019 – January 2020

Longing for Mecca, Tropenmuseum, Amsterdam, The Netherlands

Tropenmuseum, Amsterdam, The Netherlands

October 2018 – February 2019

Relieken, Museum Catharijneconvent, Utrecht, The Netherlands

Museum Catharijneconvent, Utrecht, The Netherlands

October 17, 2018 – January 14, 2019

Splendours of Imperial Japan, Musée national des arts asiatiques – Guimet, Paris, France

October 2018 – January 2019

Fabric of India, The Cincinnati Art Museum, Cincinnati, Ohio, USA The Cincinnati Art Museum, Cincinnati, Ohio, USA

July – August 2018

FUKAMI: une plongée dans l'esthétique japonaise, Hôtel Salomon de Rothschild in Paris, France

September 2017 – March 2018

Hajj: Memories of a Journey, Sheikh Zayed Grand Mosque, Abu Dhabi, UAE

June – Oct 2017

Aventuriers des mers: de Sindbad à Marco Polo. Méditeranée – Océan Indien, Musée des civilisations de l'Europe et de la Méditerranée (MuCEM), Marseiile, France

April – July 2017

Trésors de l'Islam en Afrique de Tomboctou à Zanzibar, Institut du Monde Arabe, Paris, France

15 November 2016 – 26 February 2017

Aventuriers des mers: de Sindbad à Marco Polo. Méditeranée – Océan Indien, Institut du Monde Arabe, Paris, France

Oct 2016 – Jan 2017

Power and Protection: Islamic Art and the Supernatural, Ashmolean Museum, Oxford, UK

Sep 2016 – Jan 2017

Jerusalem 1000–1400: Every People Under Heaven, Metropolitan
 Museum of Art, New York, USA

Apr – Aug 2016

Sicily: culture and conquest, British Museum, London, UK

April – July 2016

Court & Cosmos: The Great Age of the Seljuqs, Metropolitan
 Museum of Art, New York, USA

April – September 2016

Jardins d'Orient, de l'Alhambra au Taj Mahal, Institut du Monde
 Arabe, Paris, France

October 2015 – January 2016

The Fabric of India, Victoria and Albert Museum, London, UK

September 2014 – January 2015

Ming: 50 Years that changed China, British Museum, London, UK

Sep 2014 – Jan 2015

Sacred Places, Sacred Books, Museum Aan de Stroom, Antwerp,
 Belgium

23 April – 10 August 2014

Hajj, le pèlerinage à La Mecque, Institut du Monde Arabe, Paris

March – June 2014

Kings and Pawns: Board Games from India to Spain, Museum of
 Islamic Art, Doha, Qatar

February – May 2014

Court and Craft in Medieval Mosul: A Masterpiece from Northern
 Iraq, Courtauld Institute of Art, London, UK

April – July 2014

India, Jewels that Enchanted the World, Moscow Kremlin Museums,
 Moscow, Russia

October – December 2013

The Everlasting Flame: Zoroastrianism in History and Imagination,
 Brunei Gallery, School of Oriental and African Studies, London,
 UK

Sept 2013 – March 2014

Longing for Mecca: The Pilgrim's Journey, Rijksmuseum Volkenkunde,
 Leiden, Netherlands

September – December 2012

Bronze, Royal Academy of Arts, London, UK

March – June 2012

Gifts of the Sultan. The Arts of Giving at the Islamic Courts, Museum
 of Islamic Art, Doha, Qatar

January – April 2012

Hajj: journey to the heart of Islam, British Museum, London, UK

October 2011 – January 2012

Gifts of the Sultan: The Arts of Giving at the Islamic Courts, Museum
 of Fine Arts, Houston, Texas, USA

June – September 2011

Gifts of the Sultan: The Arts of Giving at the Islamic Courts

Los Angeles County Museum of Art, Los Angeles, California, USA

April – July 2011

Une cour royale en Inde: Lucknow (XVIIIème – XIXème siècle)

Musée national des arts asiatiques-Guimet, Paris, France

Loans to Museums and Galleries

December 2010 – February 2011

India's Fabled City: The Art of Courtly Lucknow, Los Angeles County Museum of Art, Los Angeles, California, USA

October 2010 – March 2011

Al-Mizan: Sciences and Arts in the Islamic World, Museum of the History of Science, Oxford, UK

September 2010 – January 2011

Epic of the Persian Kings: The Art of Ferdowsi's Shahnameh, Mellon Gallery, Fitzwilliam Museum, Cambridge, UK

July – September 2010

Kyoto–Tokyo: from Samurai to Manga, Grimaldi Forum, Monaco, Grimaldi Forum, Monaco

March – June 2010

The Indian Portrait: 1560–1860, National Portrait Gallery, London, UK

February – June 2009

Shah 'Abbas: The remaking of Iran, British Museum, London, UK

July – November 2007

Venezia e l'Islam 828 – 1797, Palazzo Ducale, Venice, Italy

March – July 2007

Moments of Vision: Venice and the Islamic World, 828 – 179, Metropolitan Museum of Art, New York, New York, USA

October 2006 – February 2007

Venise et l'Orient 828 – 1797, Institut du Monde Arabe, Paris, France

September 2006 – February 2007

East-West: Objects Between Cultures, Tate Britain, London, UK

May – September 2006

Ibn Khaldun, The Mediterranean in the 14th century: Rise and Fall of Empires, Real Alcazar, Seville, Spain

October 2005 – March 2006

L'Age d'or des sciences arabes, Institut du Monde Arabe, Paris, France

September – December 2005

Asian Games: The Art of Contest, Middlebury College Museum of Art, Middlebury, Vermont, USA

April – August 2005

The Jews of Europe in the Middle Ages, Deutsches Historisches Museum, Berlin, Germany

February – May 2005

Asian Games: The Art of Contest, Arthur M. Sackler Gallery, Smithsonian Institution, Washington, D.C., USA

December 2004 – April 2005

Iraq and China: Ceramics, Trade and Innovation, Arthur M. Sackler Gallery, Smithsonian Institution, Washington, D.C., USA

November 2004 – March 2005

The Jews of Europe in the Middle Ages, Historisches Museum Der Pfalz, Speyer, Germany

October 2004 – January 2005

Asian Games: The Art of Contest, Asia Society and Museum, New York, New York, USA

October – December 2004

Asia, Body, Mind, Spirit, Brunei Gallery, School of Oriental and African Studies, London, UK

Loans to Museums and Galleries

June – September 2004

Goa and the Great Mughal

Calouste Gulbenkian Foundation, Lisbon, Portugal

March – August 2004

Heaven on Earth: Art From Islamic Lands – Selected objects from the
Khalili Collection and The State Hermitage Museum, Hermitage
Rooms, Somerset House, London, UK

March – June 2004

A caccia in Paradiso: Arte di corte nella Persia del Cinquecento

Museo Poldi Pezzoli and Palazzo Reale, Milan, Italy

October 2003 – January 2004

Hunt for Paradise: Court Art of Safavid Iran, 1501–76

Asia Society and Museum, New York, New York, USA

April – July 2003

The Legacy of Genghis Khan: Courtly Art and Culture in Western
Asia, 1256–1353, Los Angeles County Museum of Art, Los Angeles,
California, USA

November 2002 – April 2003

The Art of Love: Love's Lust and Sorrow in World Art, Museum
Rietberg, Zürich, Switzerland

November 2002 – March 2003

Chevaux et cavaliers arabes dans les arts d'orient et d'occident, Institut
du Monde Arabe, Paris, France

October 2002 – February 2003

The Legacy of Genghis Khan: Courtly Art and Culture in Western
Asia, 1256–1353, The Metropolitan Museum of Art, New York,
New York, USA

July – November 2002

The Nature of Diamonds, Midland Center for the Arts, Midland, Michigan, USA

June 2002 – January 2003

Pearls: A Natural History, The Field Museum, Chicago, Illinois, USA

October 2001 – March 2002

L'Orient de Saladin au temps des Ayyubides, Institut du Monde Arabe, Paris, France

October 2001 – May 2002

Spirit Of Islam: Experiencing Islam through Calligraphy, Museum of Anthropology, University of British Columbia, Vancouver, Canada

October 2001 – April 2002

Pearls: A Natural History, American Museum of Natural History, New York, New York, USA

January – March 2001

Court and Conquest: Ottoman Origins and the Design for Handel's "Tamerlano", Glimmerglass Opera, Brunei Gallery, School of Oriental and African Studies, London, UK

September 2000 – June 2001

Have a Nargileh: Water-pipes from the Islamic World, Israel Museum, Jerusalem, Israel

September 2000 – February 2001

Fabergé: Imperial Craftsman and his World, River Front Arts Center, Wilmington, Delaware, USA

June 2000 – September 2001

Heavenly Art, Earthly Beauty: The Art of Islam, State Hermitage Museum, St Petersburg, Russia

Loans to Museums and Galleries

May – October 2000

La Beauté in natura, Avignon, France

December 1999 – April 2000

Heavenly Art, Earthly Beauty: The Art of Islam, Nieuwe Kerk, Amsterdam, Netherlands

November 1999 – Febuary 2000

Orakel: Der Blik in die Zukunft, Museum Rietberg, Zürich, Switzerland

July – September 1999

Royal Persian Paintings: The Qajar Epoch 1785–1925, Brunei Gallery, School of Oriental and African Studies, London, UK

February – May 1999

Royal Persian Paintings: The Qajar Epoch 1785–1925, Armand Hammer Museum of Art, University of California, Los Angeles, USA

October 1998 – January 1999

Royal Persian Paintings: The Qajar Epoch 1785–1925, Brooklyn Museum of Art, New York, New York, USA

June – September 1998

Corps à vif: art et anatomie, Musee d'art et d'histoire, Geneva, Switzerland

October – November 1997

The Quick and the Dead: Artists and Anatomy, Royal College of Art, London, UK

November 1993 – March 1994

Worlds Beyond: Death and Afterlife in Art, Cartwright Hall, Bradford, UK

January – April 1992

Jüdische Lebenswelten, Martin-Gropius-Bau, Berlin, Germany

Major Publications from the Khalili Collections

* Denotes forthcoming volume at time of writing; some publication titles may change.

Islamic art

Déroche, François (1992), *Volume I – The Abbasid Tradition: Qur'ans of the 8th to the 10th Centuries AD*.

James, David (1992), *Volume II – The Master Scribes: Qur'ans of the 10th to 14th Centuries AD*.

James, David (1992), *Volume III – After Timur: Qur'ans of the 15th and 16th Centuries*.

Bayani, Manijeh; Contadini, Anna; Stanley, Tim (1999/2009), *Volume IV – The Decorated Word: Qur'ans of the 17th to 19th Centuries, Parts I and II*.

Safwat, Nabil F. (1996), *Volume V – The Art of the Pen: Calligraphy of the 14th to 20th Centuries*.

Khan, Geoffrey (1993), *Volume VI – Bills, Letters and Deeds: Arabic Papyri of the 7th to 11th Centuries*.

Freeman, Deborah, de Blois, Francois et al.,* *Volume VII – Learning, Piety and Poetry. Manuscripts from the Islamic World*.

Leach, Linda York (1998), *Volume VIII – Paintings from India*.

Grube, Ernst J. et al. (1994), *Volume IX – Cobalt and Lustre: The First Centuries of Islamic Pottery.*

Morgan, Peter, Moura Carvalho, Pedro et al.,* *Volume X – A Rival to China: Later Islamic Pottery, Parts I and II.*

Spink, Michael, et al. (2022), *Volume XI – Brasses, Bronze and Silver of the Islamic Lands, Parts I–IV.*

Maddison, Francis; Savage-Smith, Emilie (1997), *Volume XII – Part I, Science, Tools and Magic: Body and Spirit Mapping the Universe and Part II Mundane Worlds.*

Bayani, Manijeh; Kalus, Ludvik et al.,* *Volume XIII – Seals and Talismans.*

Cohen, Steven, et al.,* *Volume XIV – Textiles, Carpets and Costumes, Parts I and II.*

Goldstein, Sidney M, et al., (2005), *Volume XV – Glass: From Sasanian Antecedents to European Imitations.*

Wenzel, Marian (1992), *Volume XVI – Ornament and Amulet: Rings of the Islamic Lands.*

Spink, Michael; Ogden, Jack (2013), *Volume XVII – The Art of Adornment: Jewellery of the Islamic lands, Parts I and II.*

Moura Carvalho, Pedro (2010), *Volume XVIII – Gems and Jewels of Mughal India: Jewelled and Enamelled Objects from the 16th to 20th Centuries.*

Vardanyan, Aram R.,* *Volumes XIX–XX – Dinars and Dirhams: Coins of the Islamic Lands, Parts I and II.*

Alexander, David (1992), *Volume XXI – The Arts of War: Arms and Armour of the 7th to 19th Centuries.*

Khalili, Nasser D.; Robinson, B.W.; Stanley, Tim (1996/7), *Volume XXII – Lacquer of the Islamic Lands, Parts I and II.*

Vernoit, Stephen (1997), *Volume XXIII – Occidentalism: Islamic Art in the 19th Century.*

Pinder-Wilson, Ralph, Chida-Razvi, Mehreen et al.,* *Volume XXIV – Monuments and Memorials: Carvings and Tile Work from the Islamic World.*

Sims, Eleanor et al. (2022) *Volume XXV – The Tale and the Image: History and Epic Paintings from Iran and Turkey, Part I.*

Rogers, J.M, Bayani, Manijeh et al.* *Volume XXVI – The Tale and the Image: Illustrated Manuscripts and Album Paintings from Iran and Turkey, Parts I and II.*

Blair, Shelia (1995), *Volume XXVII – A Compendium of Chronicles: Rashid al-Din's Illustrated History of the World.*

Soucek, Svat (1996) *The Khalili Portolan Atlas: Facsimile edition with text: Piri Reis and Turkish mapmaking after Columbus*

Chaldecott, Nada,* *Turcoman Jewellery.*

Parikh, Rachel (2022), *The Khalili Falnamah.*

Studies in the Khalili Collection – academic monographs

Khan, Geoffrey (1992), *Volume I – Selected Arabic Papyri.*

Soucek, Svat (1996), *Volume II – Piri Reis and Turkish Mapmaking after Columbus, The Khalili Portolan Atlas.*

Sims-Williams, Nicholas (2012), *Volume III, Part 1 – Bactrian Documents from Northern Afghanistan: Legal and Economic Documents.*

Sims-Williams, Nicholas (2007), *Volume III, Part II – Bactrian Documents from Northern Afghanistan: Letters and Buddhist Texts.*

Sims-Williams, Nicholas (2012), *Volume III, Part III – Bactrian Documents from Northern Afghanistan: Plates.*

Goodwin, Tony (2005), *Volume IV – Arab-Byzantine Coinage.*

Khan, Geoffrey (2007), *Volume V – Arabic Documents from Early Islamic Khurasan.*

Hajj and the Art of Pilgrimage

Khan, Qaisra M (2022), *Hajj and the Arts of Pilgrimage: The Khalili Collections.*

Khan, Qaisra M; Nassar, Nahla et al. * *Hajj and the Arts of Pilgrimage: Essays in Honour of Nasser David Khalili, Volumes I and II*

Khan, Qaisa M.; Burns, Michael (trans) (2024) The Pilgrim's Companion: The Khalili Anis al-Huijai

Khan, Qaisra M; Khalili, Nasser D. Hajj and the Arts of Pilgrimage, Volumes I-IX*

Aramaic documents

Naveh, Joseph; Shaked, Shaul (2012), *Aramaic Documents from Ancient Bactria.*

Japanese art of the Meiji period

Impey, Oliver; Fairley, Malcolm et al. (1995), *Volume I – MEIJI NO TAKARA – Treasures of Imperial Japan: Selected Essays.*

Impey, Oliver; Fairley, Malcolm et al. (1995), *Volume II – MEIJI NO TAKARA – Treasures of Imperial Japan: Metalwork, Parts I and II.*

Impey, Oliver; Fairley, Malcolm et al. (1995), *Volume III – MEIJI NO TAKARA – Treasures of Imperial Japan: Enamel.*

Impey, Oliver; Fairley, Malcolm; Earle, Joe et al. (1995), *Volume IV – MEIJI NO TAKARA – Treasures of Imperial Japan: Lacquer, Parts I and II.*

Impey, Oliver; Fairley, Malcolm et al. (1995), *Volume V, Part I – MEIJI NO TAKARA – Treasures of Imperial Japan: Ceramics: Porcelain.*

Impey, Oliver; Fairley, Malcolm et al. (1995), *Volume V, Part II – MEIJI NO TAKARA – Treasures of Imperial Japan: Ceramics: Earthenware.*

Earle, Joe et al. (1995), *Volume VI – MEIJI NO TAKARA – Treasures of Imperial Japan: Masterpieces by Shibata Zeshin.*

Irvine, Gregory et al. (2013), *Japonisme and the Rise of the Modern Art Movement: The Arts of the Meiji Period.*

Pollard, Clare; McDermott, Hiroko T.; Van Overbeeke, Luz; Matsubara, Fumi; Hirota, Takashi* *Embroidered Wonders: Meiji Era Textiles in the Khalili Collections.*

Elkvity, Dror; Khalili, Nasser D.,* *Japonisme: Artistry and Influence.*

Kimono

Jackson, Anna et al. (2015), *Kimono: The Japanese Art of Pattern and Fashion.* (English, Italian and French editions)

Atkins, Jacquie; Elkvity, Dror* *Images of Culture: Japanese Kimono 1915– 1950 in the Khalili Collections.*

Swedish textile art

Hansen, Viveka; Institutet för Kulturforskning (1996), *Swedish Textile Art: Traditional Marriage Weavings from Scania.*

Spanish damascene metalwork

Lavin, James D. et al. (1997), *The Art and Tradition of the Zuloagas: Spanish Damascene from the Khalili Collection*

Enamels of the world

Williams, Haydn et al. (2009), *Enamels of the World, 1700–2000: The Khalili Collections.*

Selected Exhibition Catalogues:

Islamic art

Rogers, J. M. (1995), *Empire of the Sultans, Ottoman Art from the Collection of Nasser D. Khalili, Catalogues in association with the exhibition L'empire des sultans*, Musée Rath, Geneva, Switzerland, 7 July-24 September 1995, English and French Publications

Rogers, J. M. (1996), *Empire of the Sultans, Ottoman Art from the Collection of Nasser D. Khalili, Catalogues in association with the exhibition Empire of the Sultans, Ottoman Art from the Collection of Nasser D. Khalili*, Brunei Gallery, School of Oriental and African Studies, London, UK (July – Oct 1996), Israel Museum, Jerusalem, Israel (Dec 1996 – June 1997)

Rogers, J. M. (2000), *Empire of the Sultans, Ottoman Art from the Collection of Nasser D. Khalili, Catalogue in association with the the US tour of the exhibition Empire of the Sultans*, held in 13 venues in the USA between February 2000 – February 2004

Lurie, Doron (2000), *Marvels of the East, Indian Paintings of the Mughal Period from the Nasser D. Khalili Collection*, Catalogue in association with the exhibition at the Tel Aviv Museum of Art, Tel Aviv, Israel, May – July 2000

Rogers, J. M. (2007), *The Arts of Islam. Treasures from the Nasser D. Khalili Collection*, Catalogue in association with the exhibition at the Art Gallery of New South Wales, Sydney, Australia (June – Sep 2007)

Rogers, J. M. et al. (2008), *The Arts of Islam, Treasures from the Nasser D. Khalili Collection*, Catalogues in association with the exhibition at Gallery One, Emirates Palace, Abu Dhabi, UAE (22 January – 22 April 2008)

Rogers, J. M. (2009) *Arts de l'Islam, chefs-d'œuvre de la collection Khalili* Catalogue in association with the exhibition Arts de l'Islam, chefs-d'œuvre de la collection Khalili at the Institut du Monde Arabe, Paris, France (6 October 2009 – 14 March 2010)

Rogers, J. M. et al. (2010) *The Arts of Islam, Masterpieces from Khalili Collection* Reprint of 2008 catalogue which was associated with the exhibition The Arts of Islam. Treasures from the Nasser D. Khalili Collection

Mols, Luitgard (2010) *Passie Voor Perfectie, Islamitische Kunst uit de Khalili Collecties* Catalogue in association with the exhibition Passion for Perfection: Islamic Art from the Khalili Collection at Nieuwe Kerk, Amsterdam, Netherlands (11 December 2010 – 17 April 2011)

Khalili, Nasser D. (2005-2006) *The Timeline History of Islamic Art and Architecture* – editions in English, Arabic, French and Dutch

Khalili, Nasser D. (2006) *Islamic Art and Culture: A visual History* – US edition

Khalili, Nasser D. (2008) *Islamic Art and Culture: Timeline and History* – Egyptian edition

Khalili, Nasser D. (2008) *Visions of Splendour in Islamic Art and Culture* – English and Arabic editions

Selected Exhibition Catalogues:

Japanese Art

Harris, Victor (1994) *Japanese Imperial Craftsmen: Meiji Art from the Khalili Collection*, catalogue in association with the exhibition at the British Museum, London, UK (Sep 1994 – Jan 1995)

Impey, Oliver; Fairley, Malcolm (1994) *Treasures of Imperial Japan Ceramics from the Khalili Collection*, catalogue in association with the exhibition at the National Museum of Wales, Cardiff, UK (Oct 1994 – Jan 1995)

Earle, Joe (1997) *Shibata Zeshin: Masterpieces of Japanese lacquer from the Khalili Collection*, catalogue in association with the exhibition at the National Museums of Scotland, Edinburgh, UK (Apr – Oct 1997)

Earle, Joe (1999) *Treasures of Imperial Japan: Masterpieces From The Khalili Collection*, catalogue in association with the exhibition at the First USA Riverfront Arts Centre, Wilmington, Delaware, USA, (Apr – Oct 1999)

Earle, Joe (2002) *Splendors of Imperial Japan: Arts of the Meiji Period from the Khalili Collection*, catalogue in association with the exhibition at the Portland Art Museum, Portland, Oregon, USA (June – Sep 2002)

Schiermeier, Kris; Forrer, Matthi (2006) *Wonders of Imperial Japan: Meiji art from the Khalili Collection*, Catalogue in association with the exhibition at Van Gogh Museum, Amsterdam, Netherlands (7 July – 22 October 2006)

Schiermeier, Kris; Forrer, Matthi (2007) *Japan Meiji – Kunst & Japonismus: Aus der Sammlung Khalili*, Catalogue in association with the exhibition at Kunsthalle Krems, Krems, Austria (25 February – 3 June 2007)

Irvine, Gregory; Jackson, Anna; Schiermeier, Kris; Forrer, Matthi; Amelekhina, Svetlana; Panfilov, Feodor (2017) *Beyond Imagination: Treasures of Imperial Japan from the Khalili Collection 19th to early 20th century*, Catalogue in association with the exhibition Beyond Imagination: Treasures of Imperial Japan from the Khalili Collection, 19th to early 20th century, Kremlin Museums, Moscow, Russia, 5 July – 1 October 2017

Spanish Damascene Collection

Debono, Sandro; Cassar, Robert (2012) *Ornament and Malta: An Introduction*, Catalogue in association with the exhibition Metal Magic, Spanish Treasures from the Khalili Collection, The Auberge de Provence, Valetta, Malta (Nov 2011 – Apr 2012)

Enamels of the World Collection

Williams, Haydn (2009) *Enamels of The World 1700 – 2000 From The Khalili Collections – [Russian Version]*, Catalogue in association with the exhibition Enamels of the World 1700–2000 from the Khalili Collection at the State Hermitage Museum, St Petersburg, Russia (8 Dec 2009 – 14 March 2010)

Acknowledgements

I must take this opportunity to express my gratitude to several honourable individuals: HM Queen Elizabeth II, HM King Charles III, HE Jean Paul II, HE Pope Benedict XVI, HE Pope Francis, RH Baroness Valerie Amos, Sir David Attenborough, RH Sir Anthony Charles Lynton Blair KG, Irina Bokova, Daniel and Samantha Cohen, Sir Nicholas David Coleridge CBE, Rabbi Daniel and Illana Epstein, Elena Gagarina, António Guterres, Prof. Adam Habib, François Hollande, Dr Tristram Hunt, Lady Susan Hussey, Sir Richard Lambert, HE Jack Lang, Sir Tim Lancaster, Neil Macgregor OM, Cardinal Renato Raffaele Martino, Dr Robin Niblett, Professor Mikhail Piotrovsky, Lieutenant Colonel Charles Richards, Lord Jacob Rothschild, Rabbi Lord Jonathan Sacks, RH Lord Chris Patten, Baron Patten of Barnes, Axel Rüger, RH Baroness Patricia Scotland, RH James Stourton, Alexander Sturgis, Professor Paul Webley, Hon Dame Annabel Whitehead, Lord Young of Graffham and Lord Edward Young, Baron Young of Old Windsor.

I would also like to extend my heartfelt gratitude to my curator and confidant, Dror Elkvity, for his tireless dedication, advice and support, without whom this book would have been made possible.

Furthermore, I would like to personally thank everyone who went with me along the journey of writing this book and have generously given their time and experience.

Neil Blair and Rory Scarfe, my literary agents, Joel Rickett, Elizabeth Bond, Fionn Hargreaves and Howard Watson from Penguin Random House, Waqās Ahmed, Hugo Burnard, William Green, William Fiennes, Mansoureh and Daryoosh Pirnia, Nizam Uddin.

Additionally, I would like to thank the devoted members of my team at the Khalili Collections – editor of my encyclopaedic Islamic volumes, Dr Julian Raby as well as curators for the Islamic and Hajj collections, Nahla Nassar and Qaisra Khan, and additionally, Eyal Oz, Pouya Hosseinpour, Roberta Marin and Shireen Ellinger, for all their dedication and hard work in maintaining and sustaining the collections' existence, and lastly my publishing team, Loran Raby and Misha Anikst.

I would like to extend further acknowledgements to these individuals whose friendship helped shape my journey. I thank them all from the bottom of my heart: Dr Robert Anderson, Karen Armstrong, Robin Birley, Alan Borg CBE, Eric Bruce, Anthony Bunker, Sheila Canby, Edmund Capon AM OBE, Benedict Carter, Philippe Castro, Clive Cheesman, Shirin Daghighian, Edward Gibbs, Mark Hinton, Esther Iseppi, Professor Jeremy John, Major Andrew and Wendy Keelan, Hugh Kelly, Tim Knox, Aron Laviere, Jamie Lightford, James Muyskens, Terry O'Neill, Claire Penhallurick, Anton de Piro, Dr Venetia Porter, William Robinson, Alexandra Roy, Claudia Schadler-Bissig, James S. Snyder, Karimzadeh Tabrizi, Amanda Thirst, Ernest Veen, Jonathan Williams, Mariá Rosa Suárez Zuloaga.

Acknowledgements

We have been honoured to have the world's leading scholars and experts in their respective fields work with us over the years. I would like to thank each of them, and list them here according to the collection they researched:

Islamic Art: Rudolf Abraham, David Alexander, Professor James Allan, Manijeh Bayani, Professor Doris Behrens-Abouseif, Professor Sheila S. Blair, Dr François de Blois, Christopher Cavey, Nada Chaldecott, Henrietta Sharp Cockrell, Dr Steven Cohen, Professor Anna Contadini, Georgette Cornu, Jacqueline Coulter, Mitchell Abdul Karim Crites, Professor Walter B. Denny, Professor François Déroche, Dr Layla Diba, Shireen Ellinger, Dr Rebecca M. Foote, Deborah Freeman, Dr Melanie Gibson, Dr Sidney M. Goldstein, Dr Javad Golmohammadi, Tony Goodwin, Hero Granger-Taylor, Professor Ernst J. Grube, Dr Rosalind Wade Haddon, Stephen Hirtenstein, Rahul Jain, Dr David James, Professor Ludvik Kalus, Dr Derek Kennet, Professor Geoffrey Khan, Dr Mark G. Kramarovsky, Dr Jens Kröger, Dr Linda York Leach, Mary McWilliams, Francis Maddison, Marielle Martiniani-Reber, Behnaz Atighi Moghaddam, Dr Peter Morgan, Dr Pedro Moura Carvalho, Professor Alastair Northedge, Dr Jack Ogden, Dr Alison Ohta, Dr Rachel Parikh, Ralph Pinder-Wilson, B.W. Robinson, Professor J.M. Rogers, Dr Martina Rugiadi, Dr Nabil F. Safwat, Professor Emilie Savage-Smith, Dr Emily Shovelton, Dr Eleanor Sims, Professor Nicholas Sims-Williams, Robert Skelton, Milton Sonday, Professor Svat Soucek, Michael Spink, Tim Stanley, Professor Wheeler M. Thackston, Dr Cristina Tonghini, Dr Elena Tsareva, Dr Aram R. Vardanyan, Dr Stephen Vernoit, Marie-France Vivier, Dr Marian Wenzel, Dr Elaine Wright and Mohamed Zakariya.

Hajj and the Art of Pilgrimage: Dr Bilal Badat, Dr Sami De Giosa, Dr Sabiha Göloğlu, Professor Alastair Hamilton, Dr Edmund Hayes, Qaisra Khan, Janie Lightfoot, Professor Jan Loop, Dr Michael Christopher Low, Dr Sergio Carro Martín, Professor Ulrich Marzolph, Professor Richard McGregor, Dr Luitgard Mols, Dr Harry Munt, Nahla Nassar, James Nicholson, Dr Julian Raby, Seif el Rashidi, Yousuf Saeed, Dr Saarthak Singh, Dr John Slight, Dr Aram Vardanyan, Dr Arnoud Vrolijk, Dr Muhammad Isa Waley, Dr Peter Webb and Michael Wolfe.

Aramaic Documents: Joseph Naveh and Shaul Shaked.

Japanese Art of the Meiji Period: Dr Gunhild Avitable, Ellen P. Conant, Joe Earle, Dr Rupert Faulkner, Dr Barbara Ford, Goke Tadaomi, Victor Harris, Hida Toyojiro, Jack Hillier, Dr Janet Hunter, Julia Hutt, Dr Oliver Impey, Greg Irvine, Hiroko T. McDermott, Clare Pollard, Sato Doshin, Lawrence Smith, Luz and Bart Van Overbeeke, Vibeke Woldbye, Edward Wrangham and Yamazaki Tsuyoshi.

Kimono: Jaquie Atkins, Professor Kendall Brown, Dr Christine Guth, Professor Iwao Nagasaki, Anna Jackson and Professor Timon Screech.

Swedish Textiles: Viveka Hansen.

Spanish Damascene: Claude Blair, Ramiro Larrañaga and Dr James D. Lavin.

Enamels of the World: Julia Clarke, Tatiana Fabergé, Rose Kerr, Daniela Mascetti and Haydn Williams.

Finally, I would also like to thank my dealers who have played a role to safeguard many masterpieces across all the collections: Didier Aaron, Elias Assad, Hamid Atighetchi, the Boisgirard family, Marino

Acknowledgements

and Clara Dall'Oglio, Barry Davies, Malcolm Fairley, Eric Graus, Robert Hall, Jonathan Harris, Alan Hartman, Simone Hartman, Oliver Hoare, Murat Kargili, Farid Kioumgi, Clive Loveless, Abraham Nejat Moussai, Francis Norton, the Sakhai brothers – Isaac, Joseph and Shauk, Paul and Peter Schaffer, Tsumugi Shoji, Eli Sinai and sons, Jean Sostil, David Sulzberger, Peter Willborg, and all major auction houses around the world.

Index

Index

Index

Index